FIGURE DRAWING
FOR FASHION

ISAO YAJIMA

017092

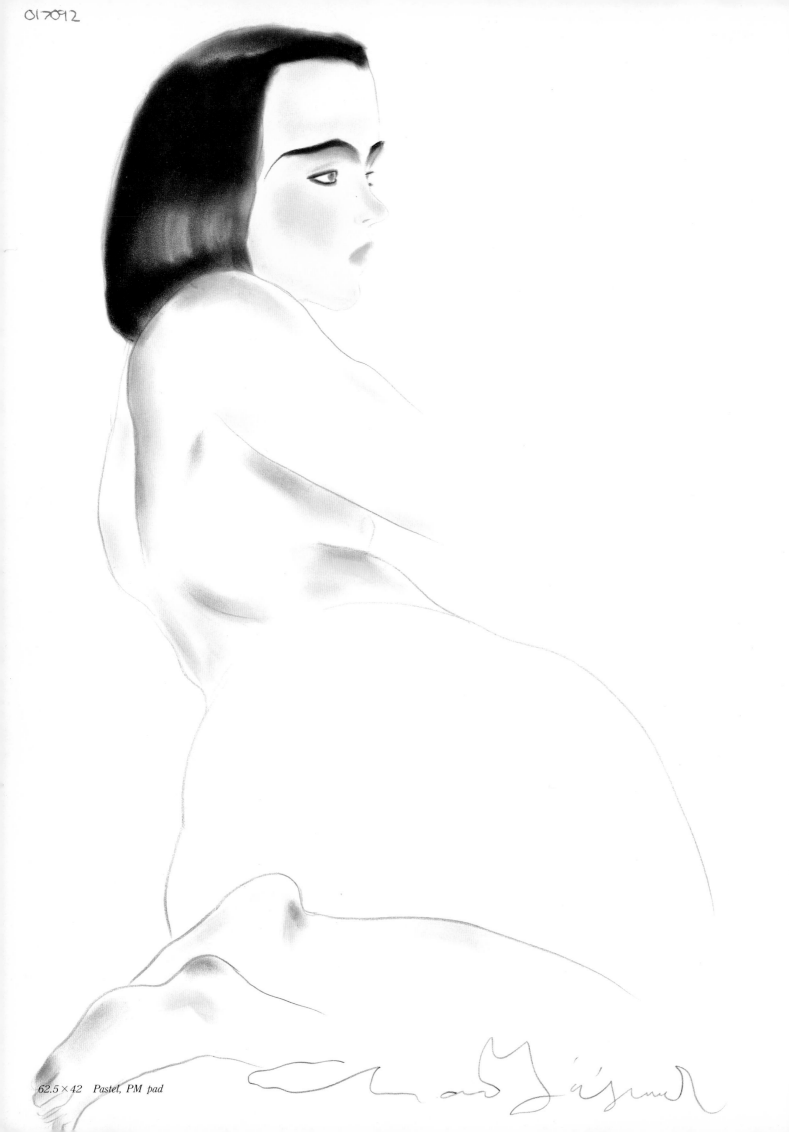

62.5 × 42 Pastel, PM pad

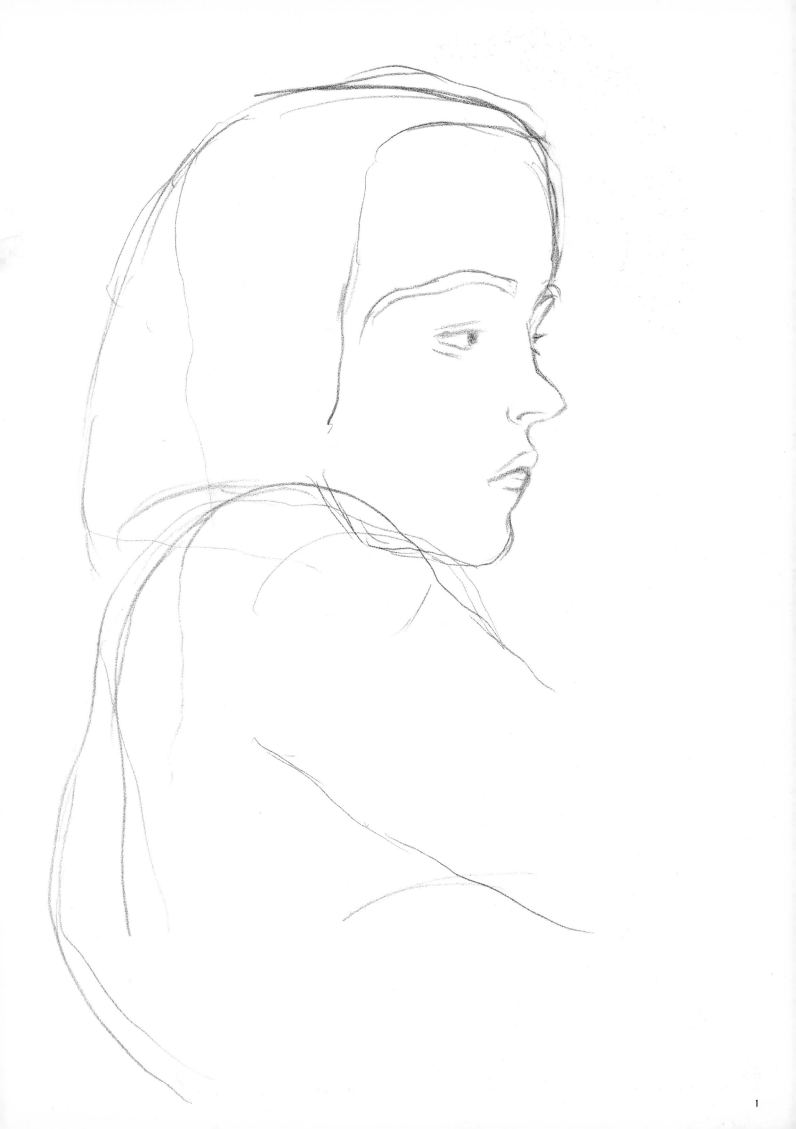

1

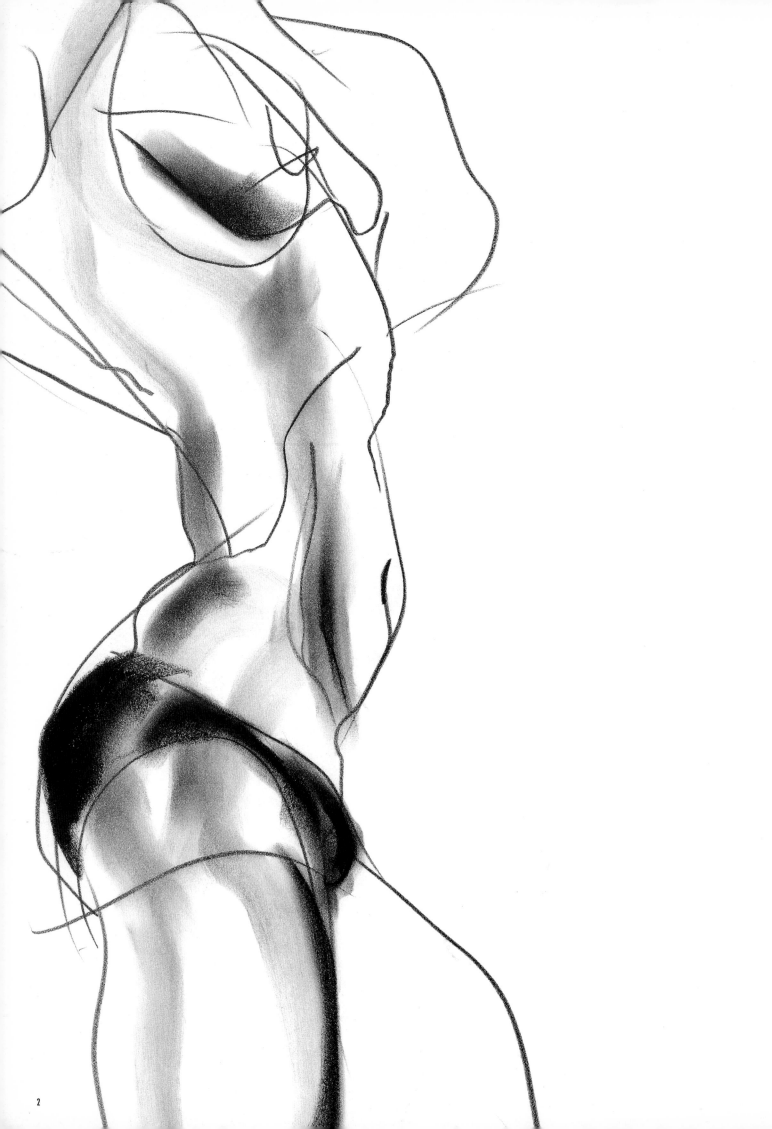

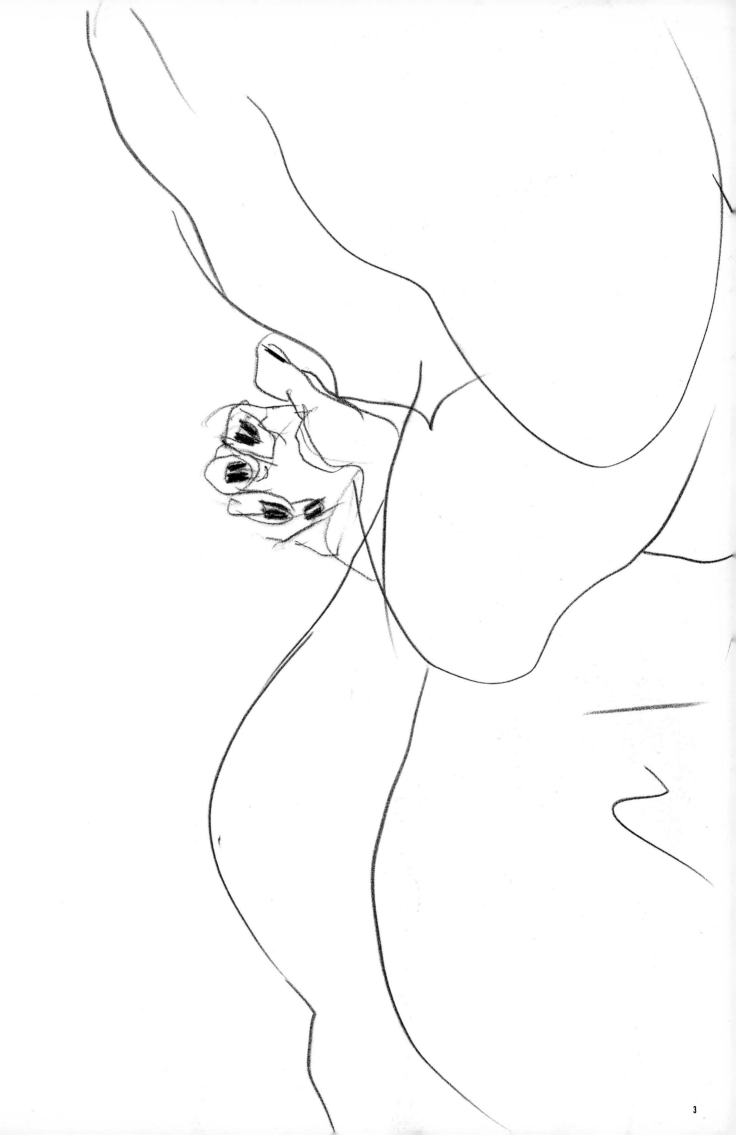

FIGURE DRAWING
FOR FASHION ❷

Translation by James Fukuda

Copyright © 1990 by Graphic-sha Publishing Co., Ltd.
1-9-12 Kudankita, Chiyoda-ku, Tokyo 102, Japan.
ISBN4-7661-0598-2

Printed in Japan

First Printing, 1990

FIGURE DRAWING FOR FASHION ❷

ファッションドローイング

KO ISAO YAJIMA

Isao Yajima

g

GRAPHIC-SHA

CONTENTS

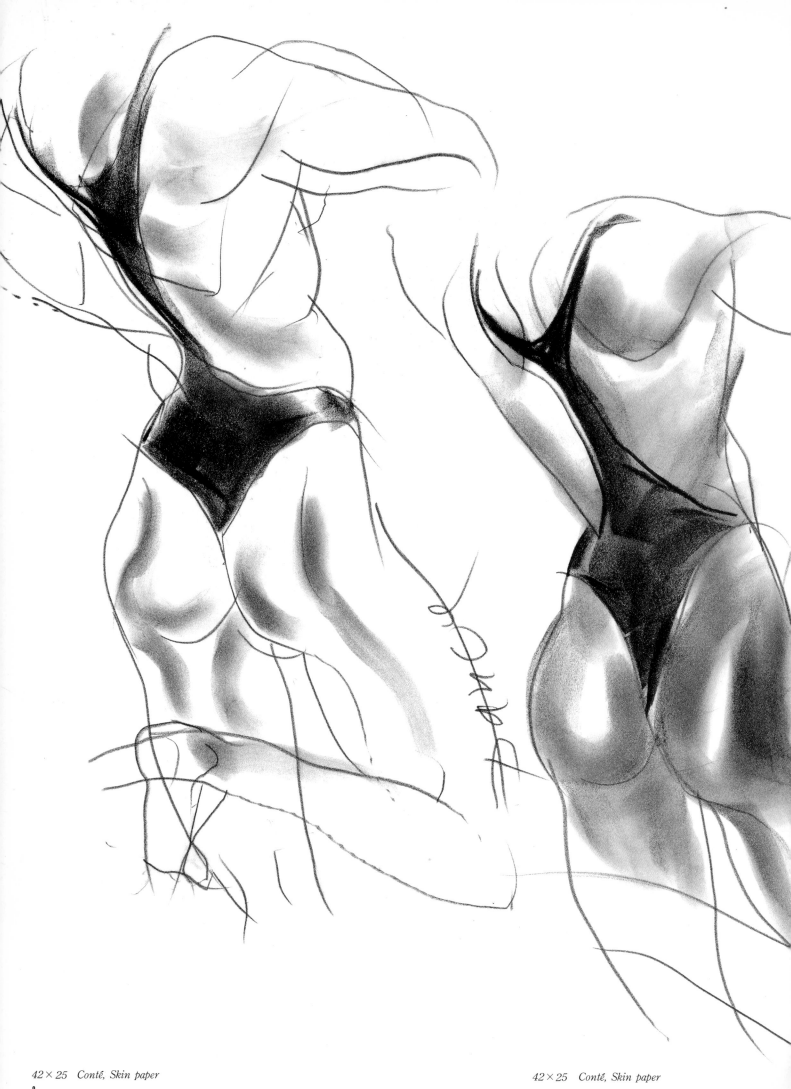

42×25 Conté, Skin paper

42×25 Conté, Skin paper

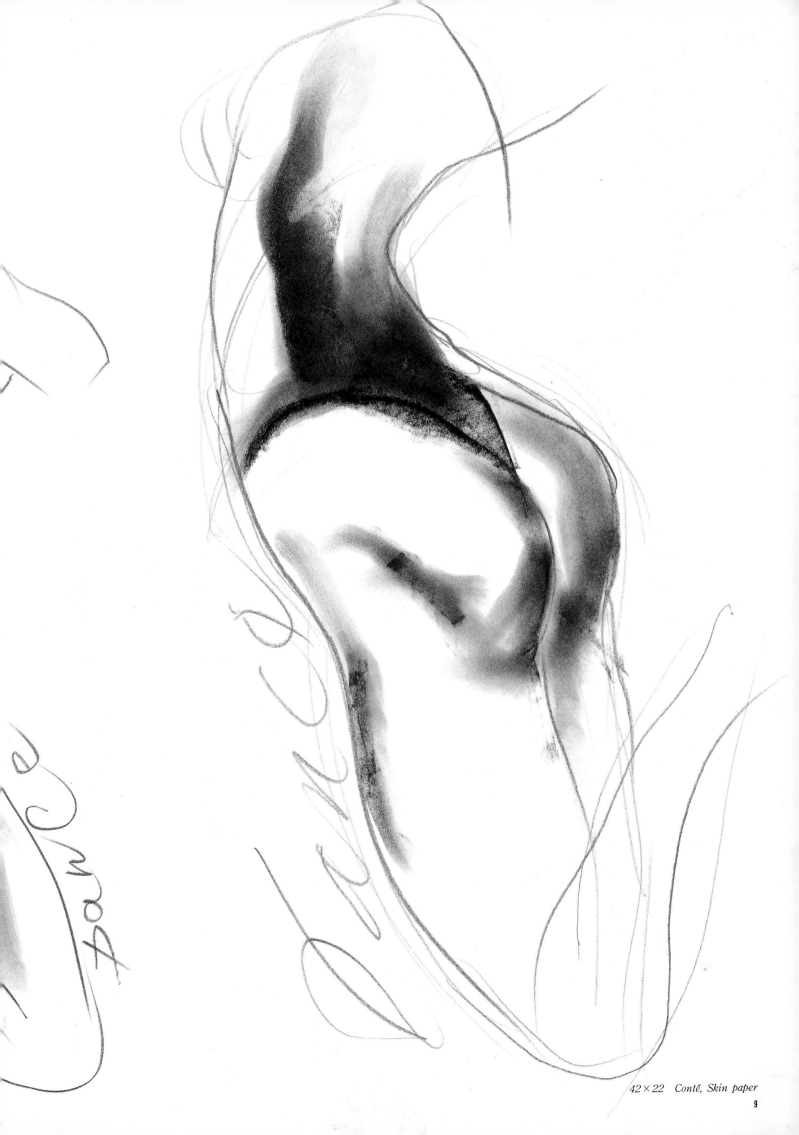

42×22 Conté, Skin paper

9

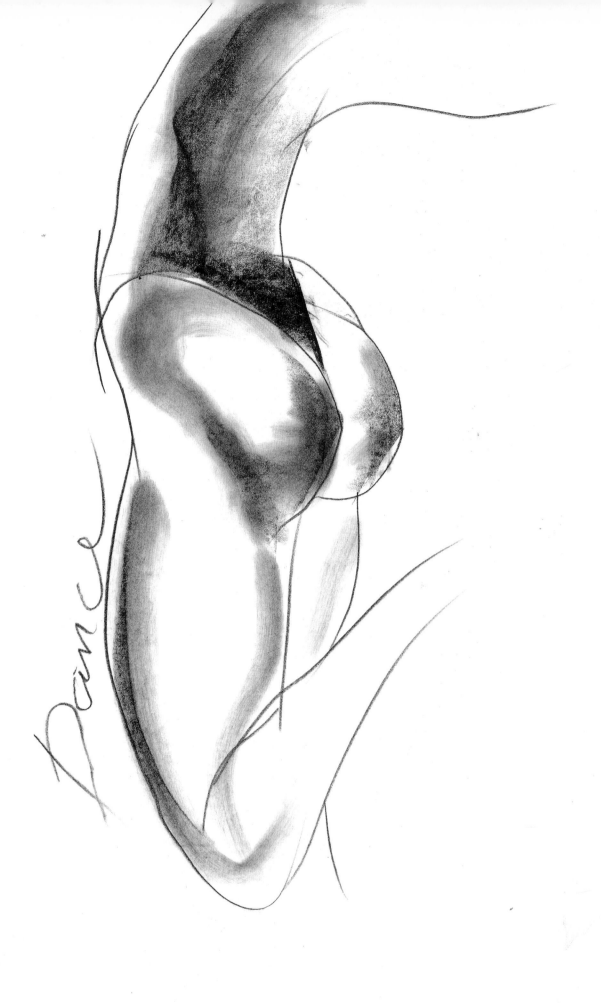

●I started out to depict the buttocks in torso form monomorphically but was immediately captivated by the double mounds.　●トルソーにこだわって描く

42×25　Conté, Skin paper

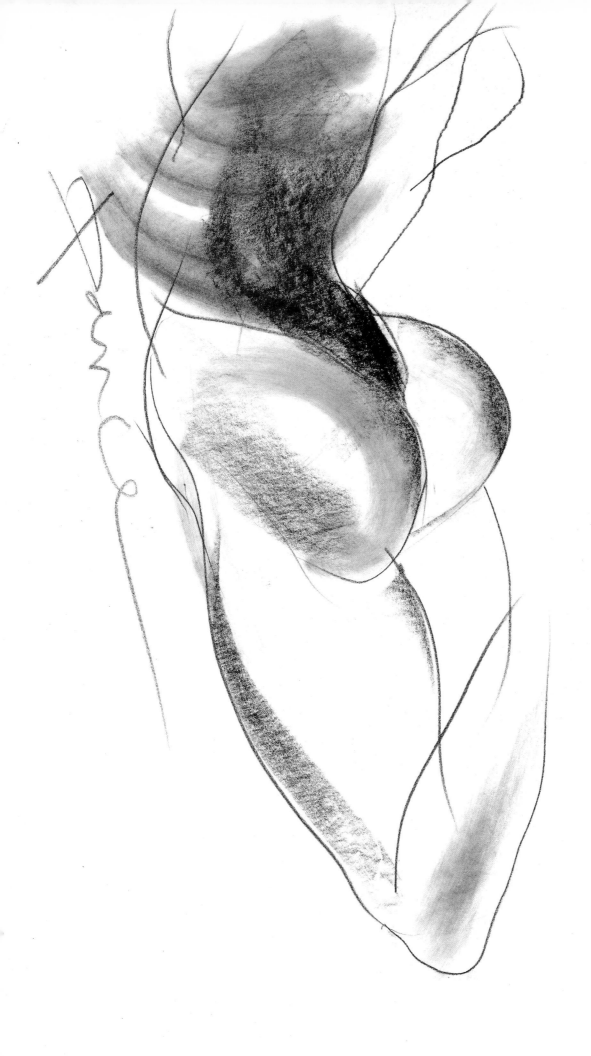

尻は，一つかと思ったら二つあった。

42×23 Conté, Skin paper

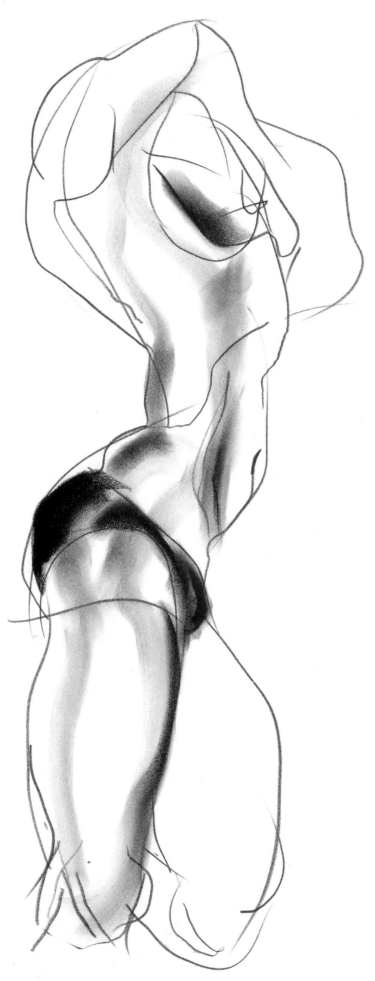

42×25　*Conté, Skin paper*

Milano Fashion

I have been commuting to Italy for the past nine years. Indeed, the fashion illustrator follows a busy schedule throughout the year. One reason why I am constantly on the move is that magazines and publishing houses compete with each other to show the designs of fashion designers even before their collections make their debut. In this sense, the fashion illustrator previews these illustrations by recreating the original sketches and samples of G. Armani, G. Versace, G. Fere, E. Coveri, Krizia, M. Valentino, Basile and other fashion designers too numerous to mention here.

Apparels undergo subtle design changes every season, every year in terms of color, material, balance, look and image. Fashion's magnetism springs from its capacity to simulate that which is made to appear as changes in the given human form. In this sense, fashion designers who are unable to use design options skillfully end up producing the same product year after year. The same can be said of fashion illustrators. In any case, fashion designers have their own conceptions about models and the people-image. For example, G. Armani's creations seem to be aimed at good-looking men and beautiful, contemporary Italian women. On the other hand, the men and women used by G. Versace are made to look demeaning to produce a feeling of cold sensuality. For structural reasons, the persons modeling G. F. Ferre's creations project a sculptured image. E. Coveri's approach is an Italian version of Castelbajac. Of Krizia, Biagiott, Cinzia Ruggeri and others, I personally feel that Cinzia Ruggeri's approach is probably the most interesting. The structure of her apparels, which can be compared to Ferre's, possesses a day-to-day element. For example, her vertical pleats, when folded, become a stairway while the apron section in the front serves as a tablecloth for dining. Perhaps it is appropriate to say that Paul Delbou's surrealism lives within his creations. Romeo Gigli, Moschino have made apparel styles available to those who frequent fastfood shops, making them popular among women belonging to the mayonnaise and ketchup strata of society.
Romeo Gigli's creations are aimed at skinny Brahmins while Moschino's are targeted at glamorous weight watchers who detest the feeling of being "encased in ropes."

Naturally, the creations of the many designers I have seen are not all to my liking, but I can say with certainty that they are all very well done. Their creations make me want to design apparels myself. Under these conditions I continue to fly back and forth from Tokyo to Milano every season——four times a year——to create my own style of illustrations before the appparel collections are publicly launched.

ミラノファッション

イタリアに行くようになってからもう9年になる。ファッションイラストレーションの仕事は一年中忙しい。しかも雑誌社ではコレクション前にフォースカミングでスティリスタの予告デザインを載せるからだ。G. アルマーニ，G. ベルサーチ，G. フェレー，E. コーベリ，クリッツア，M. バレンチーノ，バヂーレ，などなどのオリジナルスケッチやサンプルを見ながらイラストレーションに描き起こす。

服のデザインは毎シーズン，毎年，色，素材，バランス，ルックス，それにイメージ，それらが微妙に変わっていく。限られた人間の体をあれだけいろいろな方法で表情を変えて見せるのはファッションならでの妙味だ。ファッションデザイナーはその辺の変化をきちんと握んでいないと10年間同じものをつくるようになる。イラストレーターも同じだ。
ただ，モデルや人物のイメージについてスティリスタ独特の趣向がある。
G. アルマーニは甘い男とイタリアコンテンポラリーいい女っていう感じだし，G. ベルサーチの男と女はどこか自虐的で冷たいセクシーさが漂う。G. F. フェレーのは男も女も構築的理由に基づいて彫像化されている。E. コーベリのそれはイタリア版カステルバジャック。クリッツア，ビアジョッティーなどは本人そのものだ。そうそう自分が案外面白いと思うのは，チンツィア，ルジェリーだ。服はフェレーと対比できる，彼女の構築のエレメントは日常の物語なのだ。例えば階段，スカートの前身のエプロン風な切り替えは食事をとる時にテーブルクロスの役目をする。ポールデルヴォーのシュールリアリズムが作品と同居したといったらよいかもしれない。ロミオジリー，モスキーノは今までの服の格調をファーストフードショップに引きずり下ろし，マヨネーズとかケチャップで味つけしたすごくポピュラーな女のイメージ。
前者が乞食貴族，後者は "投げ縄でぐるぐる巻きにして" って泣きわめくグラマーだ。

いろいろデザイナーの作品を見ていると，一口に言って全部自分の好みでないけど格好いいと思う。やはり自分でも服をつくりたくなる。
そんな風に僕にとって仕事の連続はそれらを毎シーズン，コレクションでの発表前に描く自分流のイラストによって年四回東京，ミラノを往復する飛行機の中で過ぎていく。
ファッションイラストレーションの仕事の合間にいろいろなデザインの様相が見えてくる。

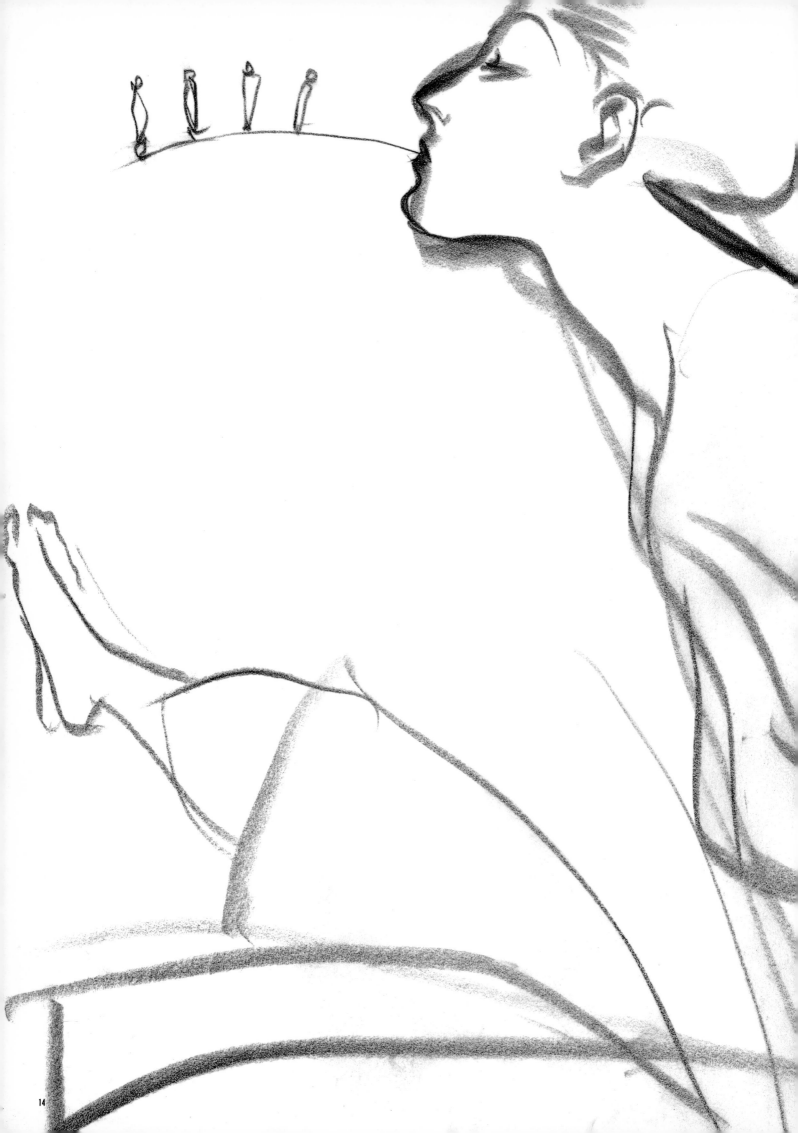

● A string of "Buddhas" flowed
out of the beautiful nude's mouth when she slipped down
hard on her bottom. It took eight seconds to record this image.
●美女が尻もちをついた瞬間，口から仏陀がポロポロと出て来た。8秒の瞬間。

37×30 Conté, Skin paper

●Try making quick sketches of a single pose
in 15-second intervals, will by themselves
you are on the road to success. ●1分間
15秒ずつの瞬間が繰り返され，ポーズは

several times within a one-minute period. Poses, produced repeatedly
follow a natural flowing pattern. When this happens,
に一つのポーズを何度も素早く描く。
勝手にアレンジされ一人歩きし始める。

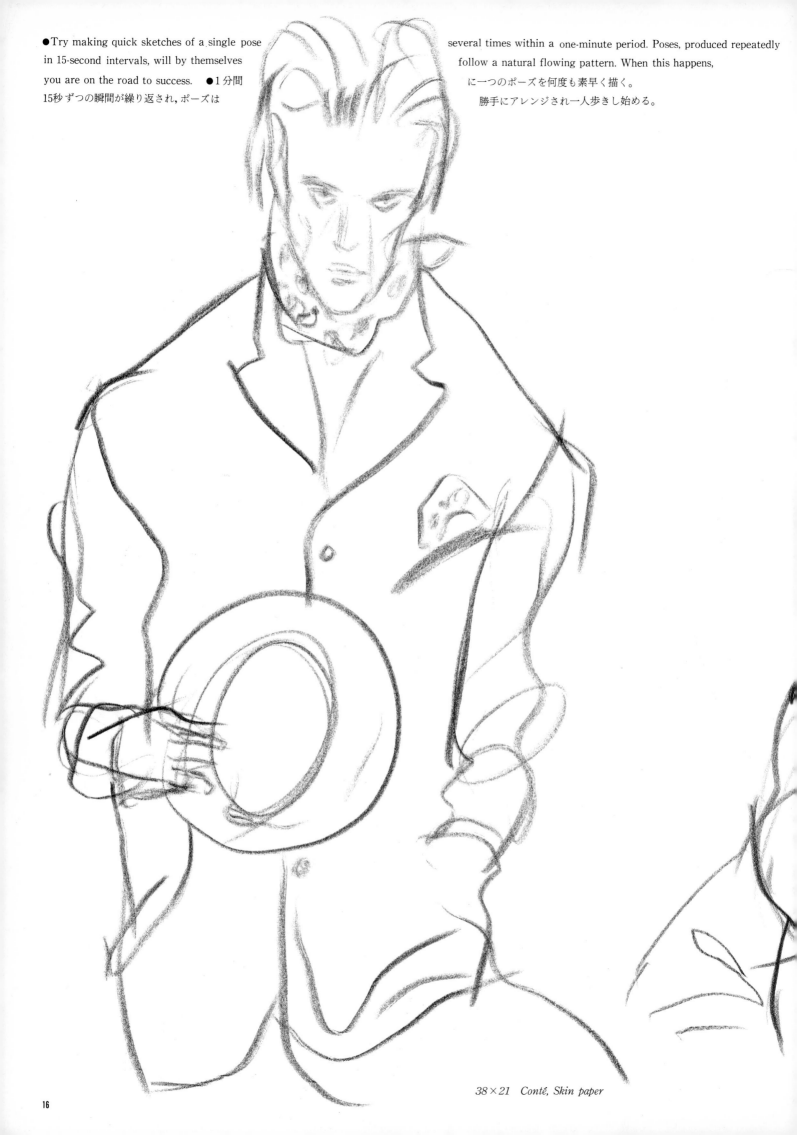

38×21 Conté, Skin paper

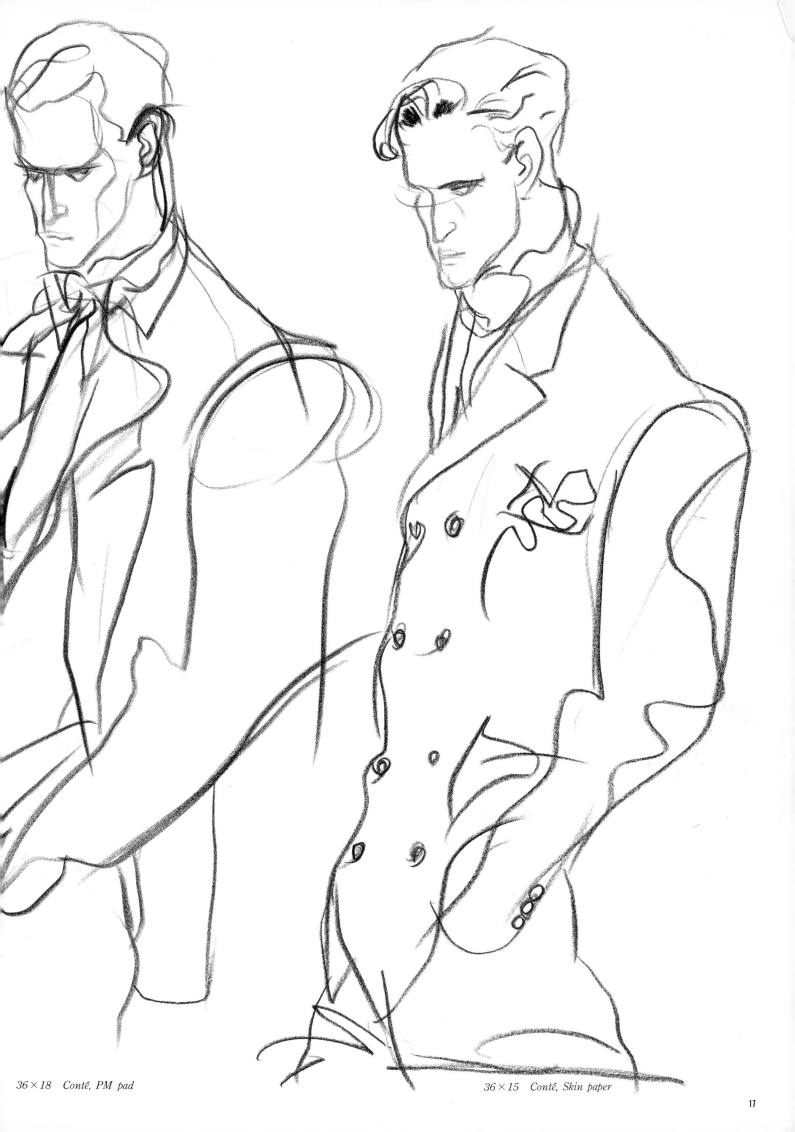

36 × 18 Conté, PM pad

36 × 15 Conté, Skin paper

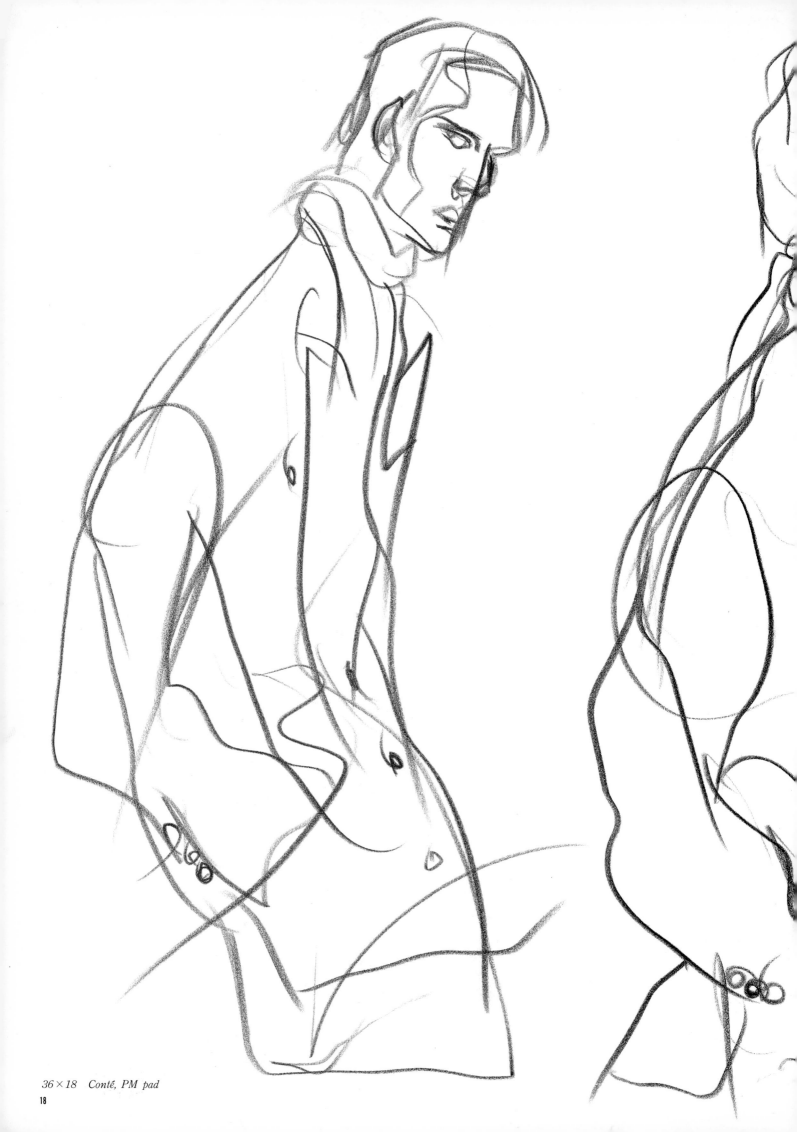

36×18 Conté, PM pad

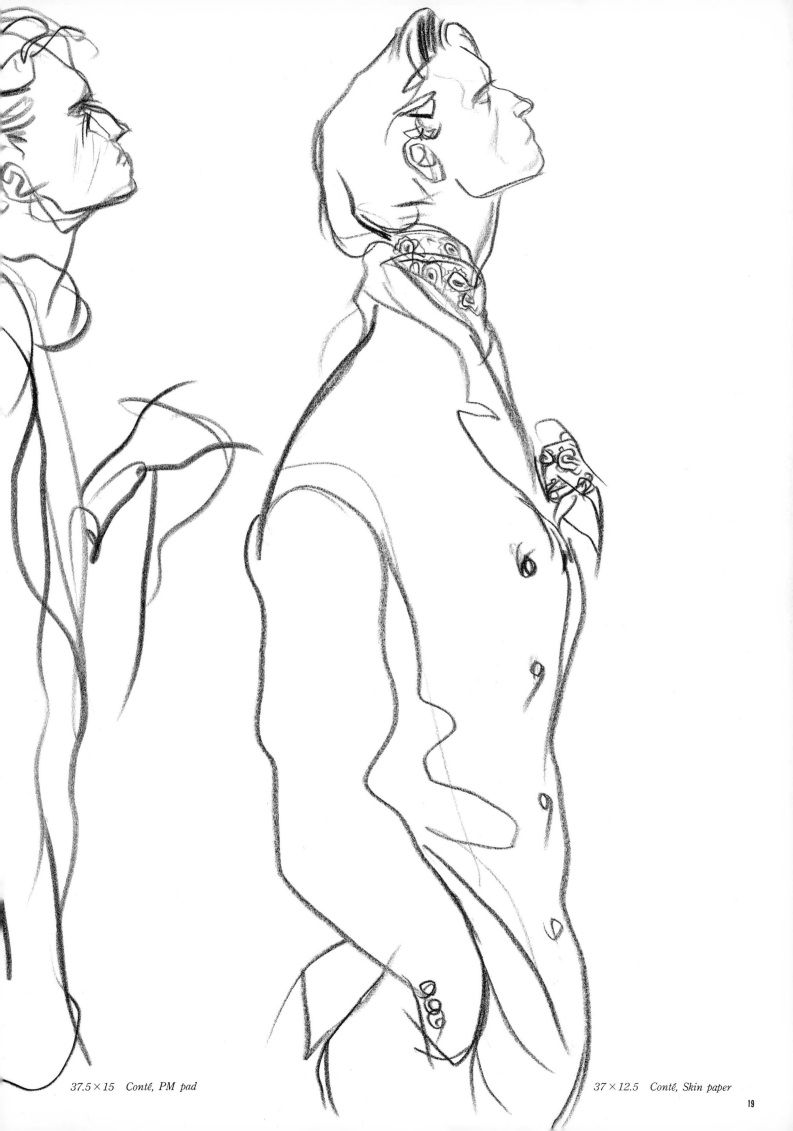

37.5 × 15 Conté, PM pad

37 × 12.5 Conté, Skin paper

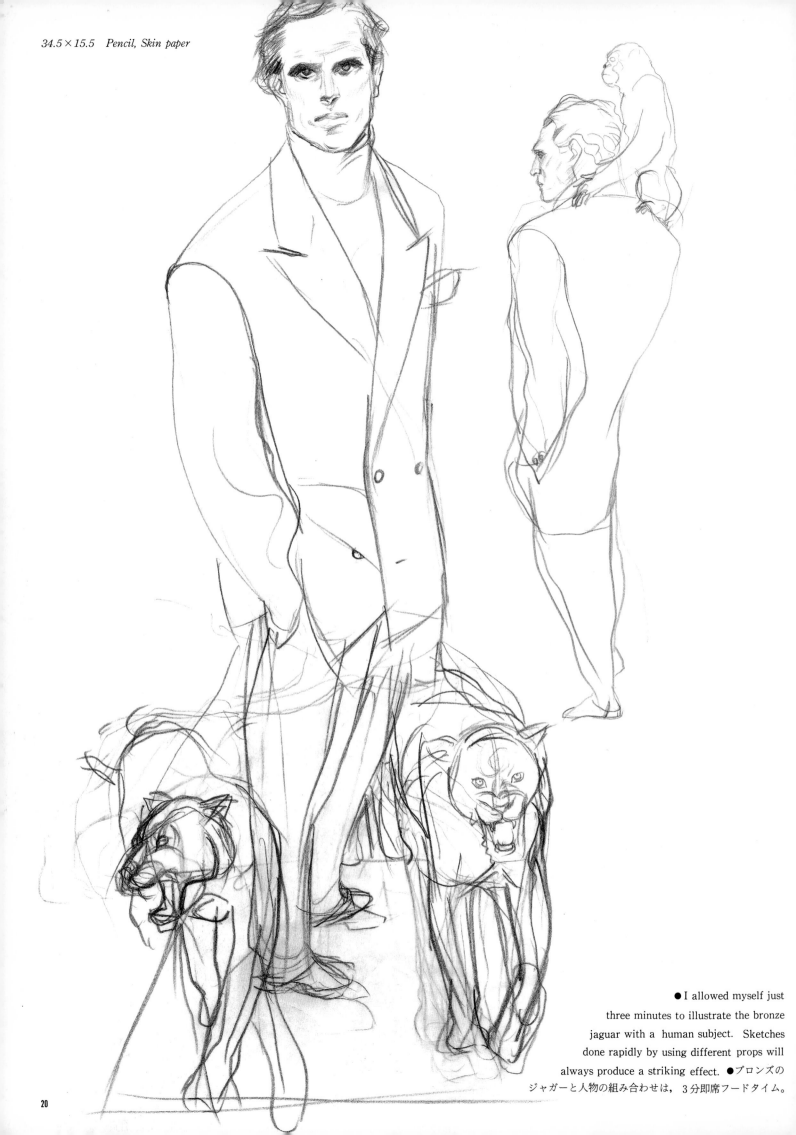

34.5×15.5 *Pencil, Skin paper*

●I allowed myself just
three minutes to illustrate the bronze
jaguar with a human subject. Sketches
done rapidly by using different props will
always produce a striking effect. ●ブロンズの
ジャガーと人物の組み合わせは，3分即席フードタイム。

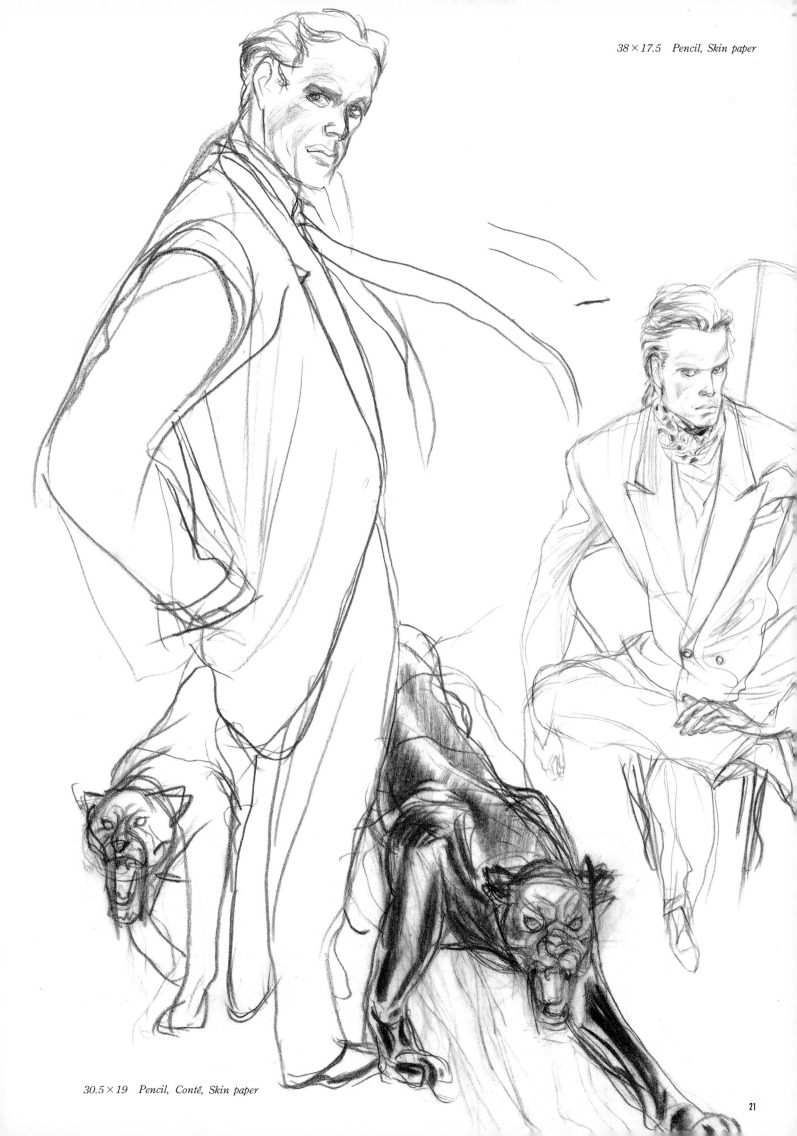

38 × 17.5 Pencil, Skin paper

30.5 × 19 Pencil, Conté, Skin paper

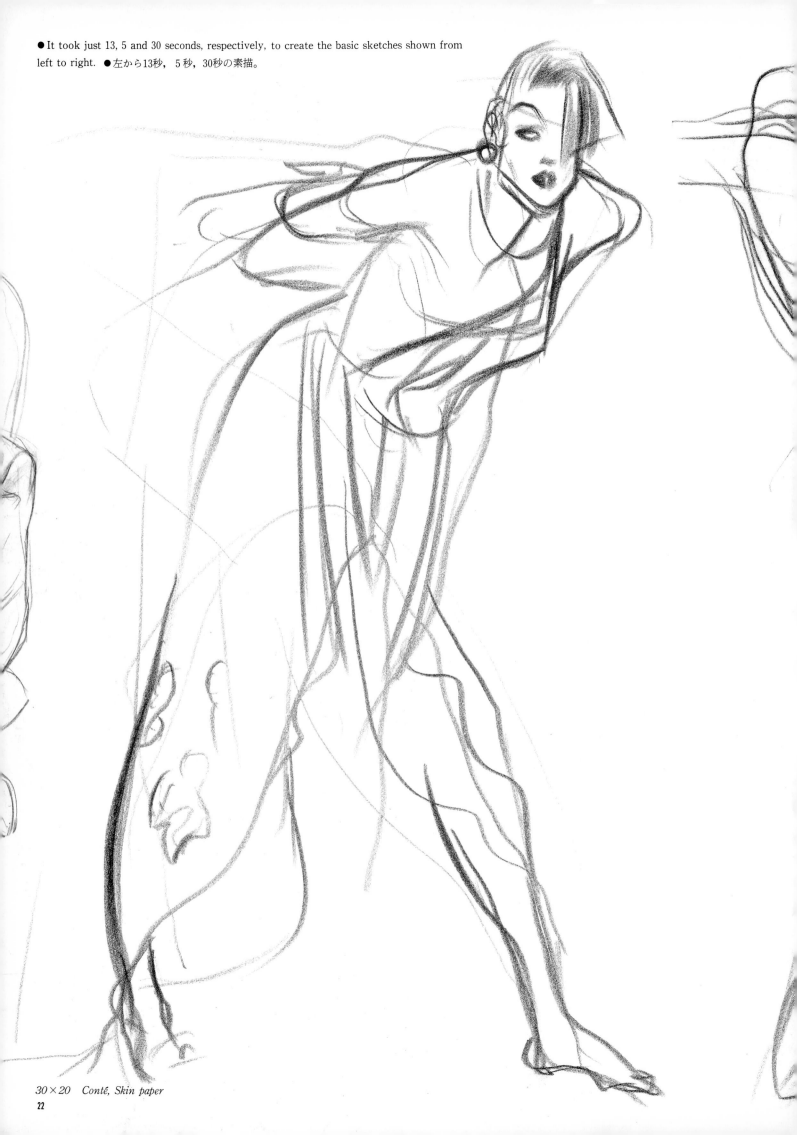

●It took just 13, 5 and 30 seconds, respectively, to create the basic sketches shown from left to right. ●左から13秒，5秒，30秒の素描。

30×20 Conté, Skin paper

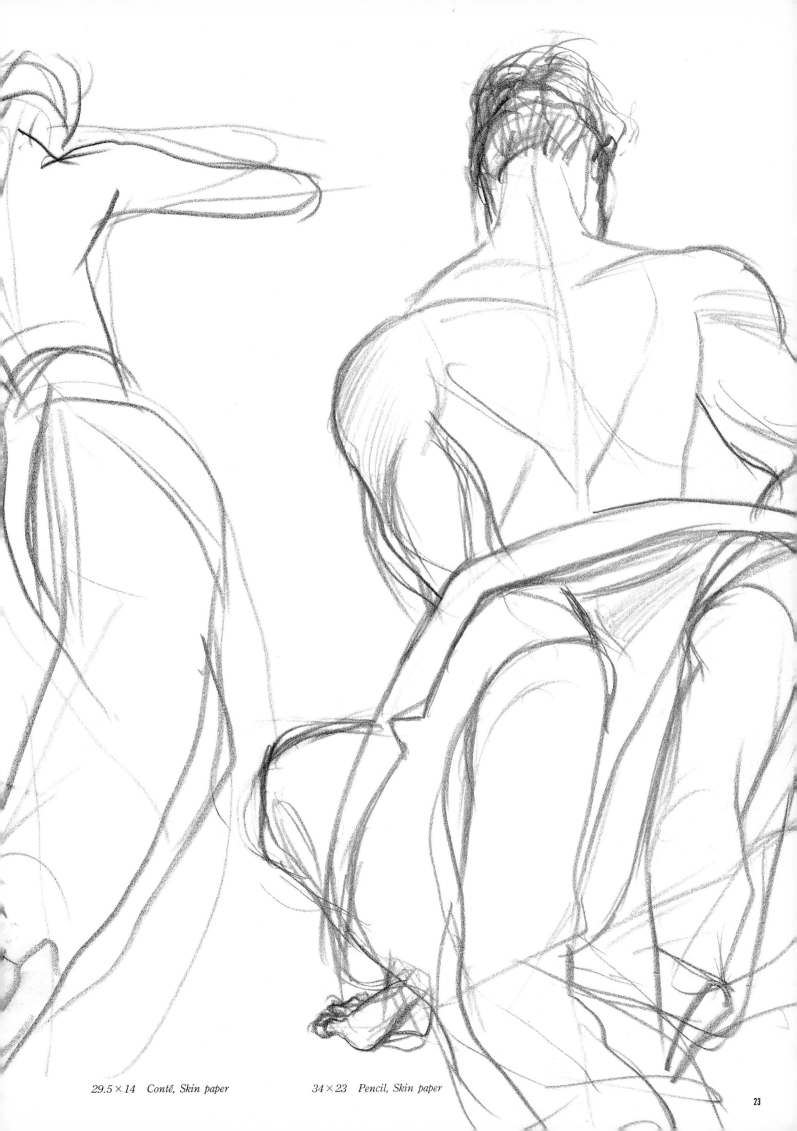

29.5×14 Conté, Skin paper 34×23 Pencil, Skin paper

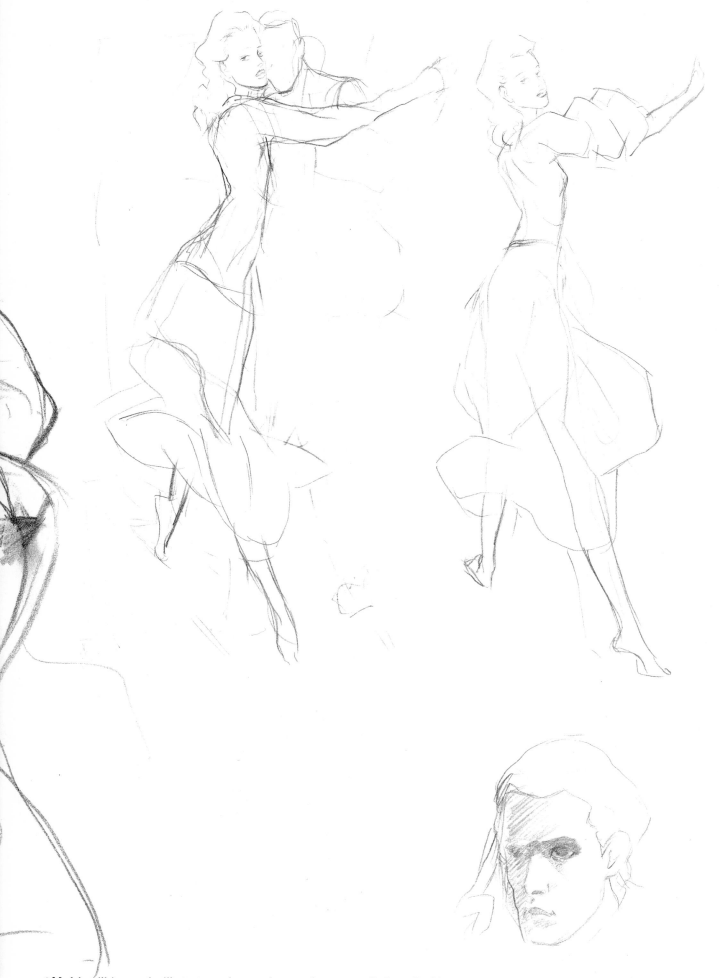

●Models will ignore the illustrator and move about as they very well please. In this sense, rely upon the most impressive pose that has been imprinted in your mind. In turn, work on your sketch as if ignoring the model, continuing to add strokes here and there to complement your main lines. ●モデ

18×17 Pencil, Skin paper

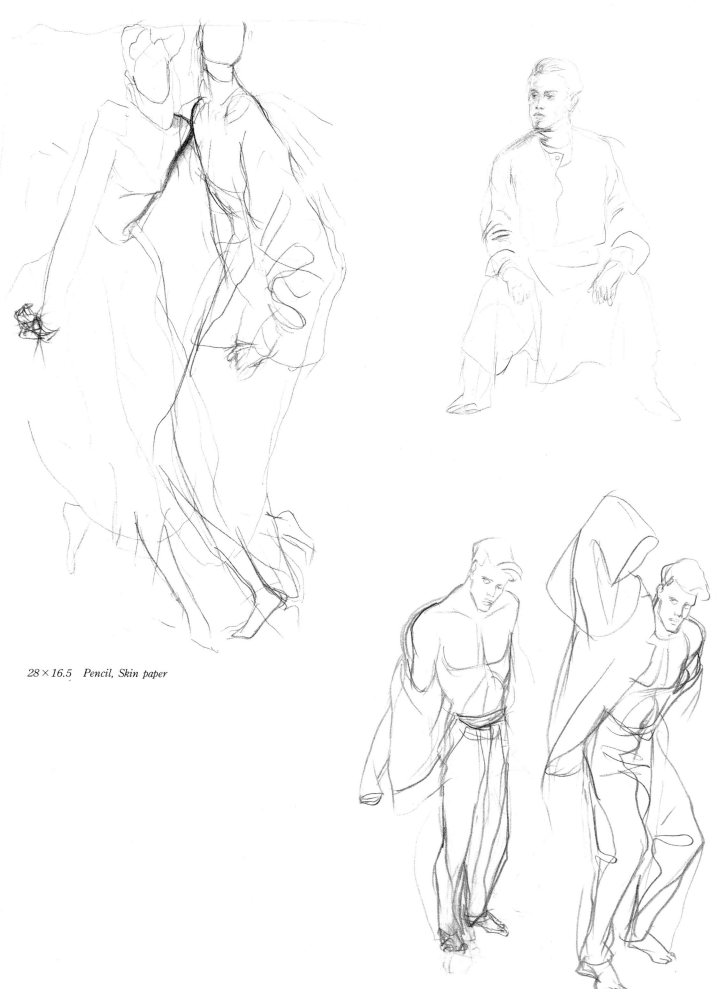

38×26 Pencil, Skin paper

28×16.5 Pencil, Skin paper

ルはこちらを無視して勝手に動く。唯一の表現の手掛りは網膜に残る残像を頼りに，今度はモデルの方を無視したふりをして観察する，そして再び描き足していく。

22.5×10 Pencil, Skin paper 27×10 Pencil, Skin paper

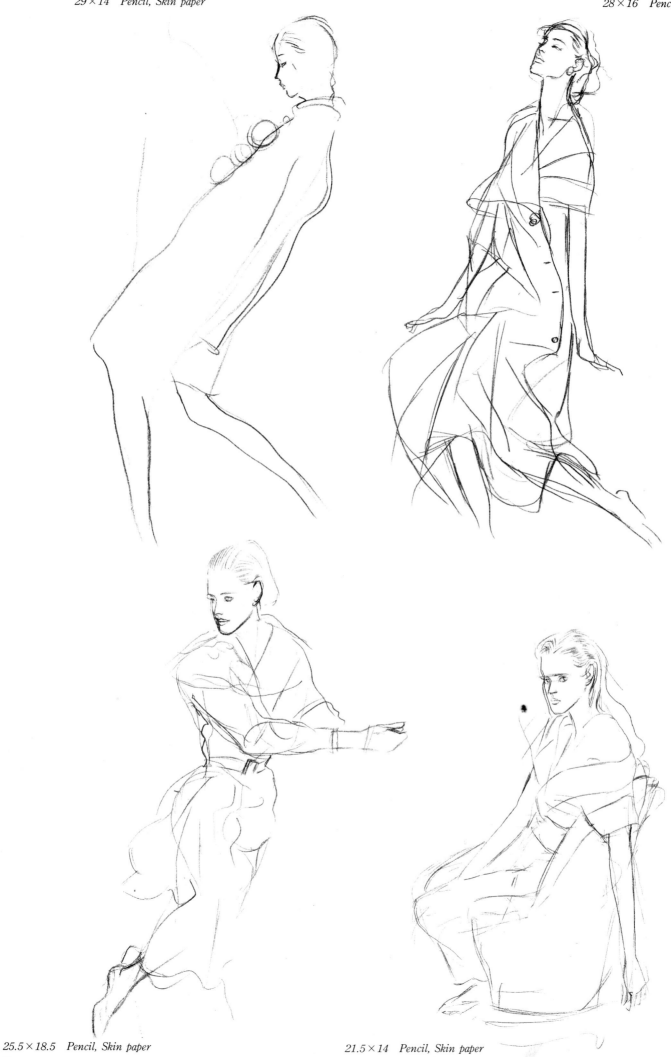

29×14 *Pencil, Skin paper*

28×16 *Pencil, Skin paper*

25.5×18.5 *Pencil, Skin paper*

21.5×14 *Pencil, Skin paper*

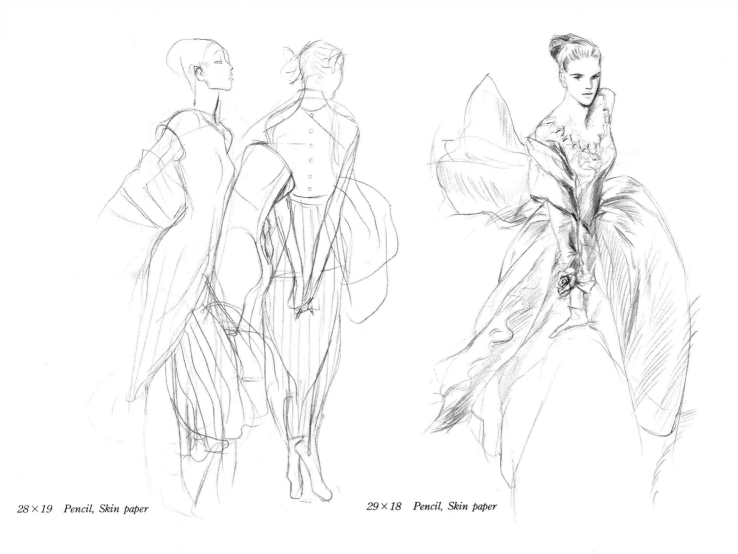

28 × 19 *Pencil, Skin paper*

29 × 18 *Pencil, Skin paper*

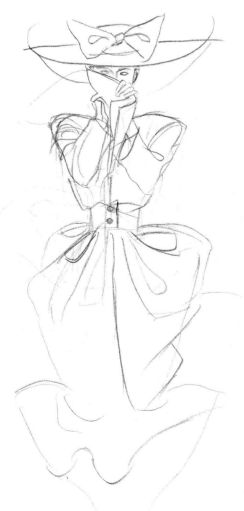

29.5 × 15.5 *Pencil, Skin paper*

30 × 13.5 *Pencil, Skin paper*

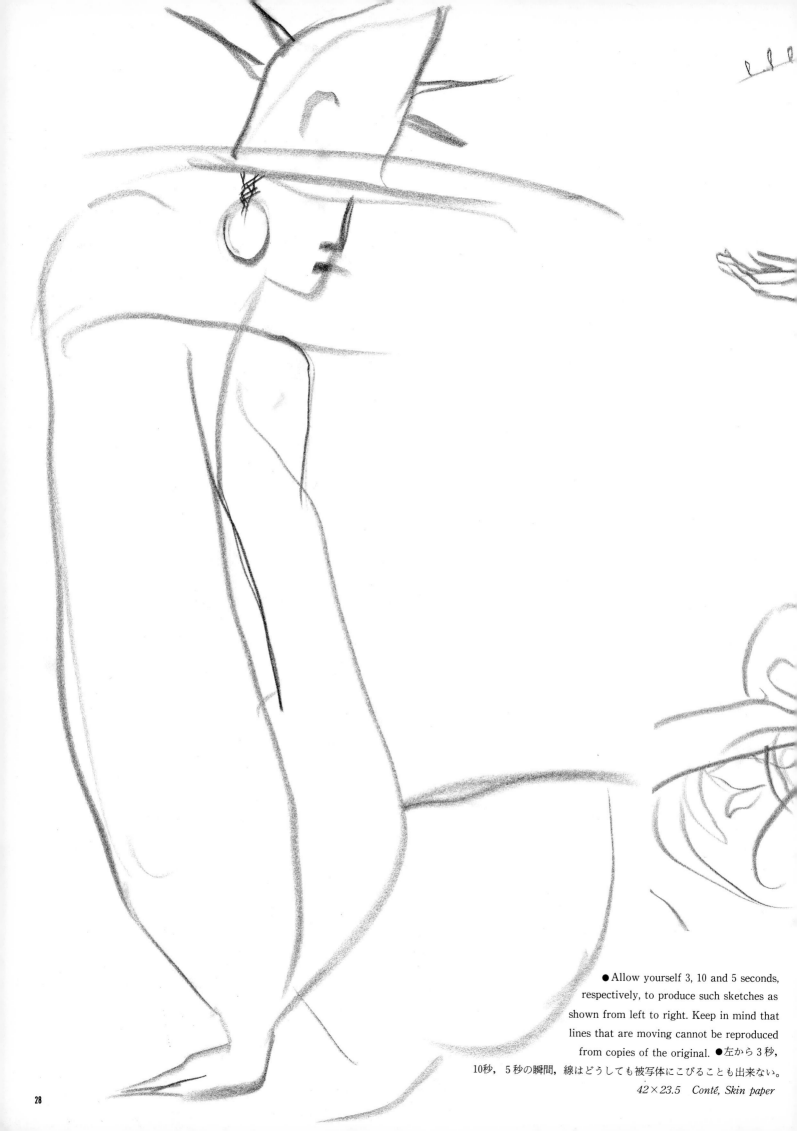

● Allow yourself 3, 10 and 5 seconds,
respectively, to produce such sketches as
shown from left to right. Keep in mind that
lines that are moving cannot be reproduced
from copies of the original. ●左から3秒，
10秒，5秒の瞬間，線はどうしても被写体にこびることも出来ない。

42×23.5 Conté, Skin paper

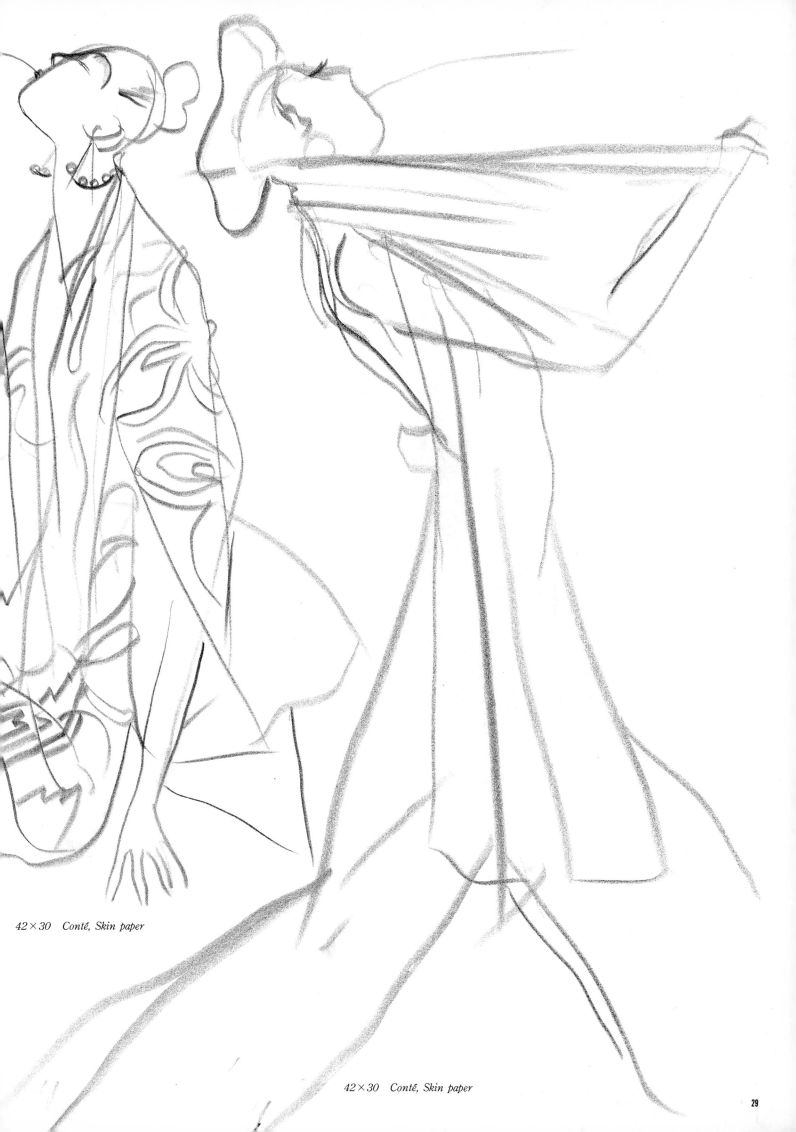

42×30 Conté, Skin paper

42×30 Conté, Skin paper

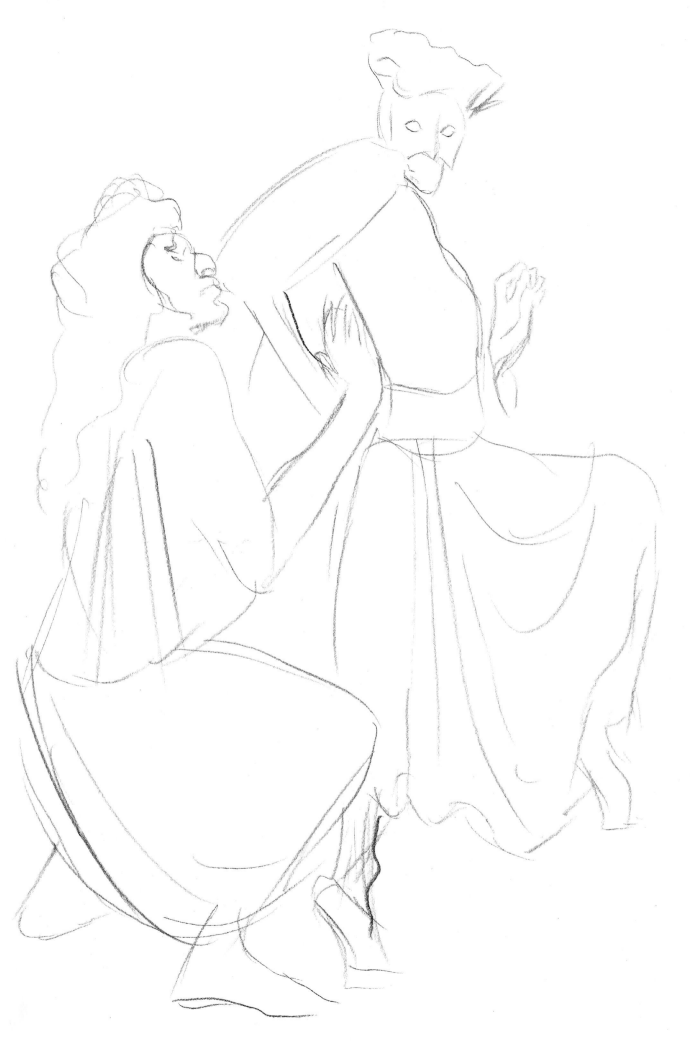

28.5×20 Pencil, Skin paper

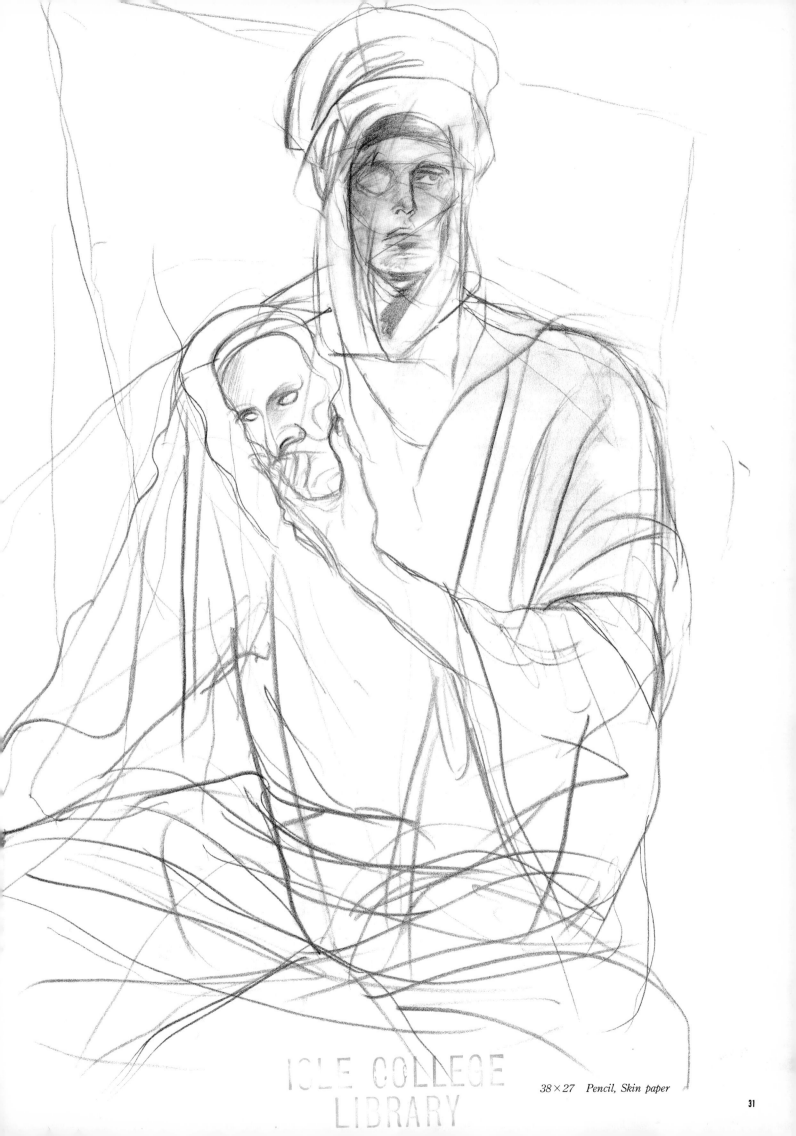

38 × 27 *Pencil, Skin paper*

39.5 × 27 Pencil, Skin paper

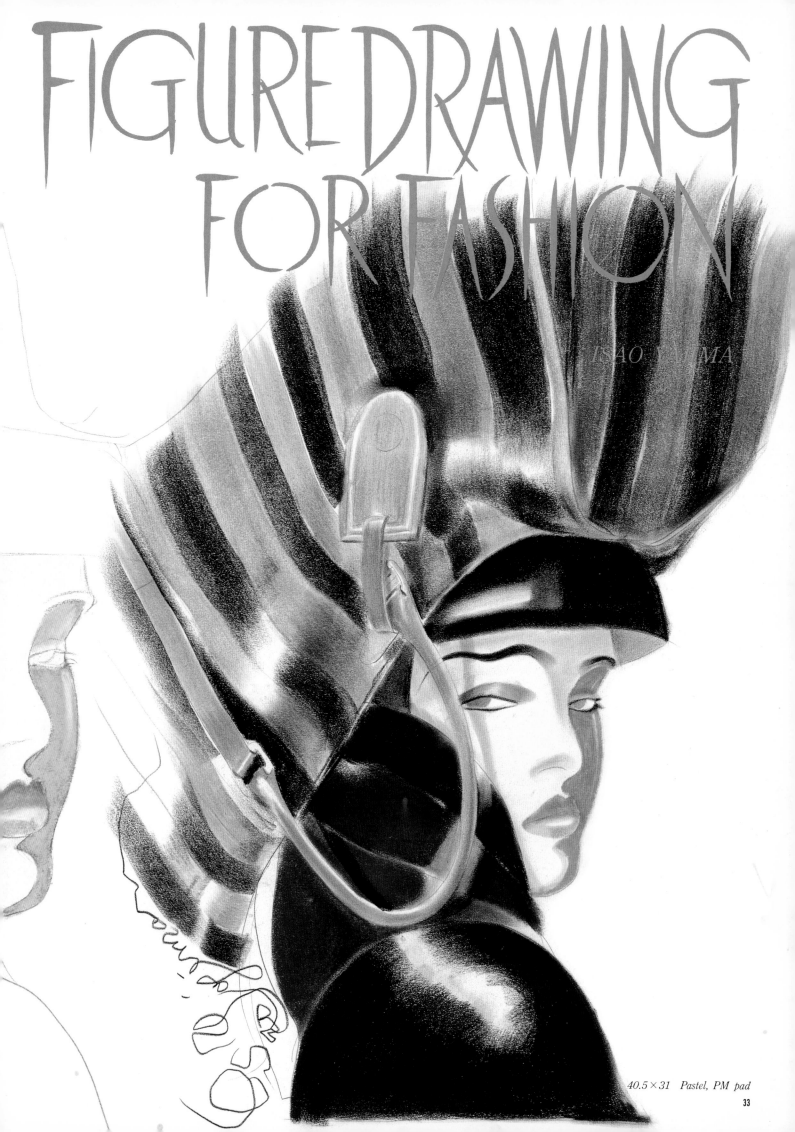

FIGURE DRAWING FOR FASHION

ISAO YAJIMA

40.5×31 Pastel, PM pad

●The rough sketch on the left-hand page depicts the model just as she has finished inhaling. On the other hand, the basic sketch supplemented with colors on the right shows that she has just completed the act of exhaling. ●左のページの素描は息を吸ったところ，右の着彩は息をはいたところ。

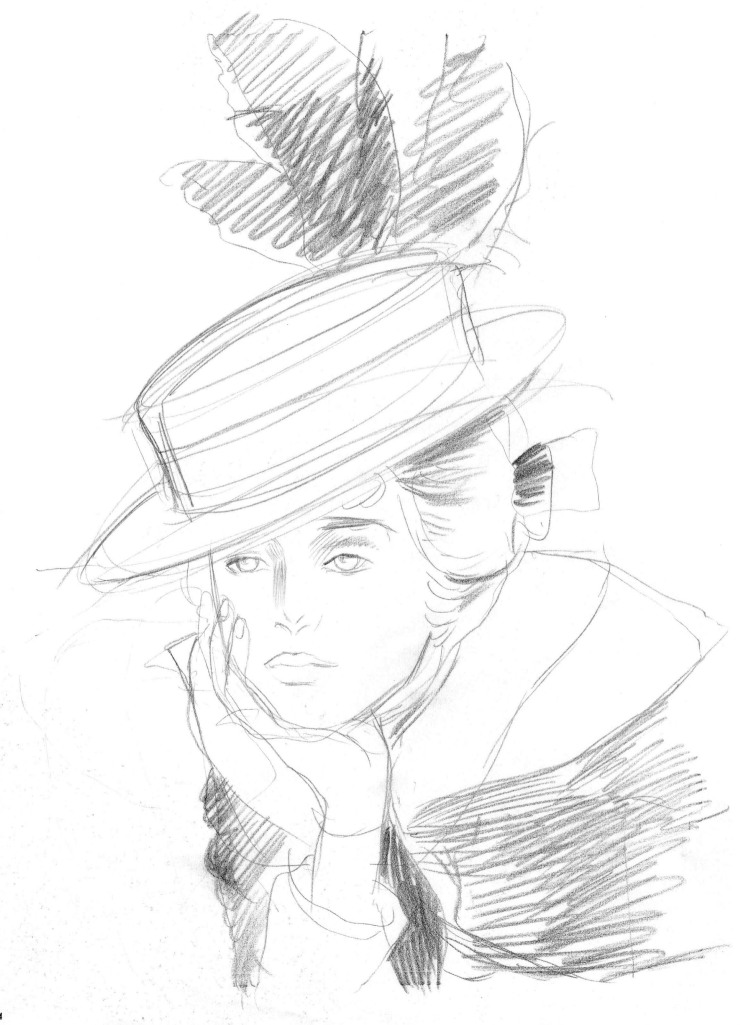

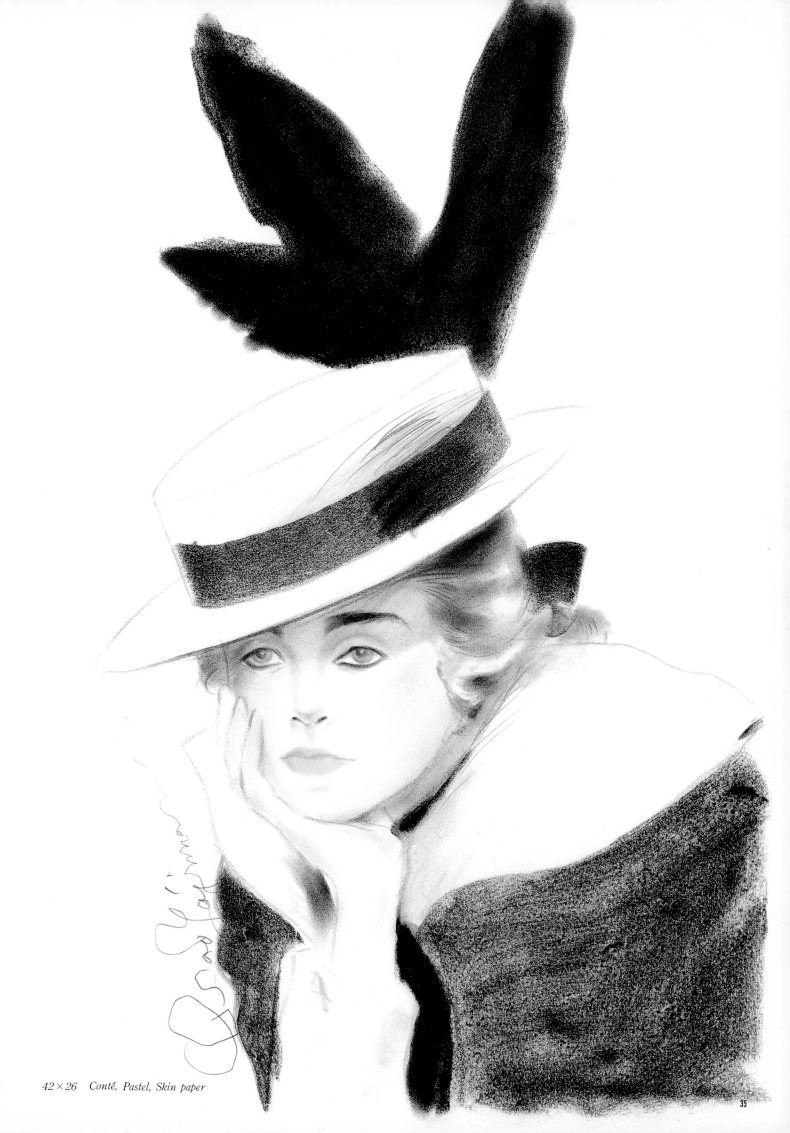

42×26 Conté, Pastel, Skin paper

35

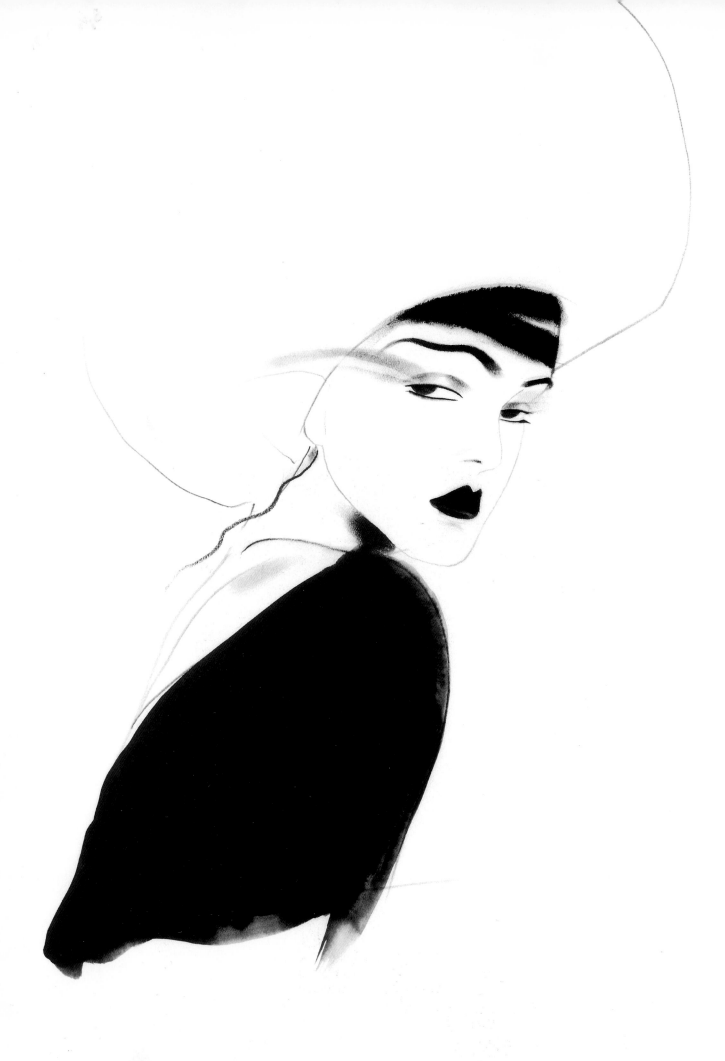

55 × 38 *Conté, Fabriano paper*

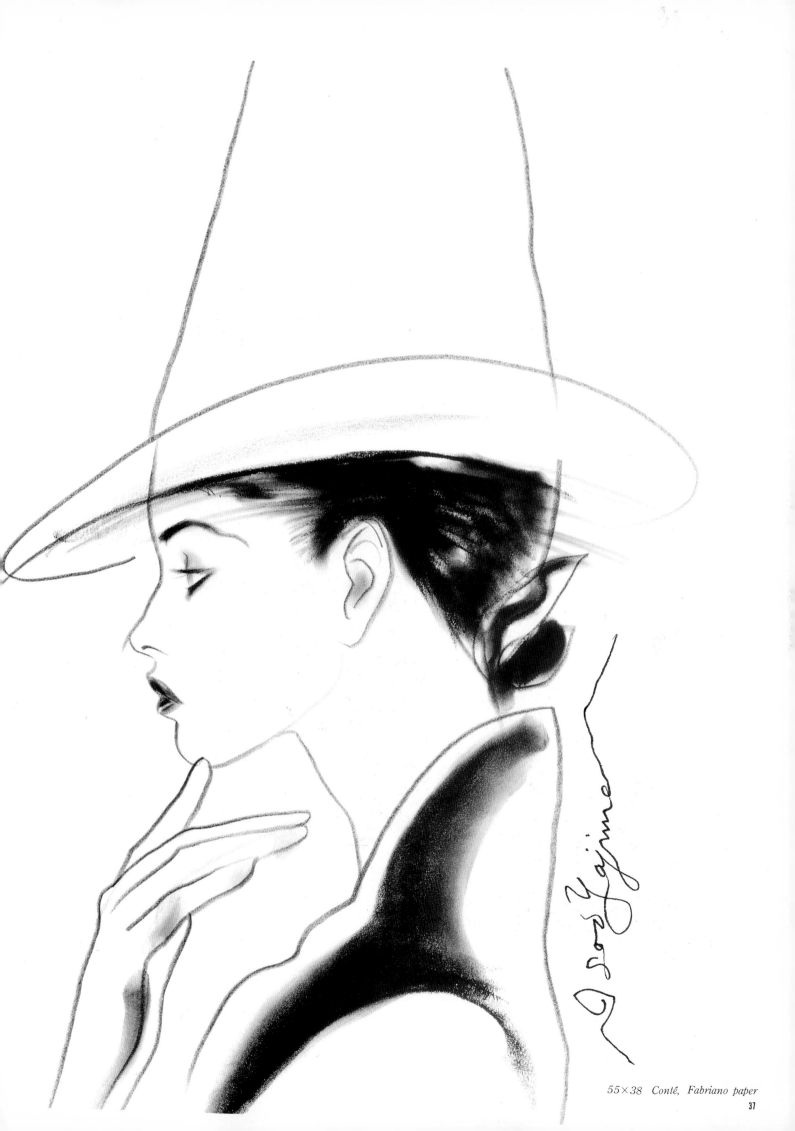

55×38 Conté, Fabriano paper

37

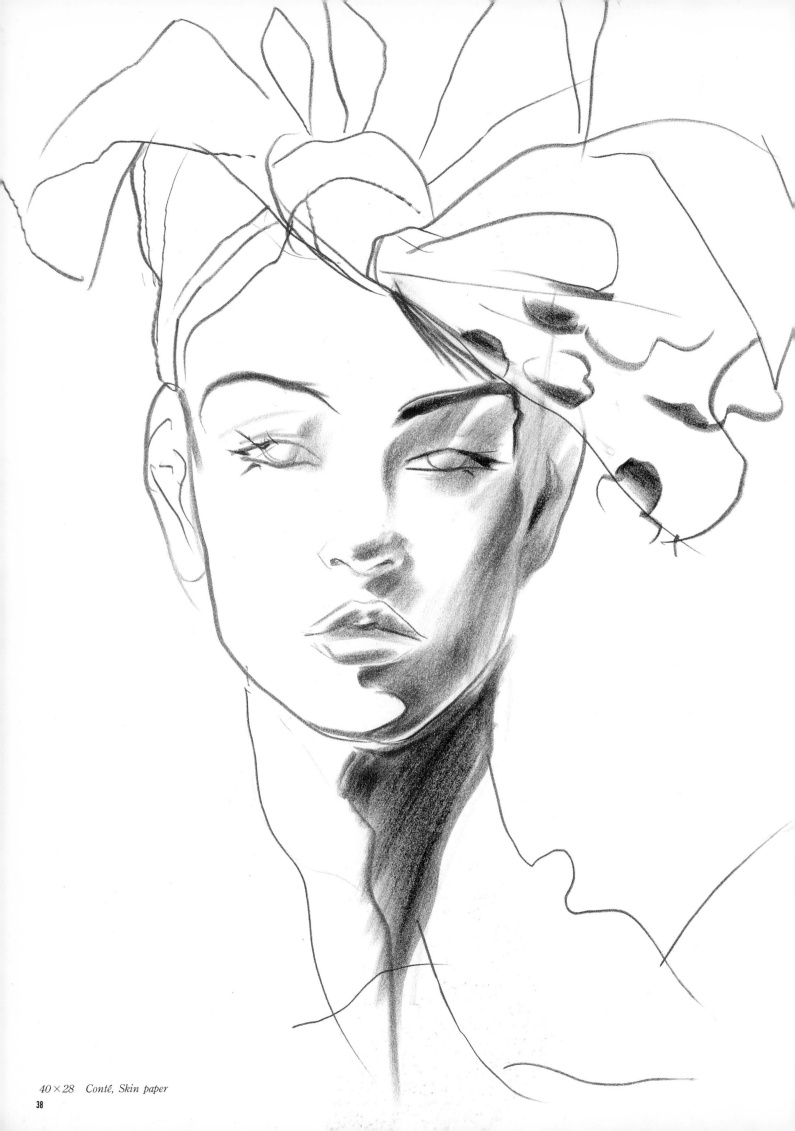

40 × 28 Conté, Skin paper

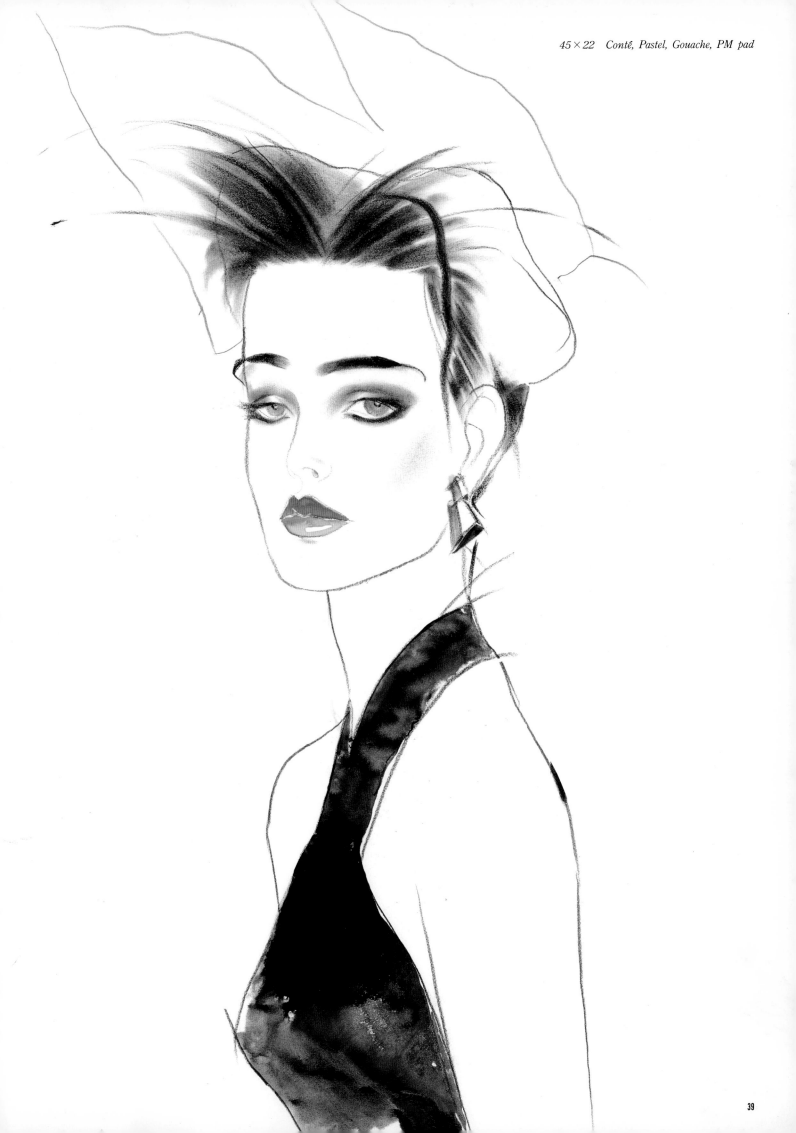

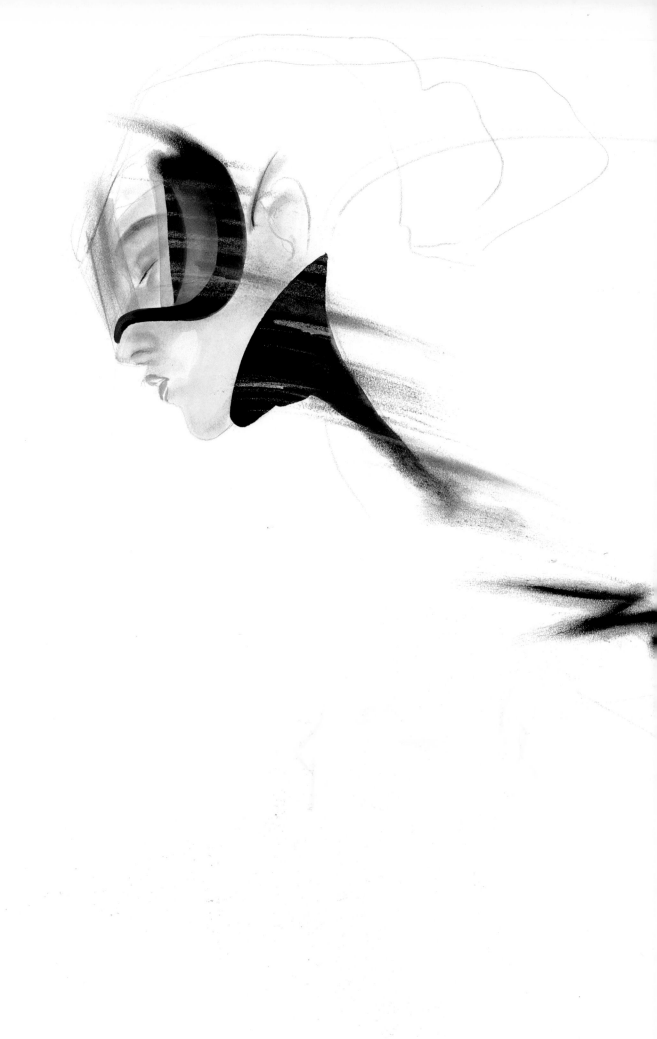

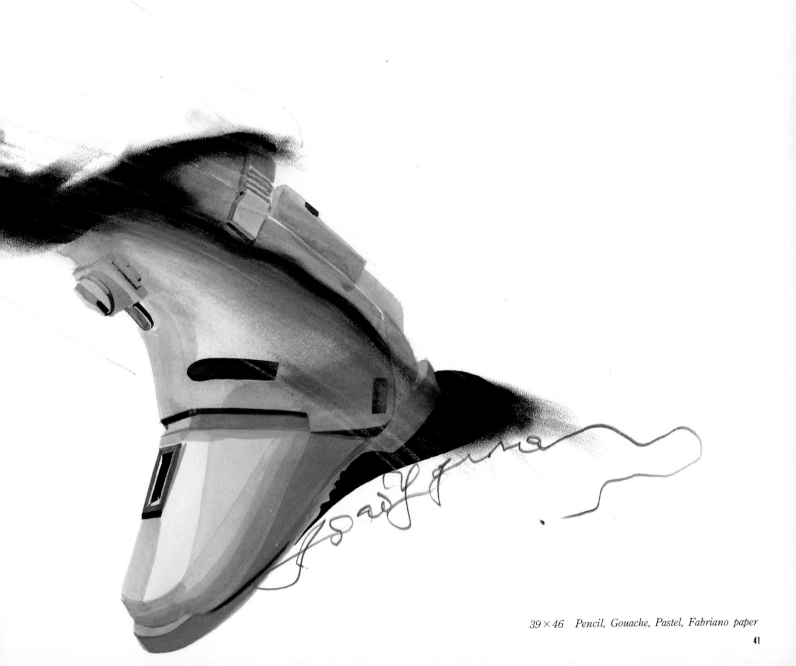

39×46 Pencil, Gouache, Pastel, Fabriano paper

41

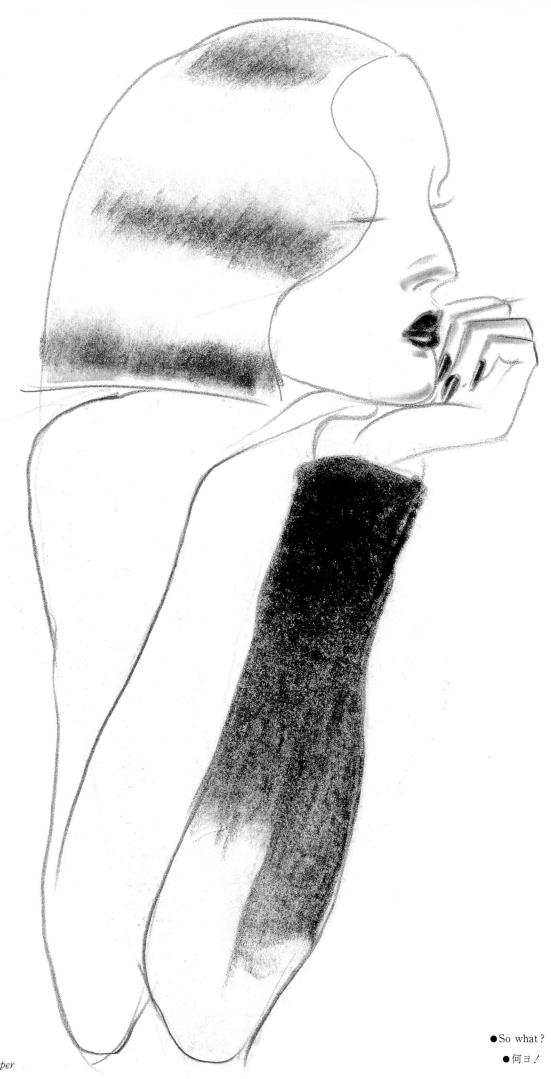

44×17.5 *Pencil, Conte, Skin paper*

● So what?

● 何ヨ！

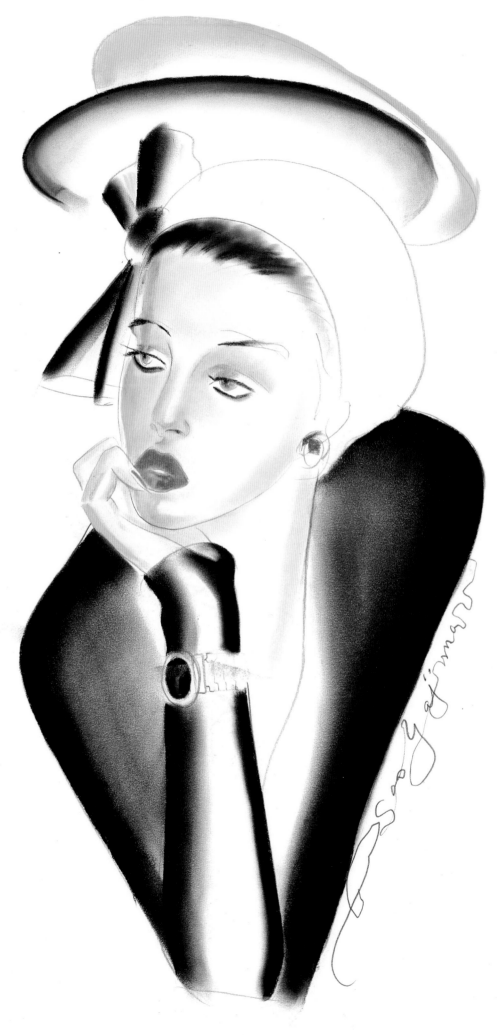

So pfutt !

何サ………。

41.5×23.5 Pencil, Pastel, PM pad

●鏡に向っていろいろな顔の表情をつくって見てみる。例えば目は笑って口元は憤る。またその反対。左側は憤った顔，眉をつり上げ右側を笑った顔にする。笑い憤り，泣き憤り，泣き笑い，かなしいけど楽しい顔，口だけ笑って他の部分は無表情，いや実に難しい。ダ＝ビンチの描いたモナリザの顔は，一種のそういう顔だと思う，何とも捉え難い顔だけに美人なのか不美人なのかわけわからない。

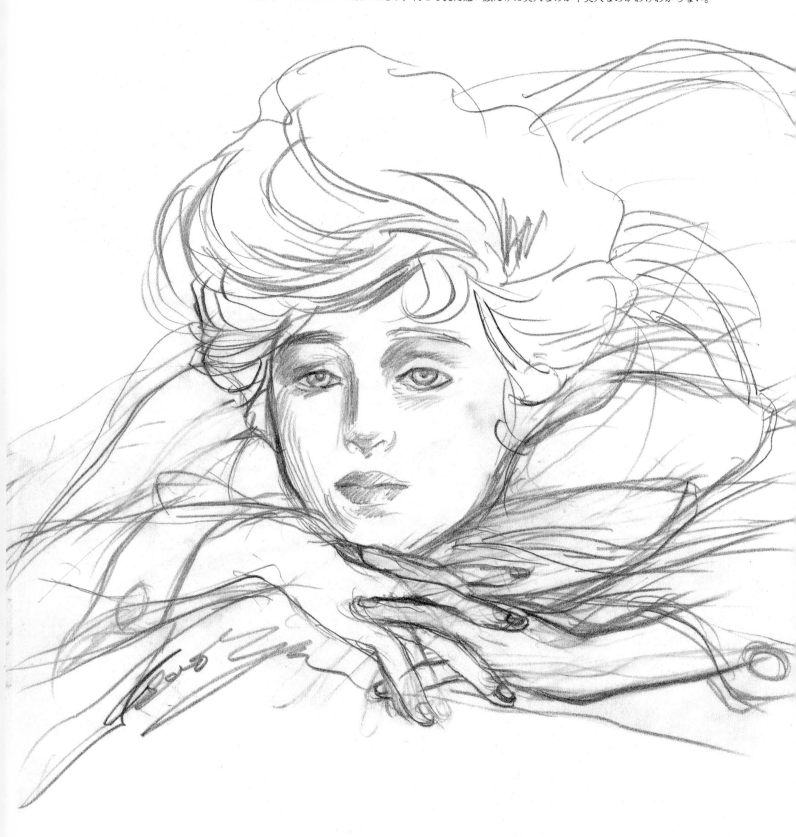

●Try making different facial expressions in front of a mirror. For example, show smiling eyes and an angry mouth simultaneously. Then invert the expressions. Express anger on the left side of your face. Raise your shoulders and convert the anger to happiness. Smile then show anger; cry, become angry; cry and then laugh. Express hints of sadness even with a smiling face. Add a smiling mouth to an expressionless face. You'll find that it is not too easy to create an expressionless face. Da Vinci's Mona Lisa has such a face. Not only are we not quite sure what her face expresses——we are even uncertain if she is really beautiful or not!

27×30 Pencil, Skin paper

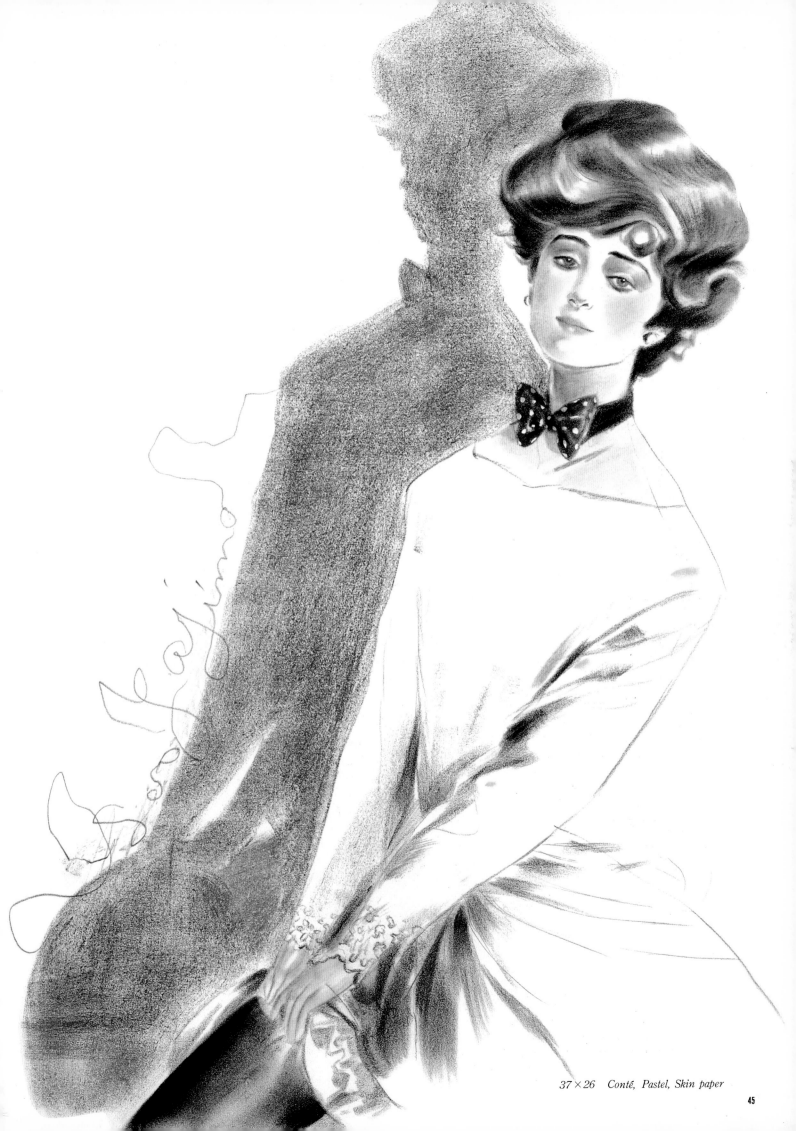

37 × 26 Conté, Pastel, Skin paper

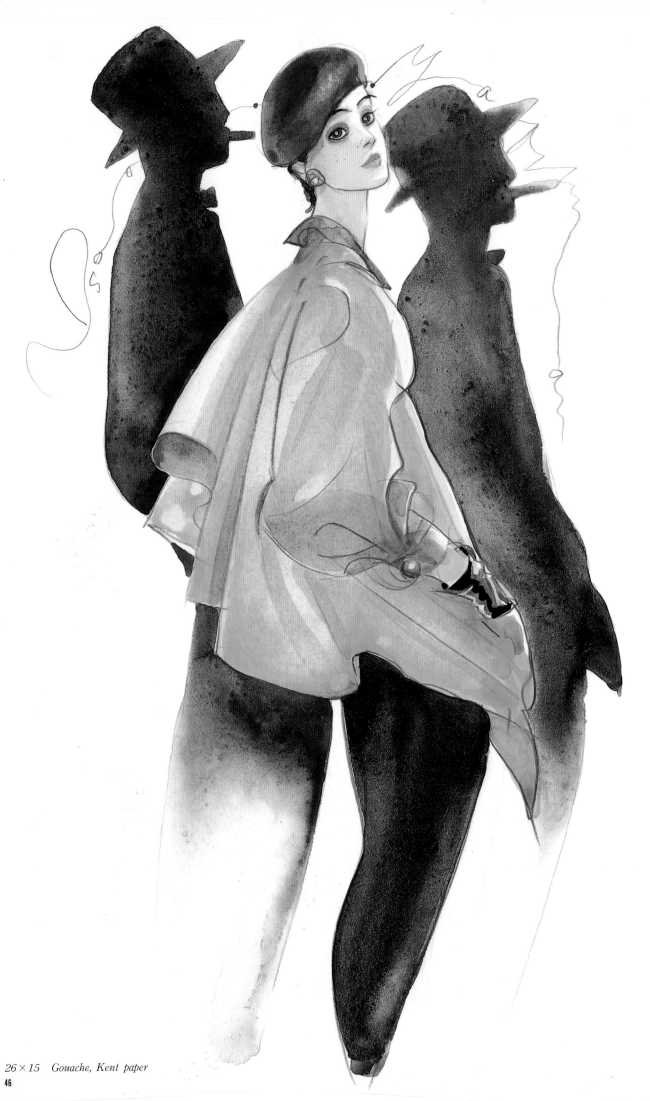

26×15 Gouache, Kent paper

46

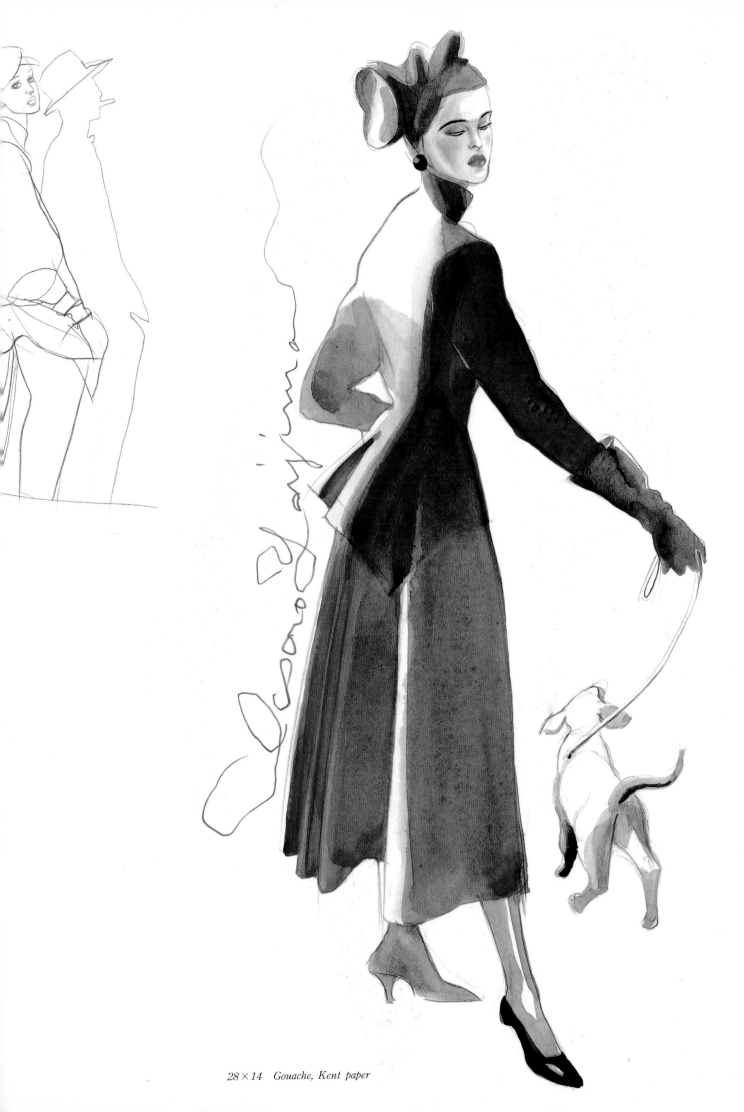

28 × 14 *Gouache, Kent paper*

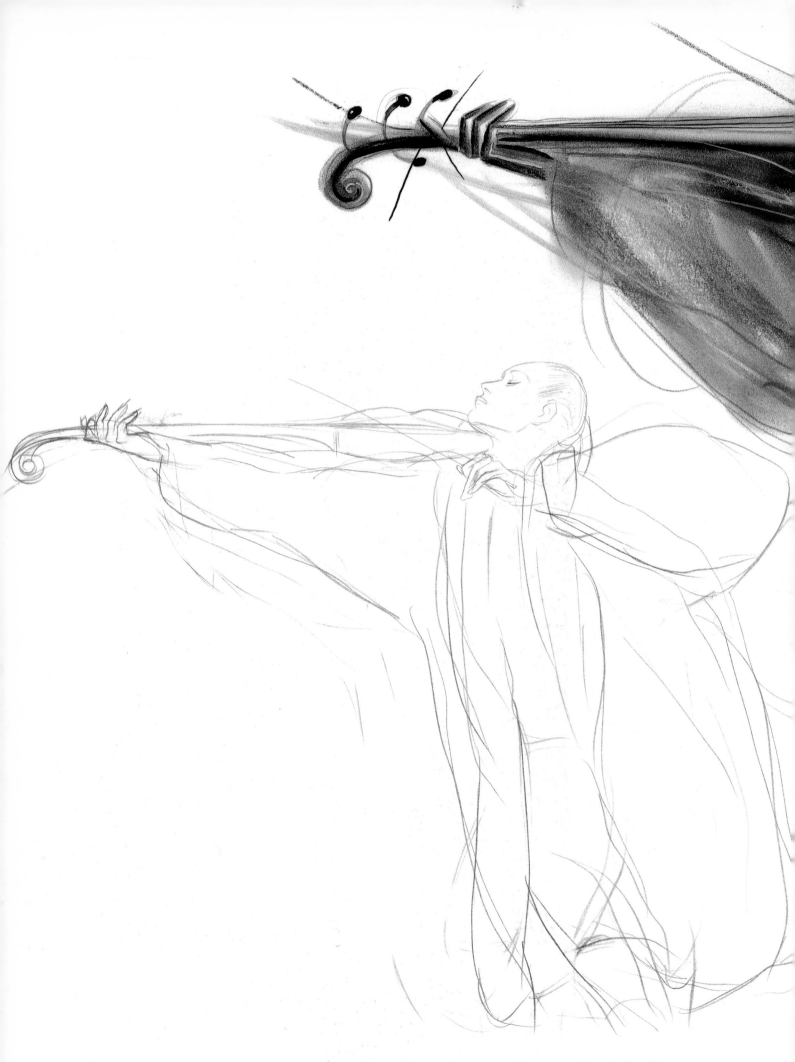

● I watched and listened to a violinist perform. The sounds she created, however, made me feel as if the violin was stretching out and shrinking to produce those sounds.　●バイオリニストの演奏を聴く，いや観ていたら音によってバイオリンが伸びたり縮んだりしているように見えた。

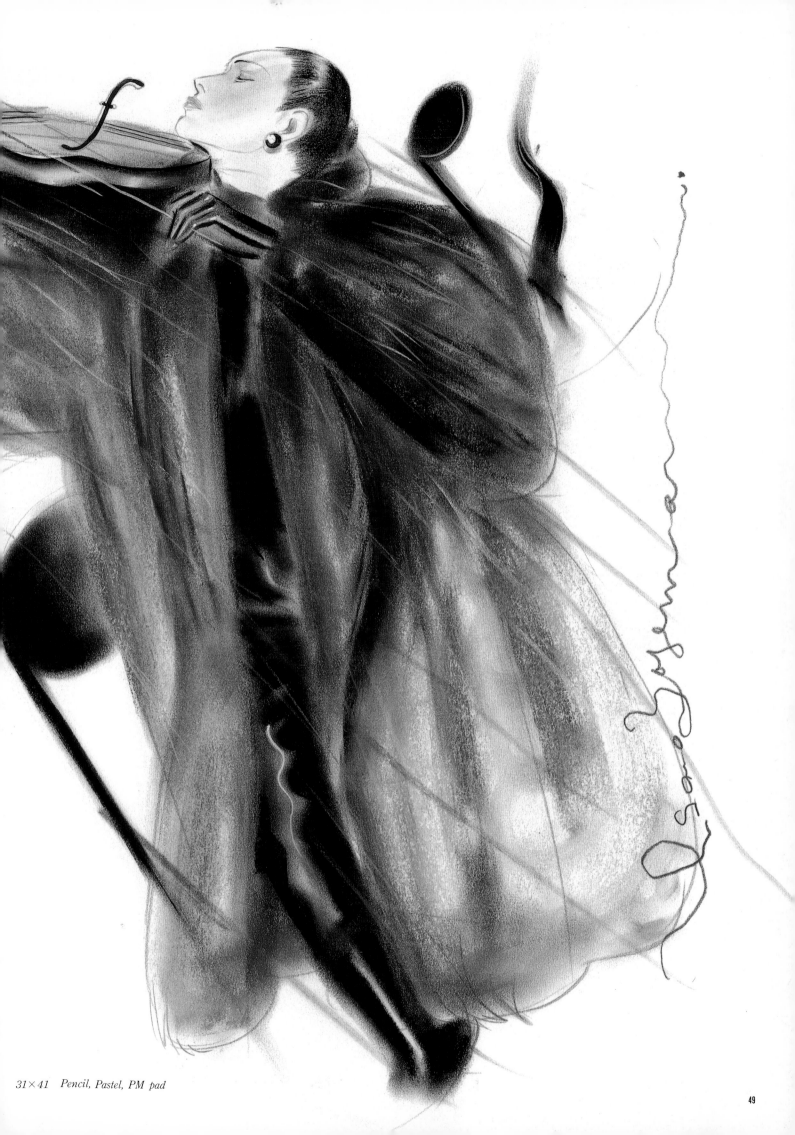

31×41 *Pencil, Pastel, PM pad*

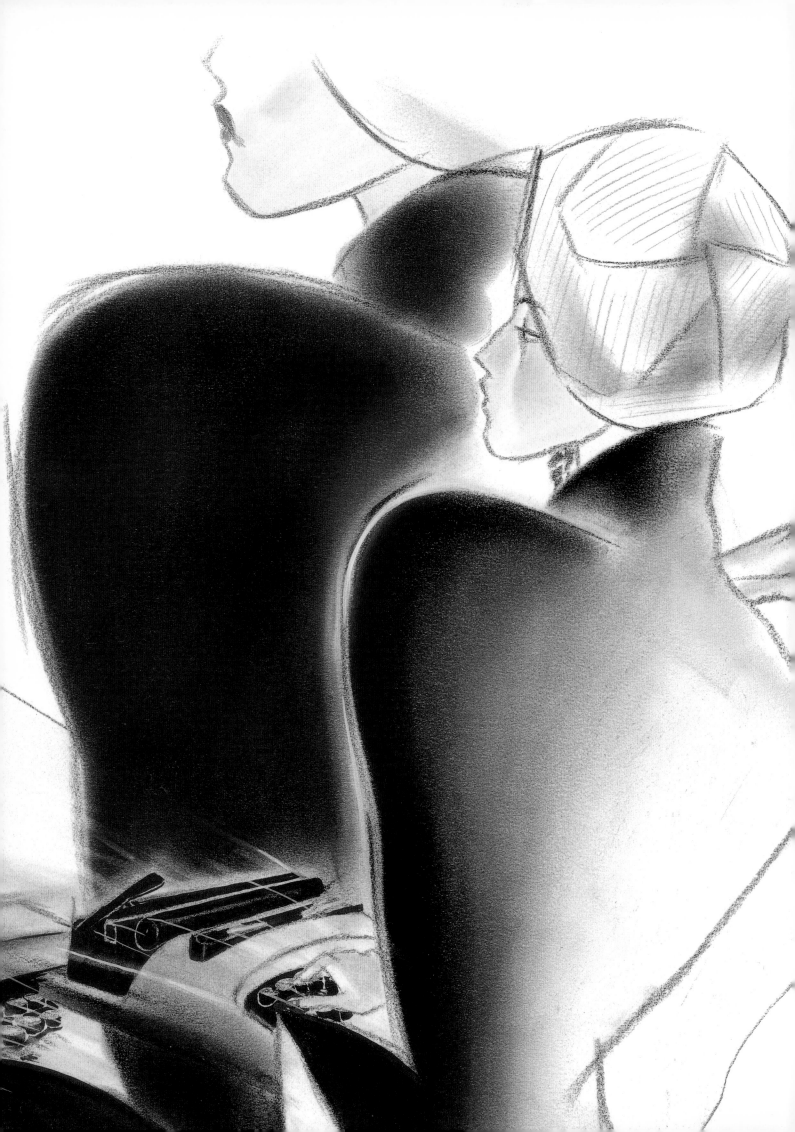

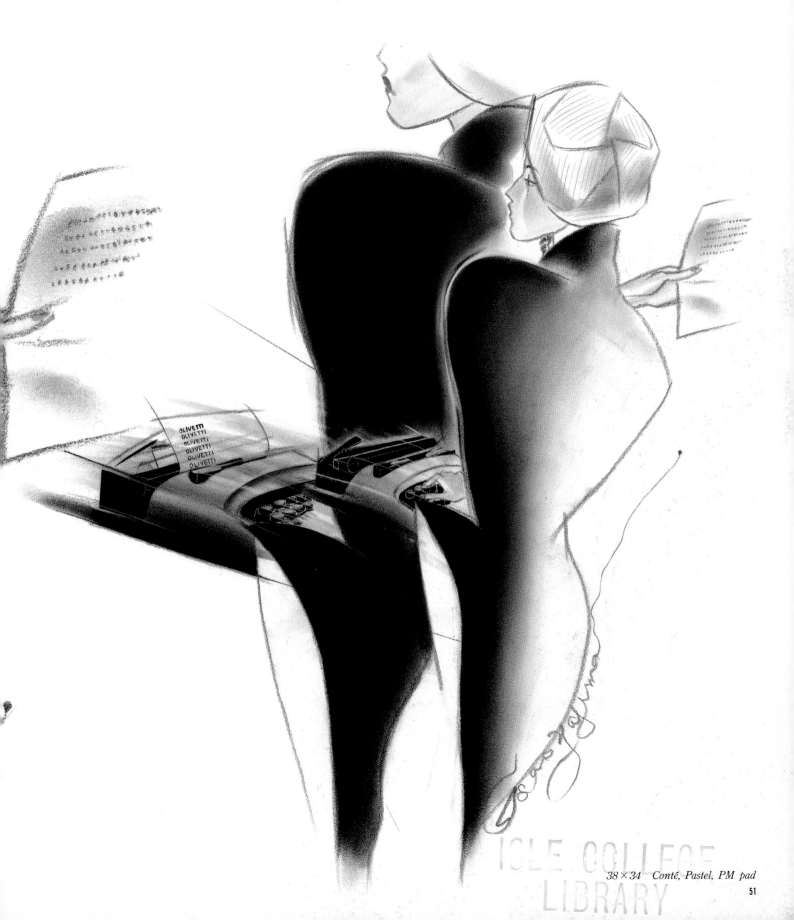

38×34 Conté, Pastel, PM pad

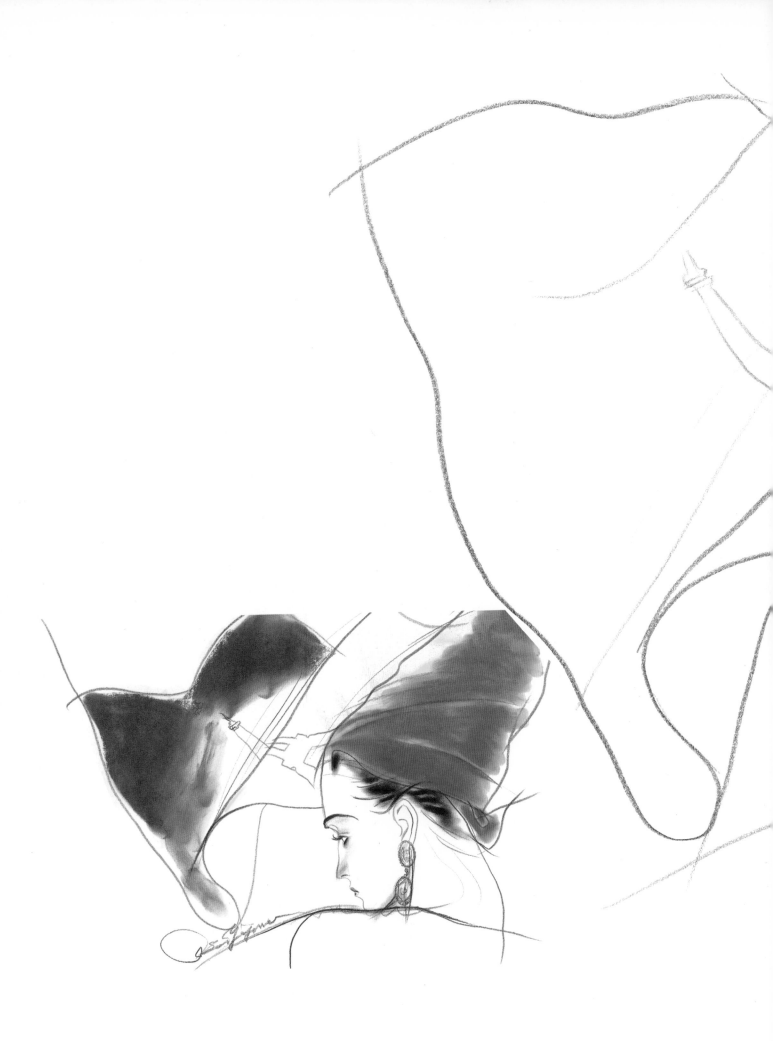

30×41.5 Conté, Fabriano paper

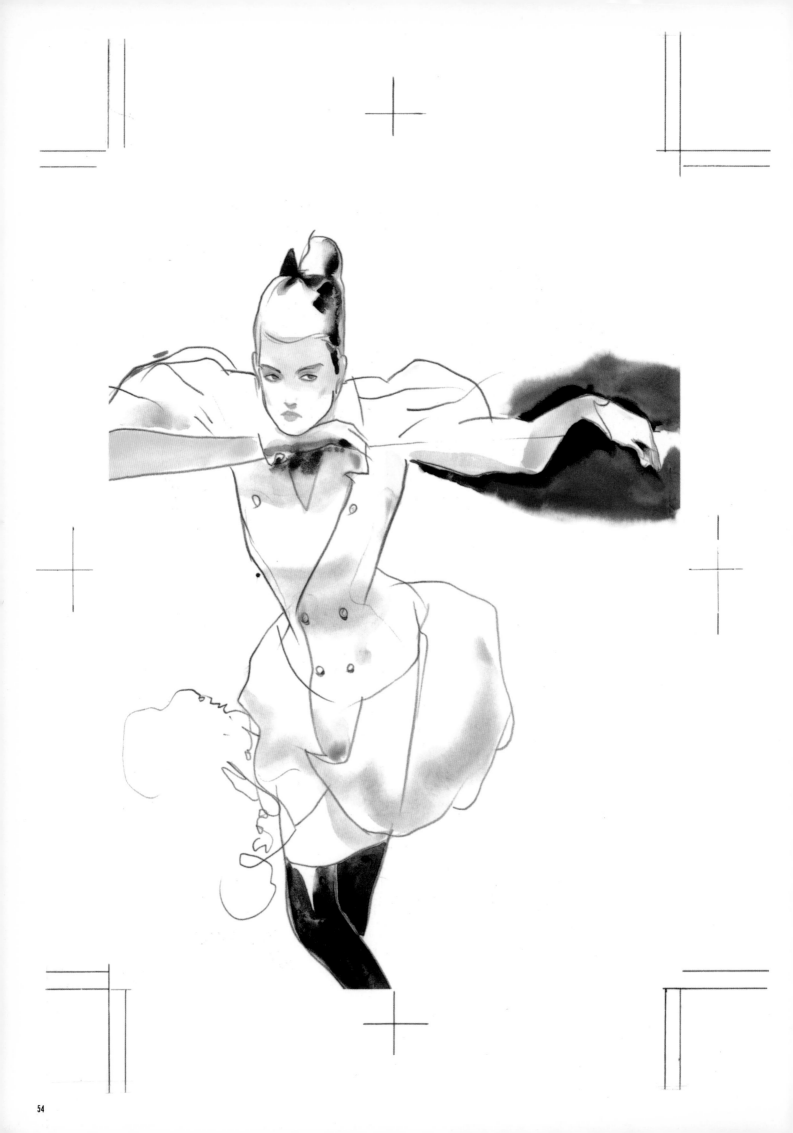

54

THE NEW YORK PRET
New York

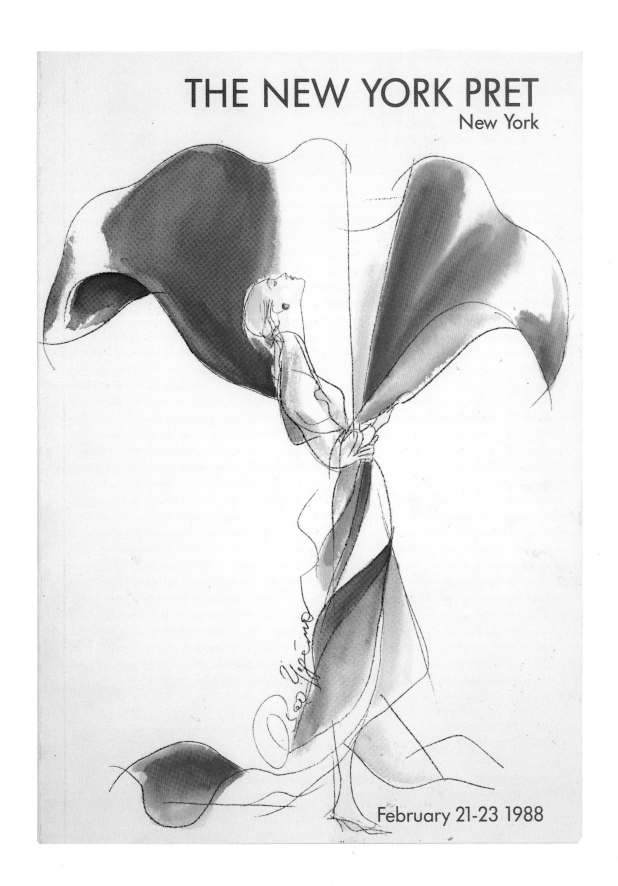

February 21-23 1988

●Somewhere deep within a motif that is used repeatedly is a woman's face that is barely noticeable.　She is there.　She's the person that I've been

40×25　Conté, Kent paper

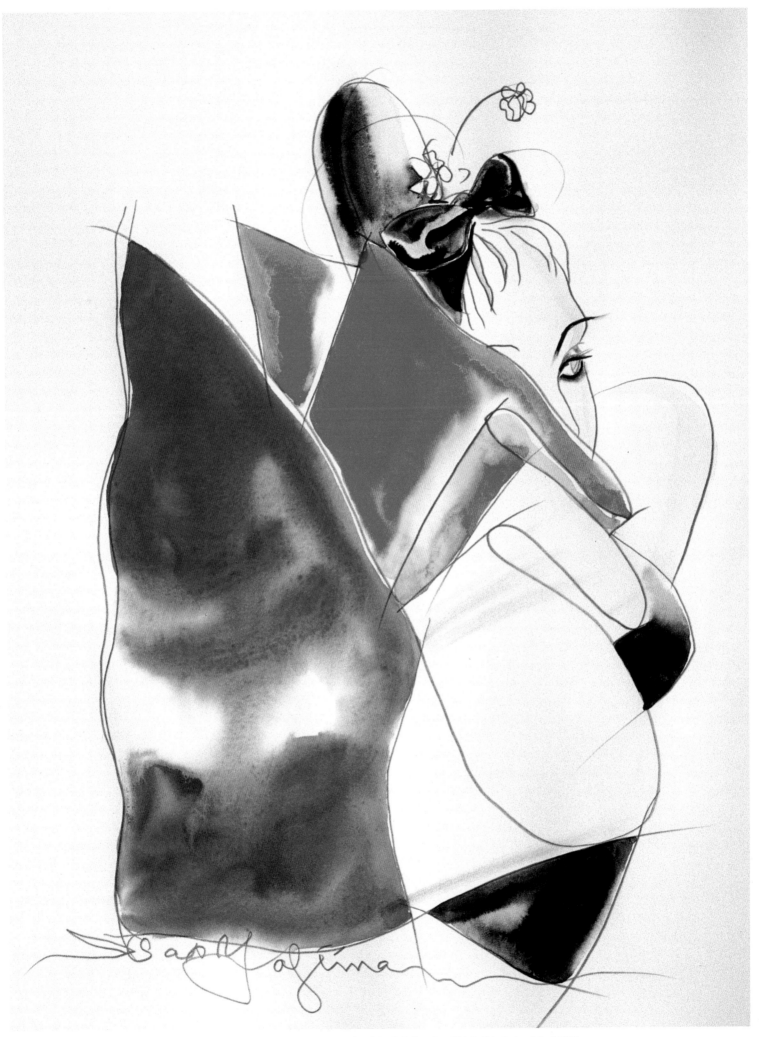

looking for.　●繰り返し重なり合うモチーフ一つの奥に，ちらりと見える女の顔。ああ向こうに居るんだなあ！　という表現。

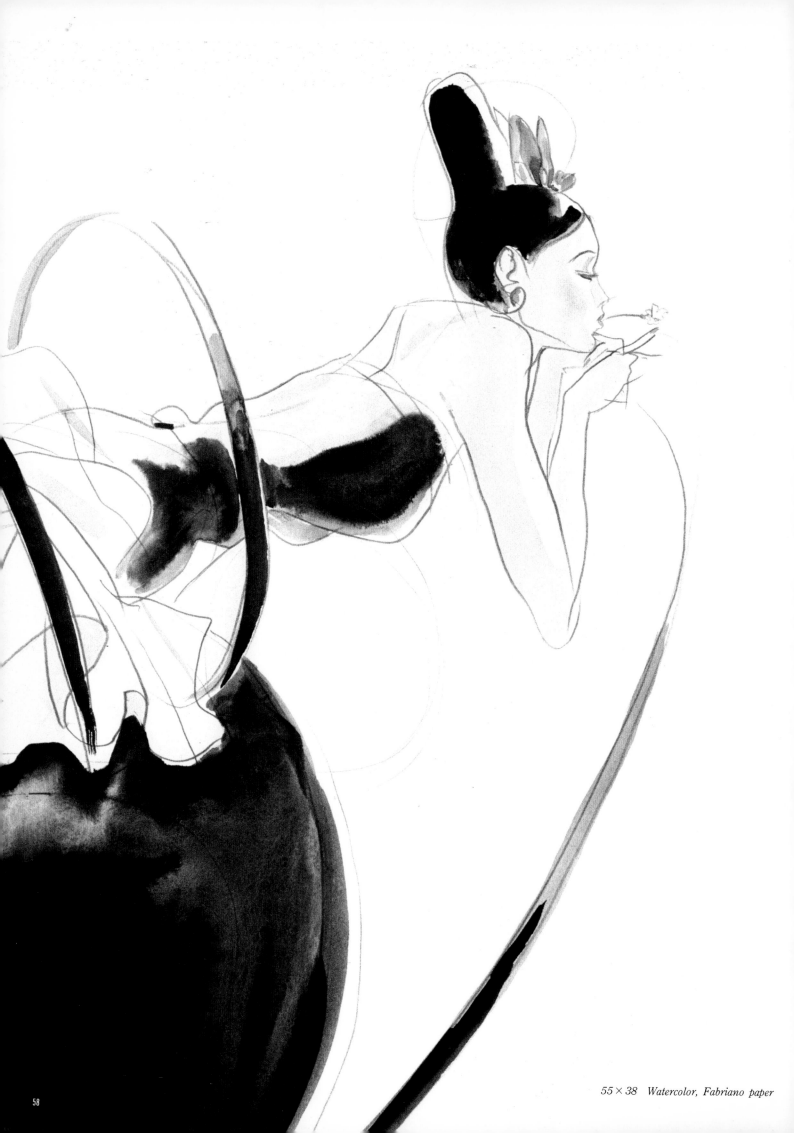

55 × 38 Watercolor, Fabriano paper

LES HALLES

**Une création jeune et forte,
la mode tendance et l'avant garde.**

PRET A PORTER

ABAYA
ANVERS
ARNAUD ET
 THIERRY GILLIER
BOA
CAPUCINE PUERARI

CHEVIGNON / IMPECA
CHUNGYU (ICC)
CLAUDIE PIERLOT
DOMINIQUE TORRIDE
ETIENNE BRUNEL
FRANCIS MORENO
FRANCK JOSEPH BASTILLE

HUNZA
LOLITA LEMPICKA
MARITHE ET FRANÇOIS
GIRBAUD
NULLE PART AILLEURS
OBLIQUE
PEPPERMINT
PERSONA GRATA
PETRA BRONS
PLASSIER STEPHANE
PLEINE LUNE
PLEIN SUD
PLUCK
POLES
SOPHIE SITBON
SUZIKLO
THE PEOPLE OF THE
 LABYRINTHS
TOUS LES CALEÇONS

CHARLES CHEVIGNON
CHIPIE / SIGNOLES
JET SET
LILY FAROUCHE
NOEMIE AZOULAY
SPECTOR'S
TAVERNITI JIMMY
UN APRES-MIDI DE CHIEN

ACCESSOIRES

ACTUEL
ALEXIS LAHELLEC
BAILLY BAZIN
BLUMBERG
BONAZZI
CLAIRE DEVE
COMPAGNIE DES COMP-
 TOIRS DE LA BANQUISE
DEGAY DELPEUCH
DOMINIQUE DENAIVE
EDOUARD RAMBAUD
GILLES HERVE
GREENWICH
GROOM
I.D.C. LUNETTES
IL BISONTE
JEAN MICHEL HALBIN
MARIA PIA
MARIA CALDERARA /
 RUSH
MARIE RANCILLAC
MOON STREET
PHILIPPE MODEL
P.M. 385 PATRICK MEYER
PRODUCTION ORIGINALE
SAC ET SAC
SACHA ACCESSOIRES
 (BLUMBERG)
SCOOTER /
 MADEMOISELLE ZAZA

LE NOUVEAU JEAN

BENSIMON POUR
 CAMOUFLAGE
CENTRAL PARK

STYLE FASHION
 PAR OLIVIER CHANAN
UPLA DIFFUSION

CHAUSSURES

ACCESSOIRE DIFFUSION
CHARLES KAMMER
COLORS
EDER
EL VAQUERO
ESPACE
ETNICS
FREE LANCE
PUCCI VERDI
ROBERT CLERGERIE
SACHA
SARTORE
SEDUCTA
STEPHANE KELIAN
ZAI BATSU

LES JEUNES TALENTS

ANNA CHOÏ
CARBUR CREATIONS
CAROLINE DANTHENY
CHRISTIAN MIGEON
CHROME COBALT
CYCLOPO LOCO
FLORENCE DEBEY
JACK GOMME
L'IMAGE DU BLEU
LOULOU D'EON
MARIE LORETTE
MIKO SUM MAN SING
MOTTA
OÙ EST LE RESPONSABLE
TRIPTYQUE / DIDIER
LEGRAND
UPPERCUT

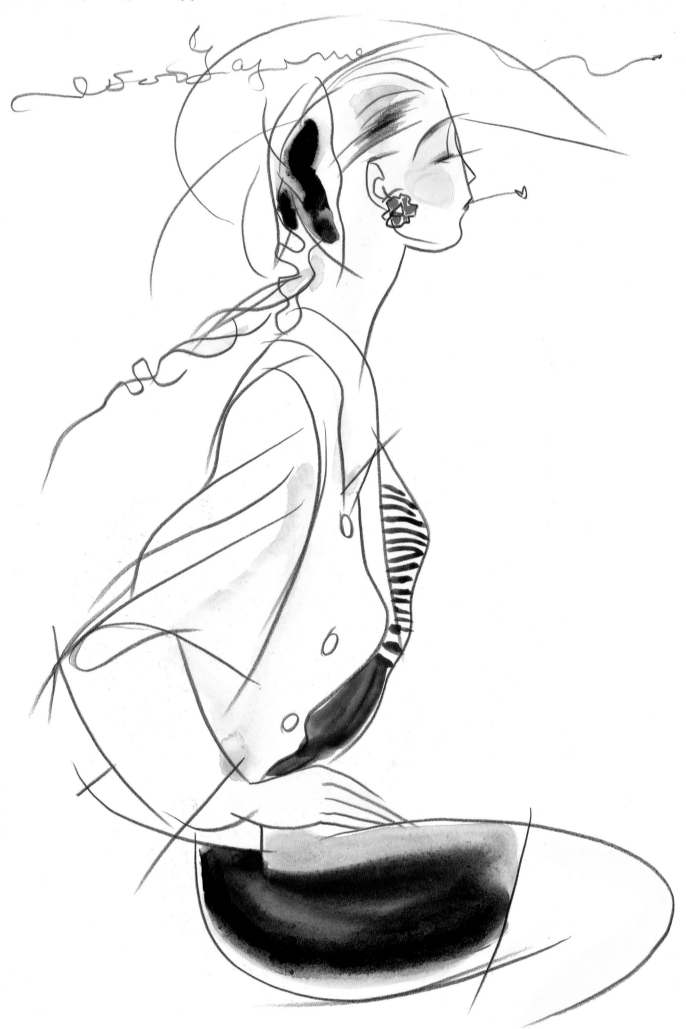

● I drew each sketch in 15 seconds. Since the coloring materials were set up beforehand, it took about a minute to complete each illustration. Believe me,

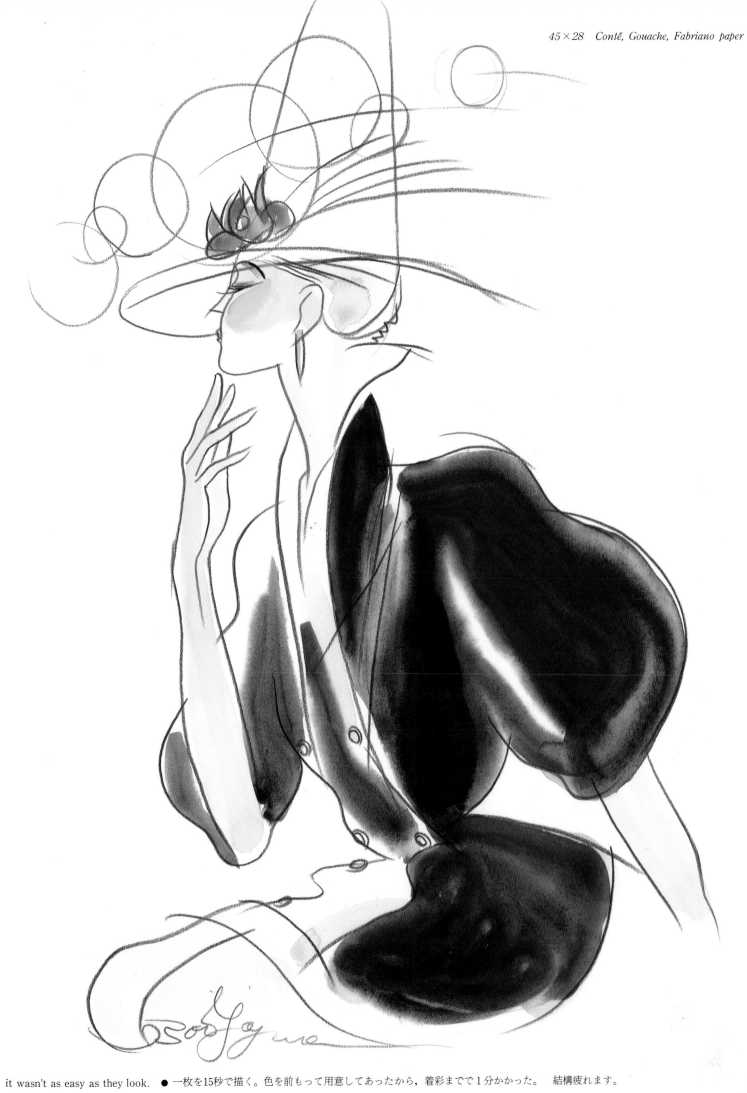

it wasn't as easy as they look. ● 一枚を15秒で描く。色を前もって用意してあったから，着彩までで1分かかった。 結構疲れます。

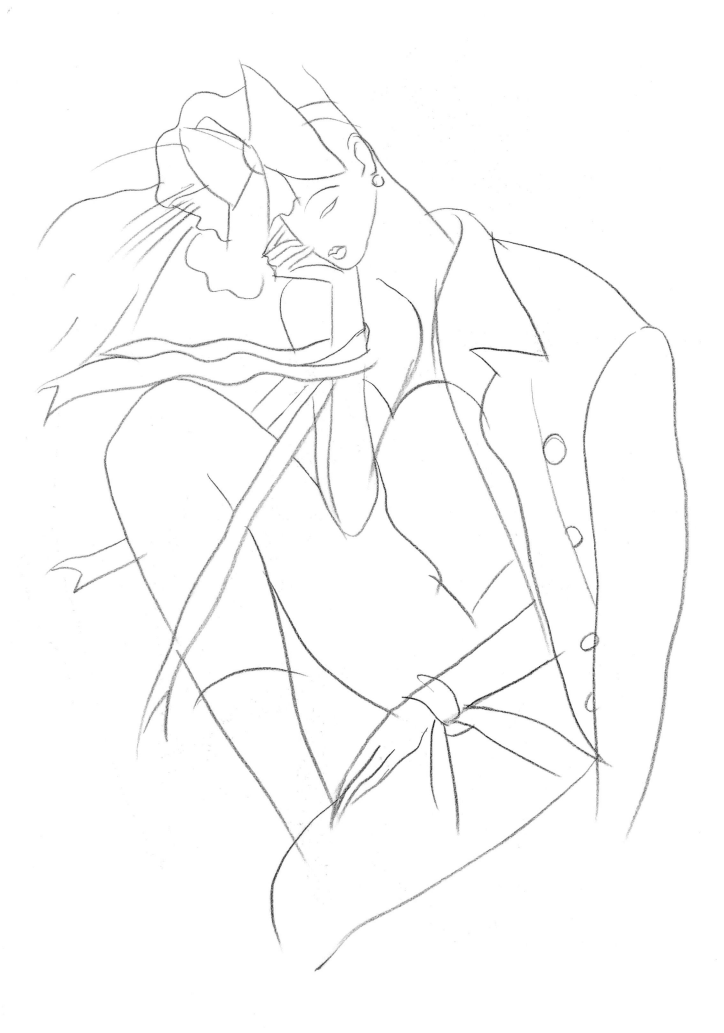

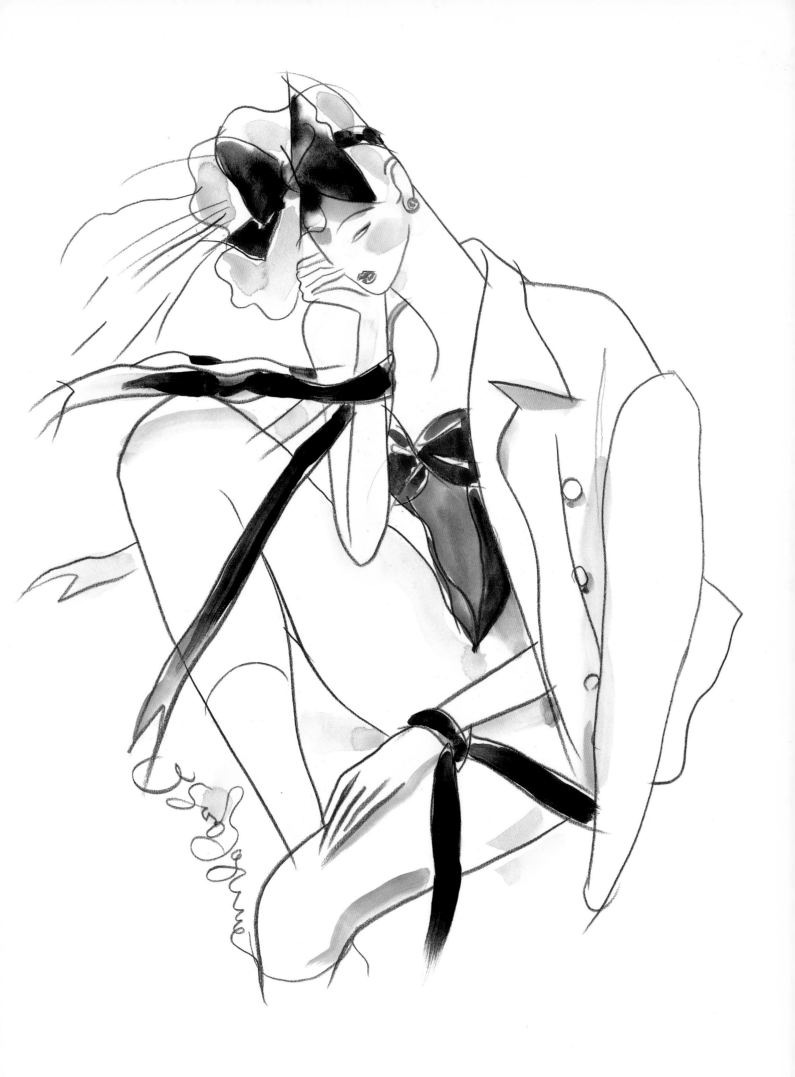

39×32 Conté, Gouache, Fabriano paper

● The arrangement of the strings of a musical instrument can make for a striking picture. The tightness of the strings blends in well with the woman's tense image.　● 弦楽器の弦の張りは美しい。ピーンと張った緊張感と女のイメージは，時として重なり合う。

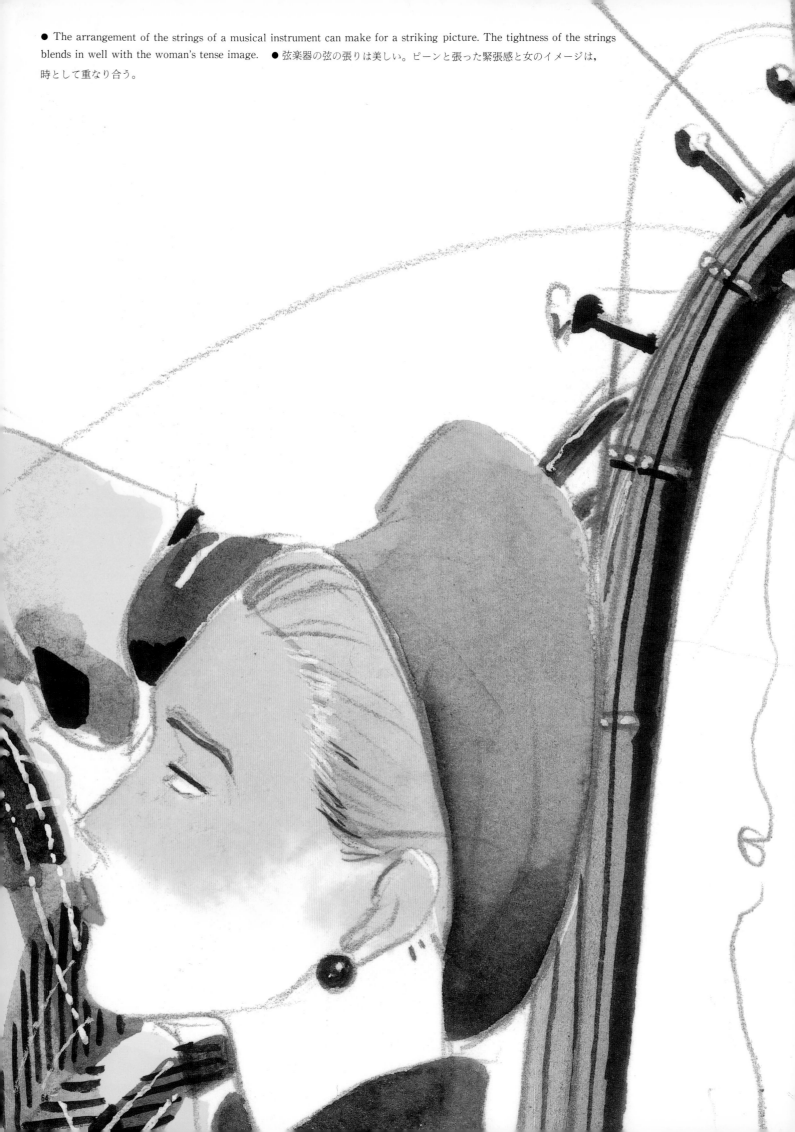

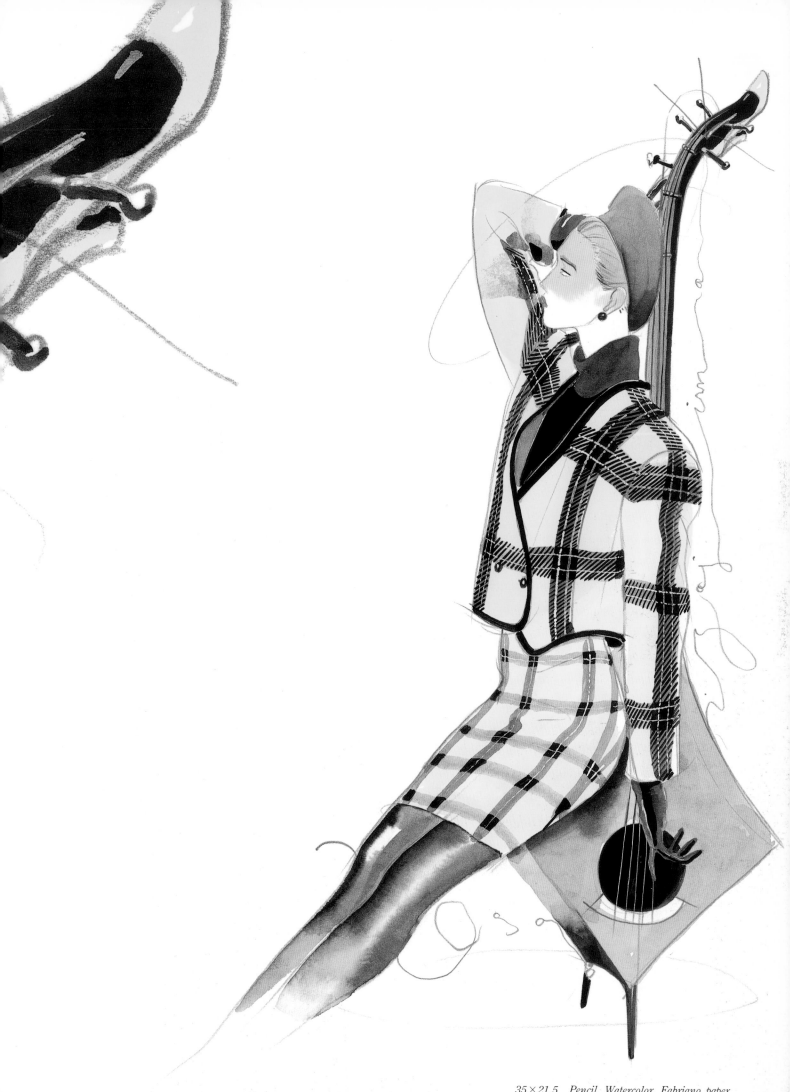

35×21.5 Pencil, Watercolor, Fabriano paper

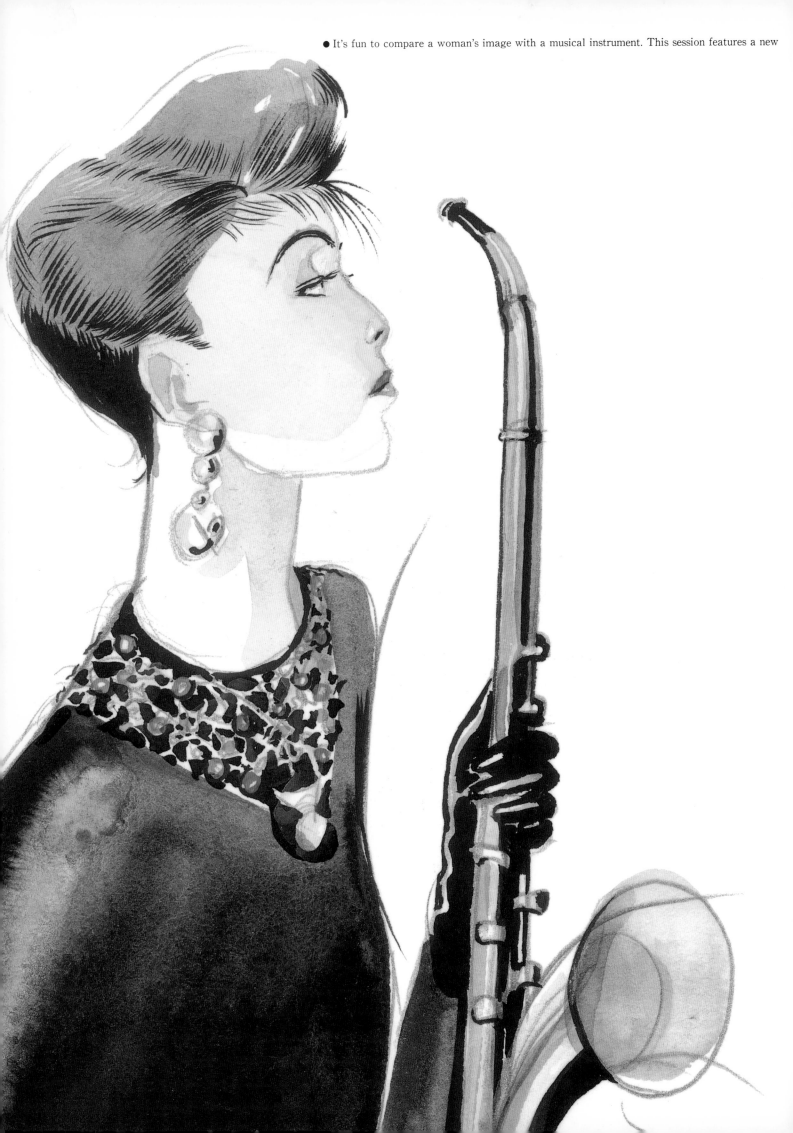

● It's fun to compare a woman's image with a musical instrument. This session features a new

type of musical instrument. ●女性のイメージを楽器に例えて見たら，新しいタイプのインストゥルメントとのセッションとなった。

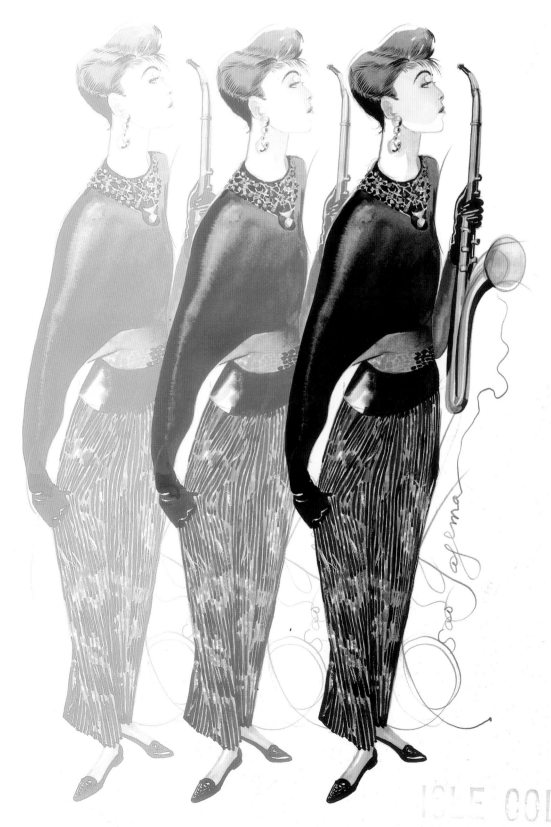

30×9.5　Pencil, Wotercolor, Fabriano paper

● At a glance, the costume will appear to be a perfect fit. However, fit the body line, the design must also allow for space at various 一見ピッタリした服でも，必ず服の部分部分に体を動かすのに必要 it is relatively difficult to faithfully reproduce the space existing∗ points so that the body can move naturally when that な空間が，ラインの特徴と合わさってデザインされているからだ．

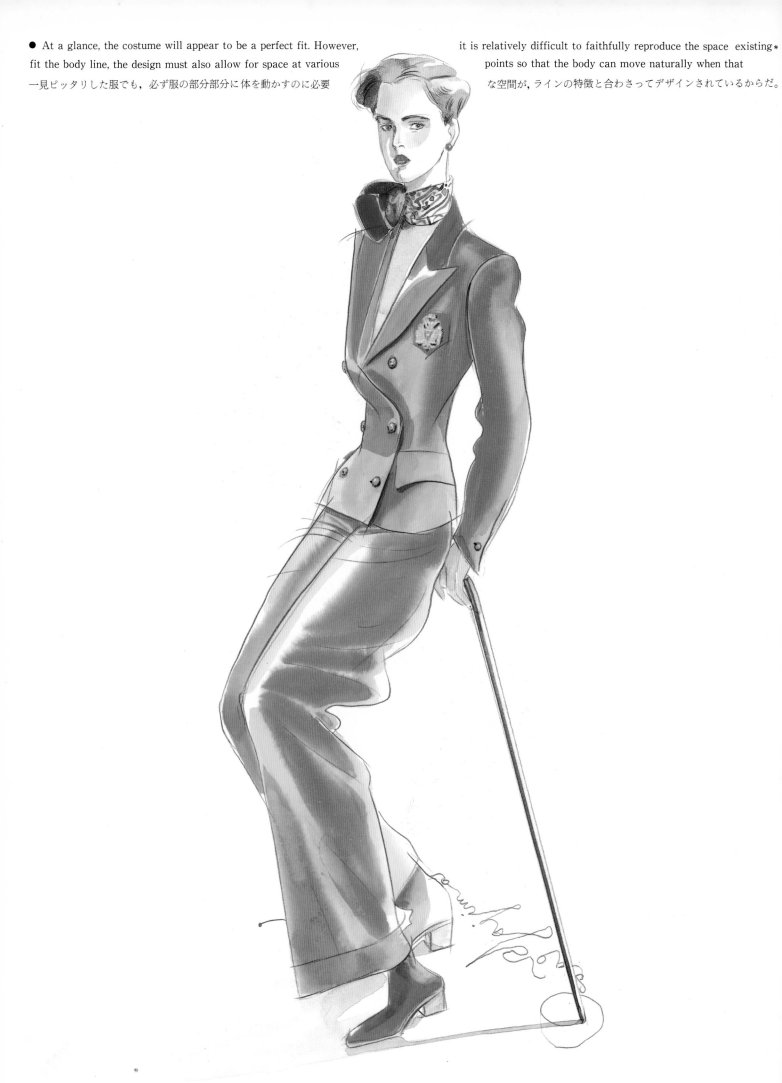

30.5×14 Pencil, Watercolor, Fabriano paper

*between the model's body and the off-body areas of her costume.
particular costume is worn. ●ボディーラインとわずかなオフ

Reason: while the costume is generally designed to
ボディー部分の量感の表現は, 以外と難しい。なぜなら

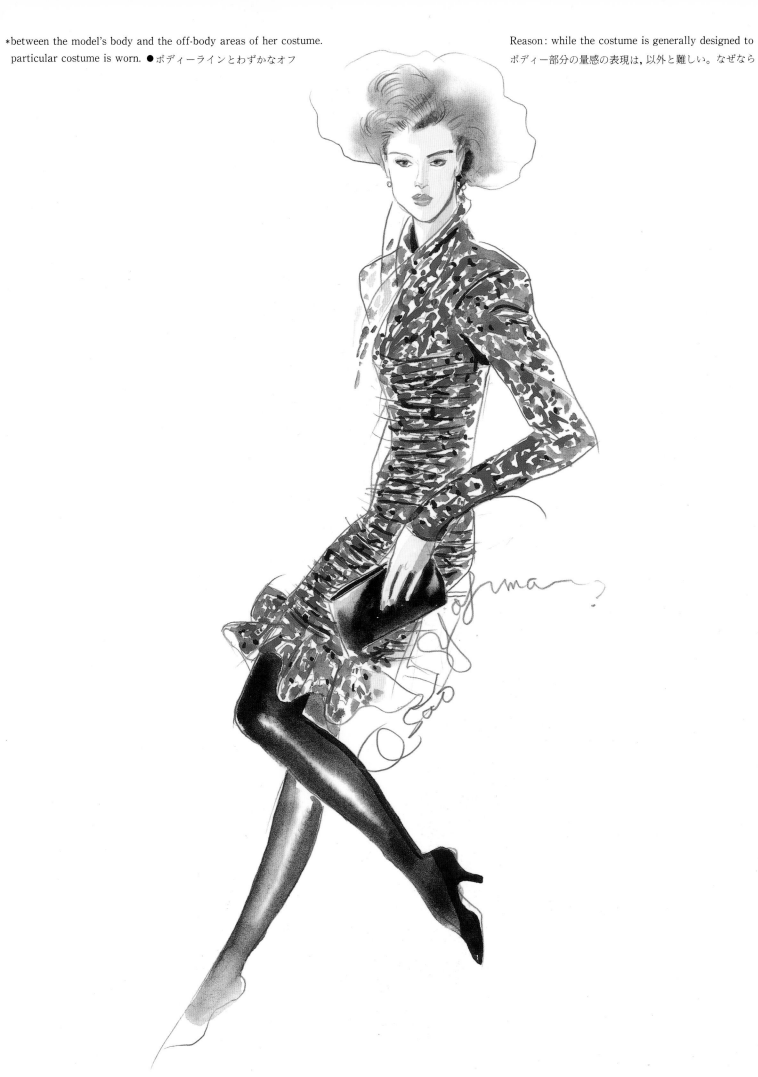

30×13.5 Pencil, Gouache, Drawing paper

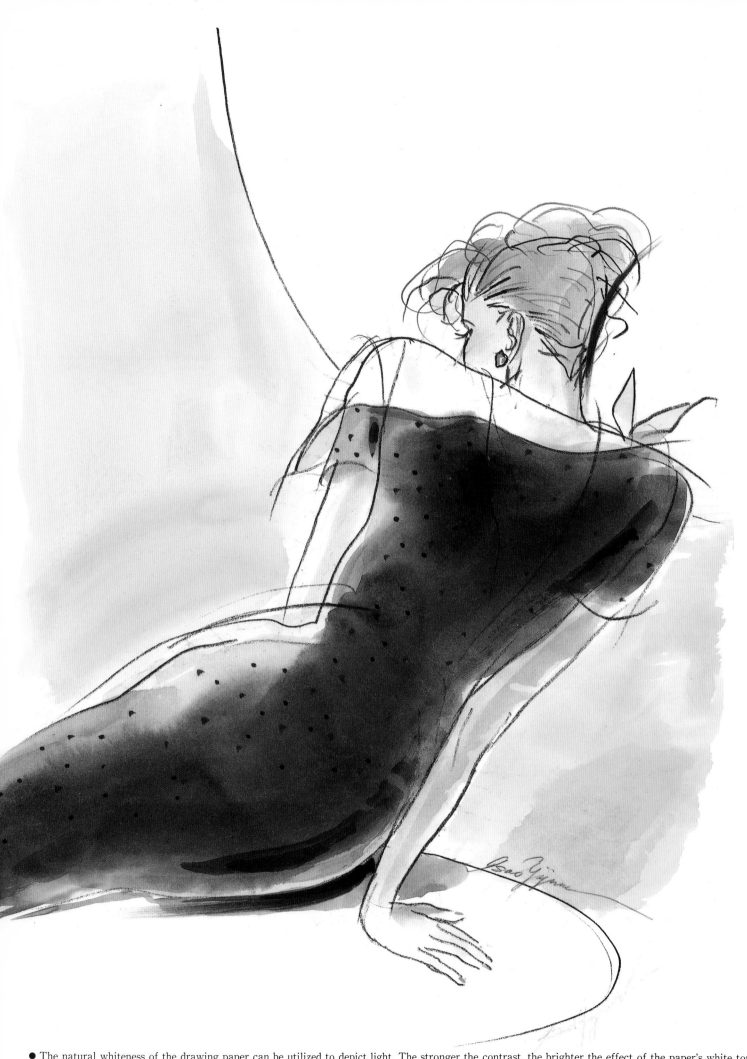

● The natural whiteness of the drawing paper can be utilized to depict light. The stronger the contrast, the brighter the effect of the paper's white tone⋯

39.5 × 29 Pencil, Watercolor, Drawing paper

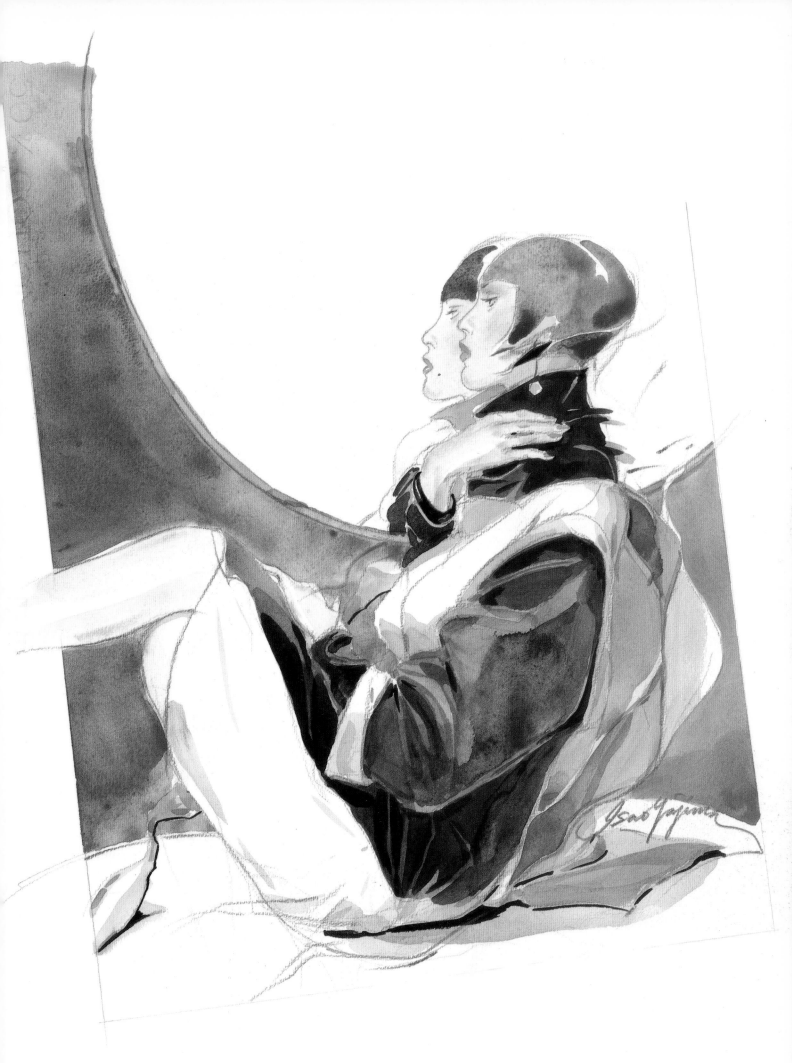

● 紙の白は絵の中で時には光となる。コントラストを強くするほど光は強く当るんだ。

38×31.5　Pencil, Gouache, Fabriano paper

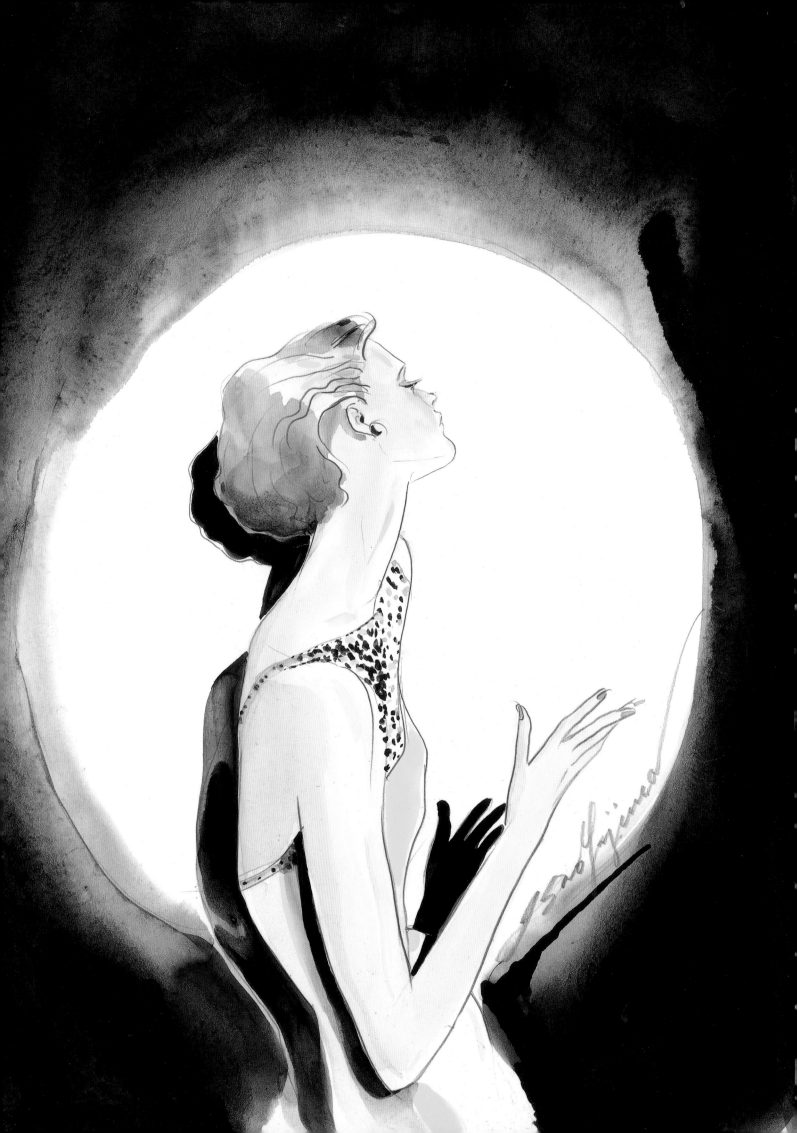

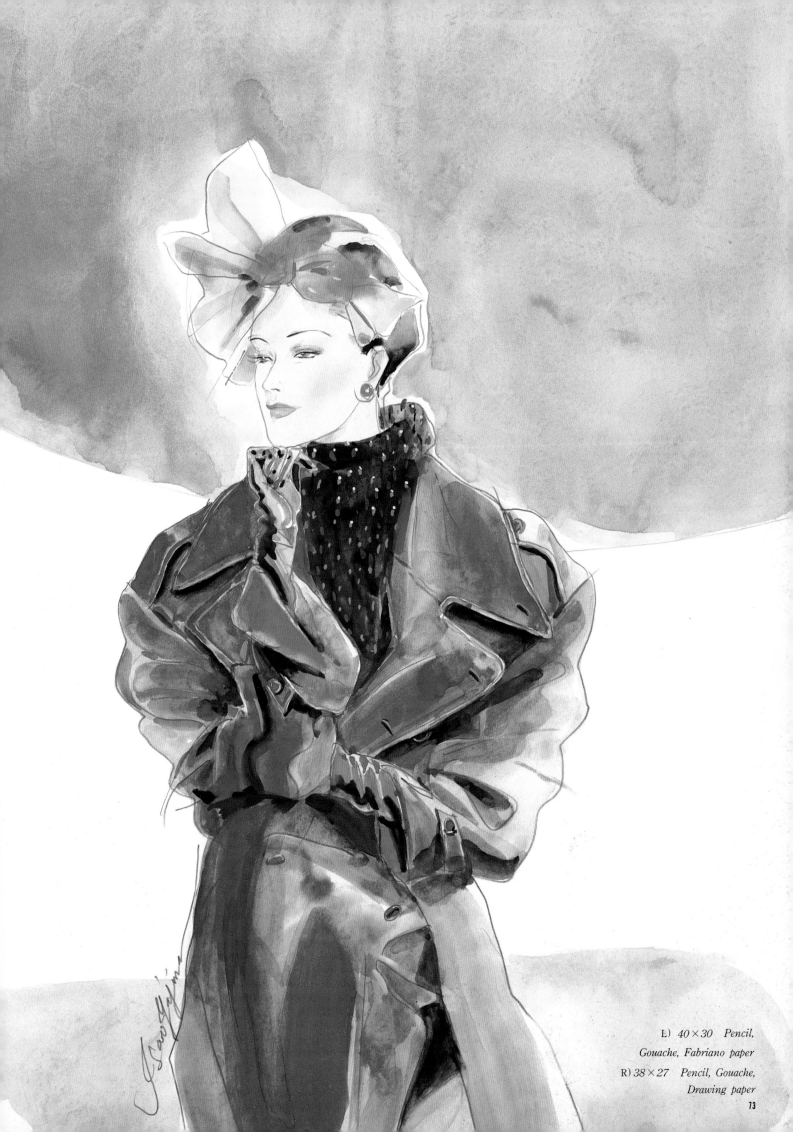

L) 40×30 Pencil,
Gouache, Fabriano paper
R) 38×27 Pencil, Gouache,
Drawing paper

FIGURE DRAWING FOR FASHION. ②

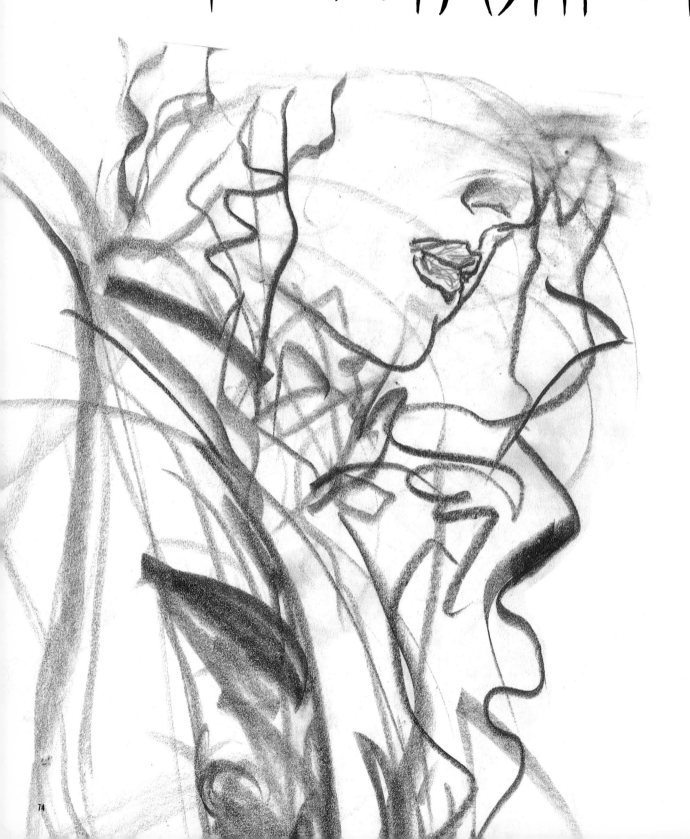

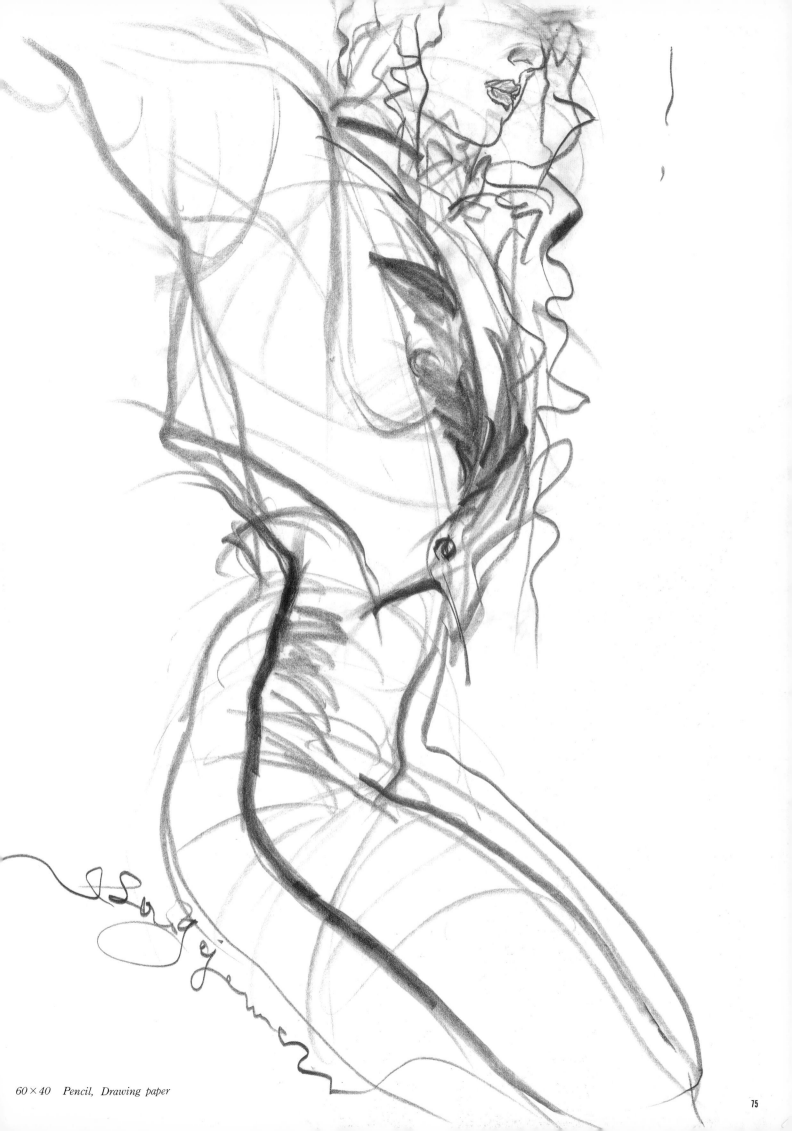

60×40 Pencil, Drawing paper

● While sketching, try to keep in mind which
however, can be a difficult task. For
face with the man's would be unacceptable.

of the model's poses is the most striking. You will note that the model will ∗
example, even if the man's face on the right-hand page is replaced with

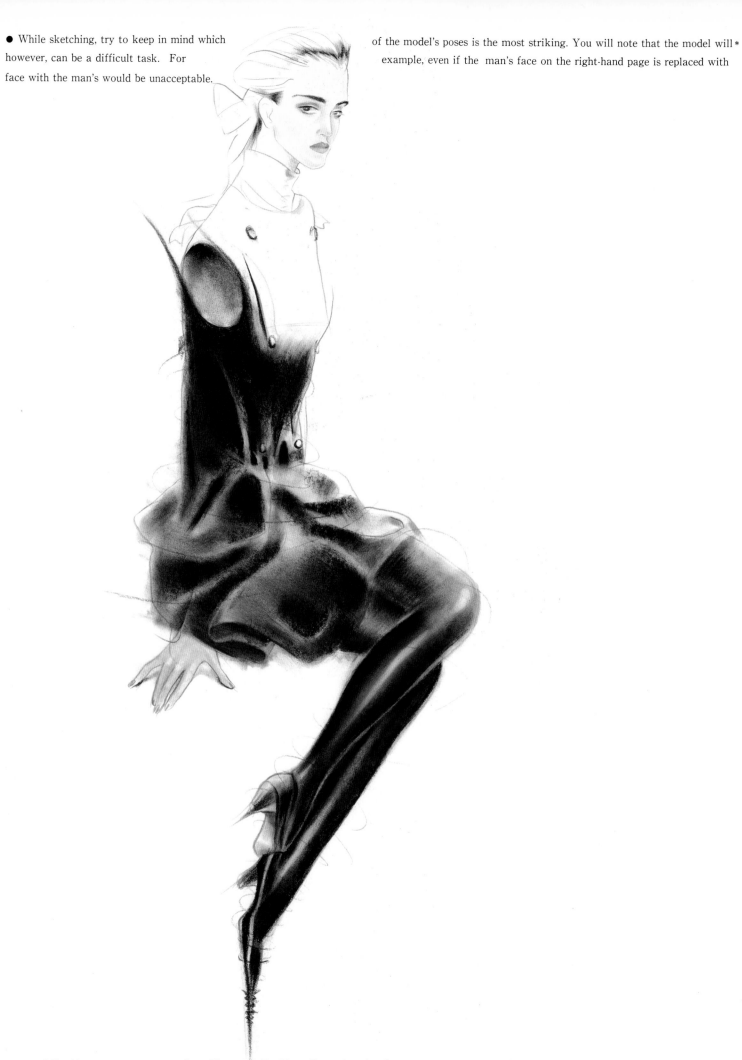

●どんな姿勢が美しいかなんていろいろ考えて描く。よく思い返して見ると女のポーズはいろいろバリエーションがある。例え男っぽく構えても意外にサマになる。

62×25 Pencil, Pastel, Fabriano paper

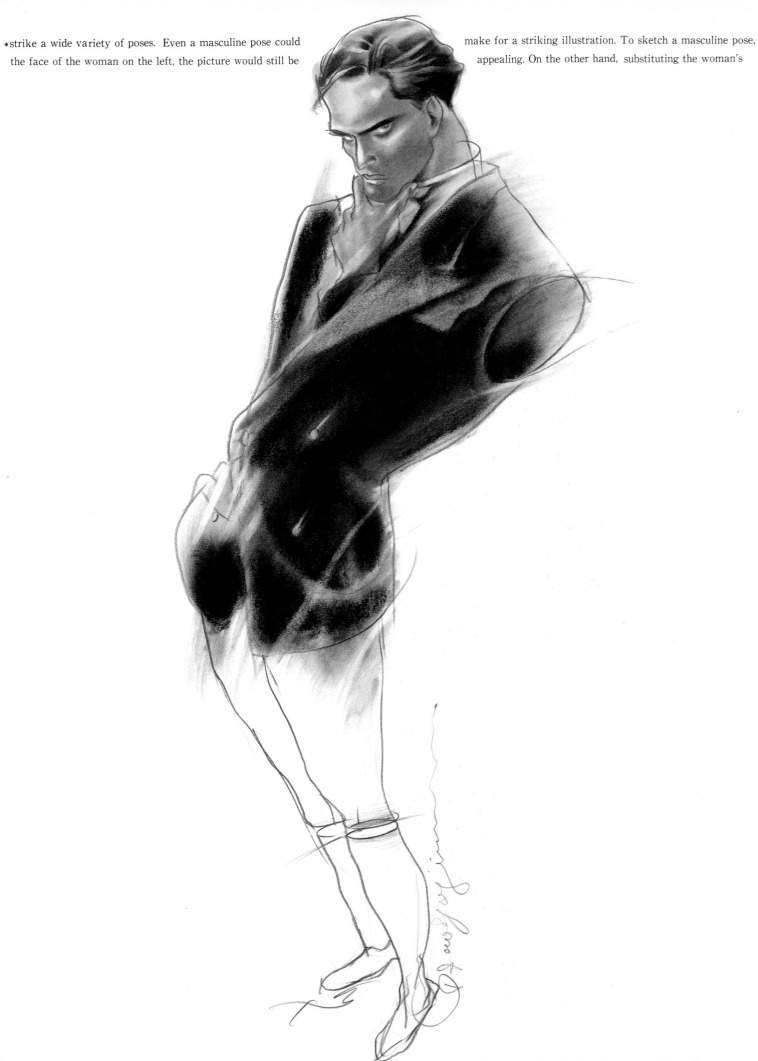

*strike a wide variety of poses. Even a masculine pose could
the face of the woman on the left, the picture would still be

make for a striking illustration. To sketch a masculine pose,
appealing. On the other hand, substituting the woman's

しかし男のポーズはちょっと難しい。右ページの男の顔を左の女の顔と入れ替えて想像すると女はまあまあいいけど男の顔と女のポーズは，これはまずい。

58×27 Pencil, Pastel, Fabriano paper

11

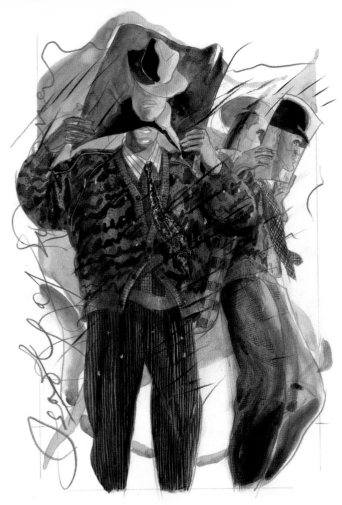

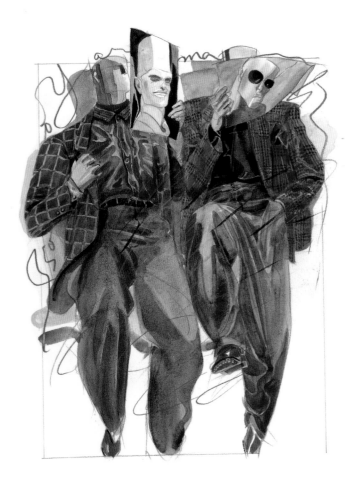

37.5×26 Pencil, Gouache, Fabriano paper

33×26 Pencil, Gouache, Fabriano paper

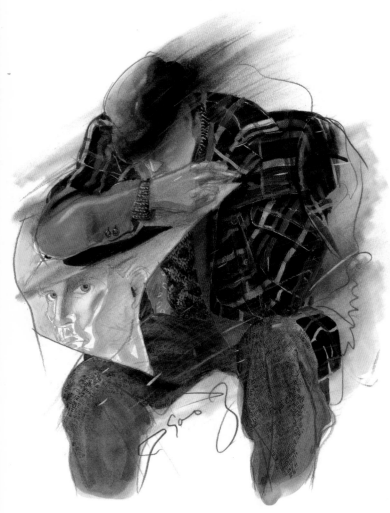

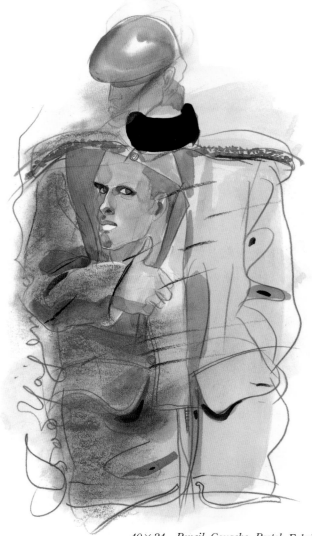

39×31 Pencil, Gouache, Pastel, Fabriano paper

40×24 Pencil, Gouache, Pastel, Fabriano paper

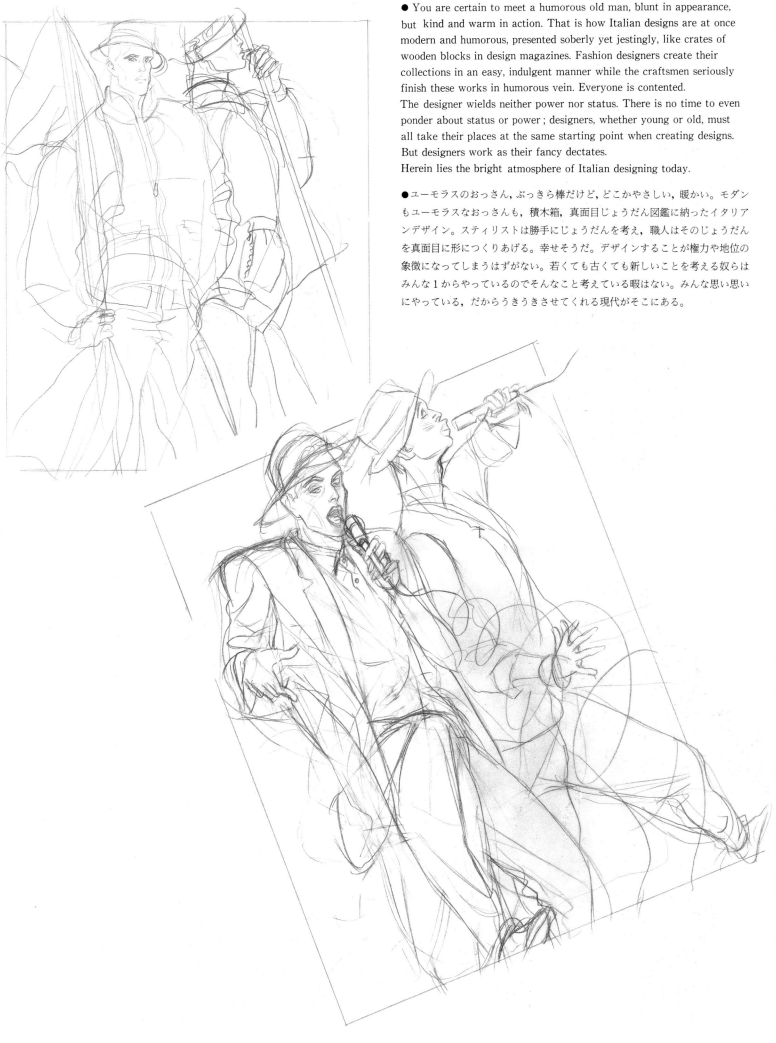

● You are certain to meet a humorous old man, blunt in appearance, but kind and warm in action. That is how Italian designs are at once modern and humorous, presented soberly yet jestingly, like crates of wooden blocks in design magazines. Fashion designers create their collections in an easy, indulgent manner while the craftsmen seriously finish these works in humorous vein. Everyone is contented.
The designer wields neither power nor status. There is no time to even ponder about status or power ; designers, whether young or old, must all take their places at the same starting point when creating designs. But designers work as their fancy dectates.
Herein lies the bright atmosphere of Italian designing today.

●ユーモラスのおっさん，ぶっきら棒だけど，どこかやさしい，暖かい。モダンもユーモラスなおっさんも，積木箱，真面目じょうだん図鑑に納ったイタリアンデザイン。スティリストは勝手にじょうだんを考え，職人はそのじょうだんを真面目に形につくりあげる。幸せそうだ。デザインすることが権力や地位の象徴になってしまうはずがない。若くても古くても新しいことを考える奴らはみんな1からやっているのでそんなこと考えている暇はない。みんな思い思いにやっている，だからうきうきさせてくれる現代がそこにある。

31×25.5 Pencil, PM pad

31×25.5 Pencil, Skin paper

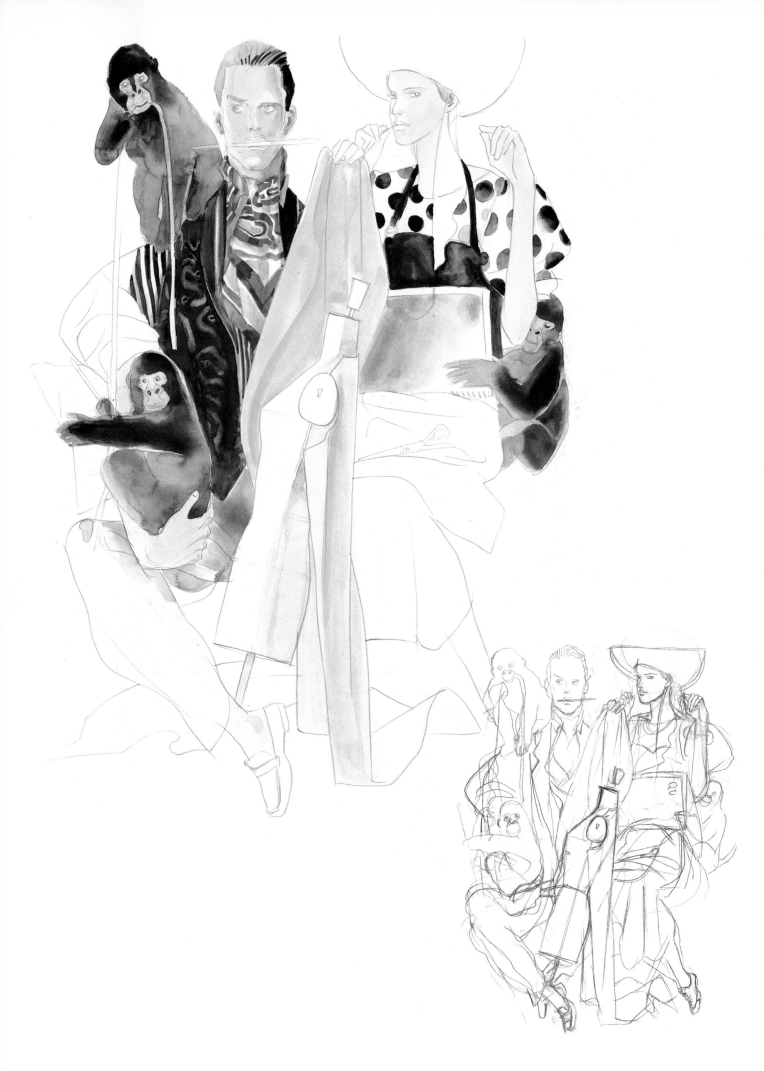

41×31 Pencil, Gouache, Fabriano paper

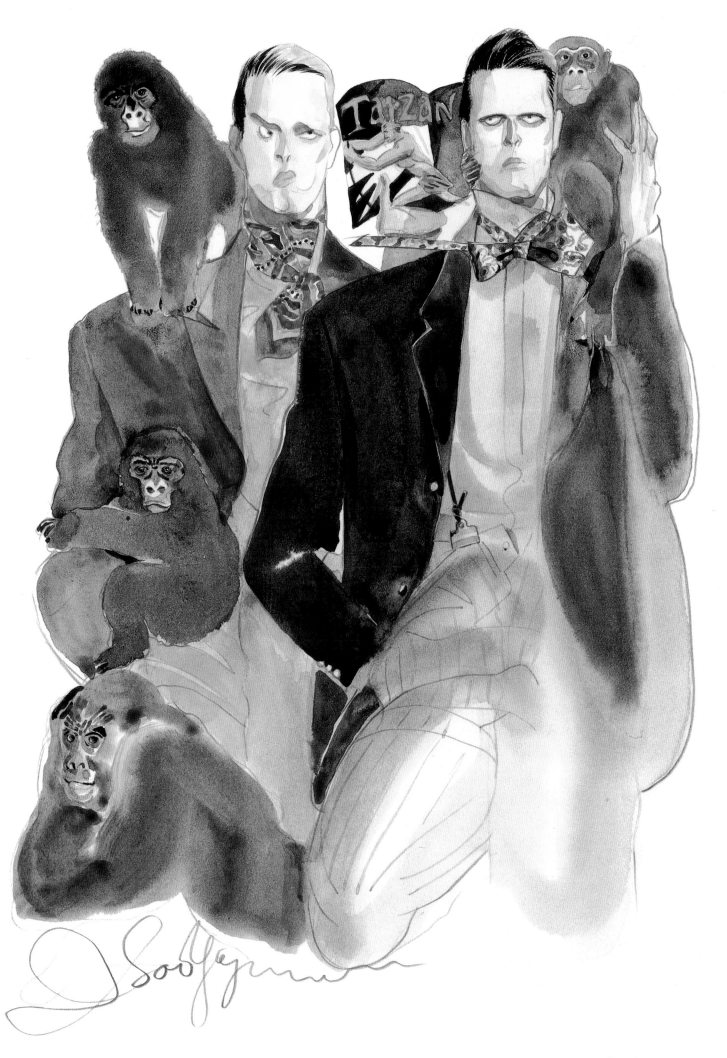

32×22 Pencil, Gouache, Fabriano paper

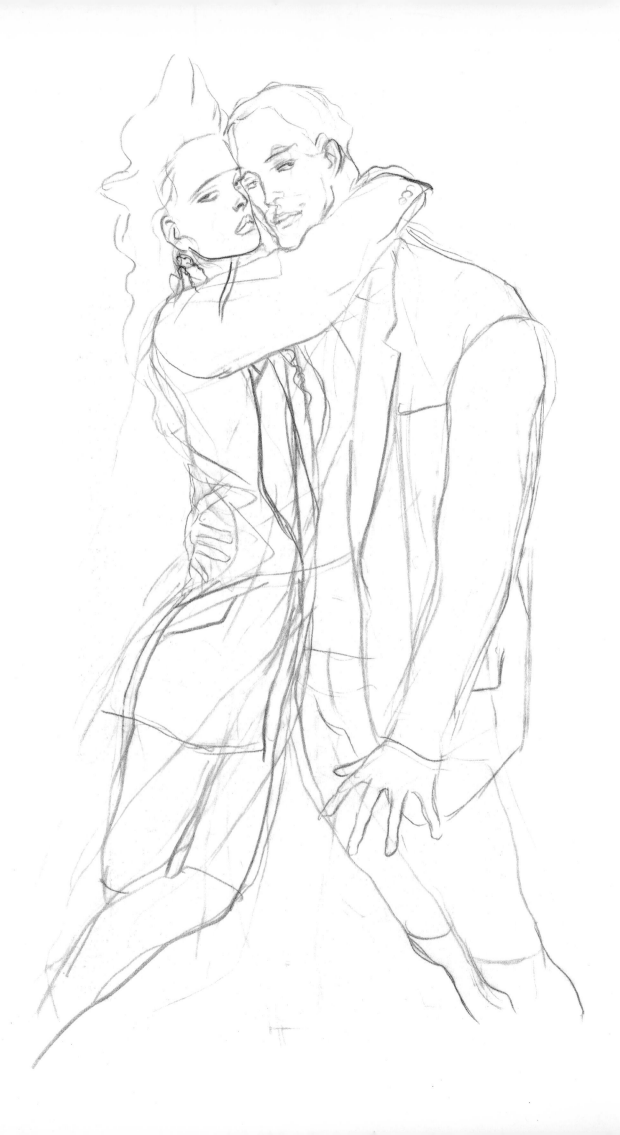

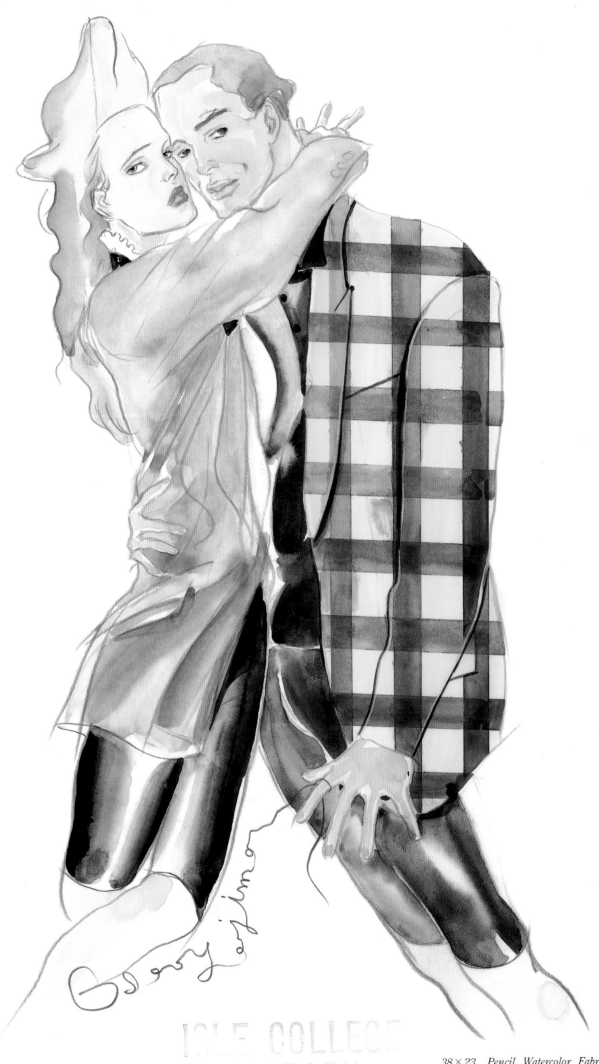

38 × 23 *Pencil, Watercolor, Fabriano paper*

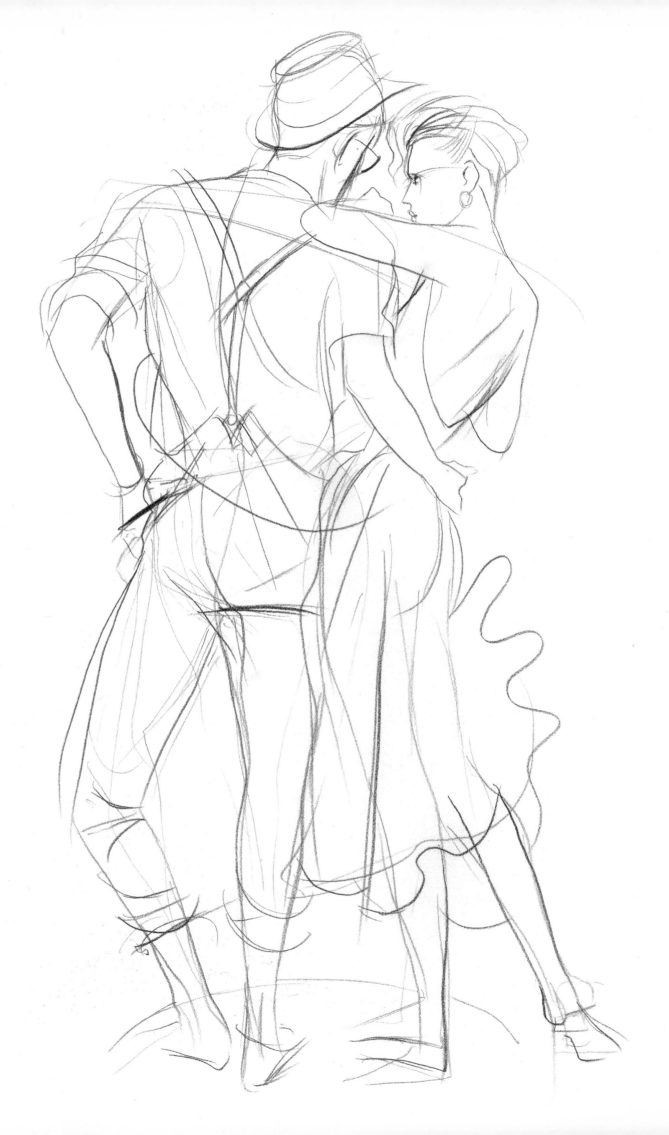

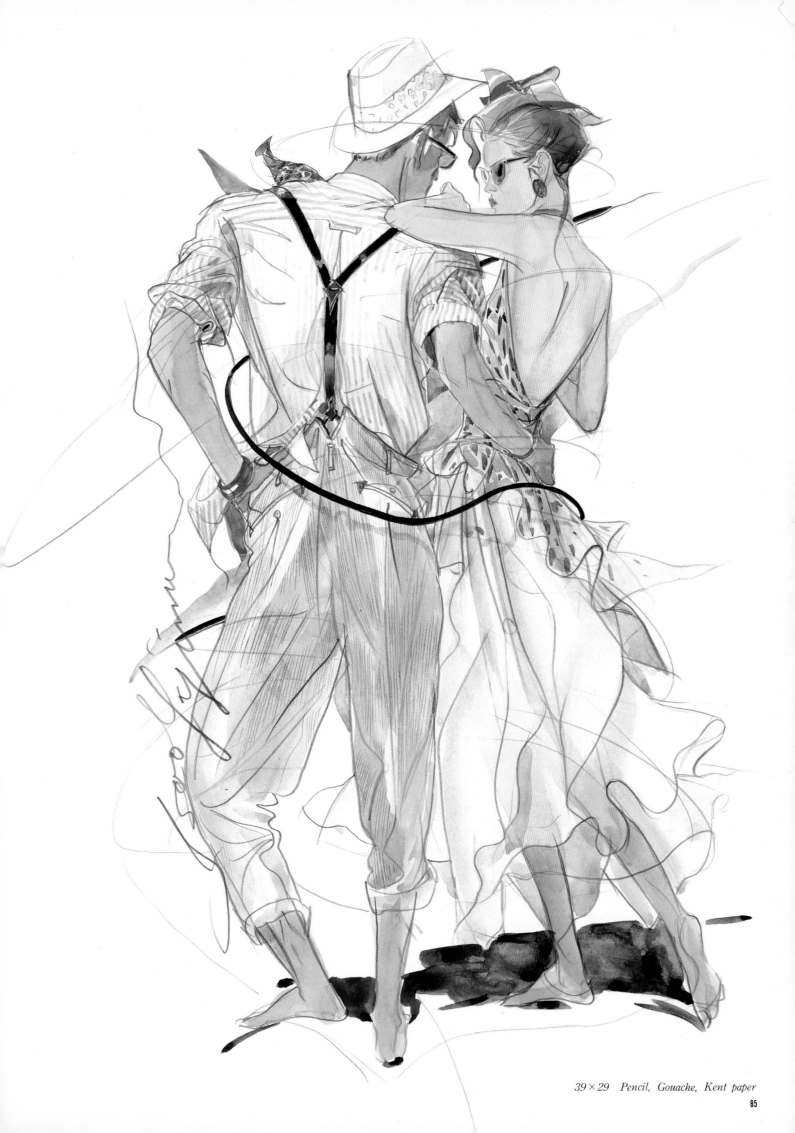

39×29 Pencil, Gouache, Kent paper

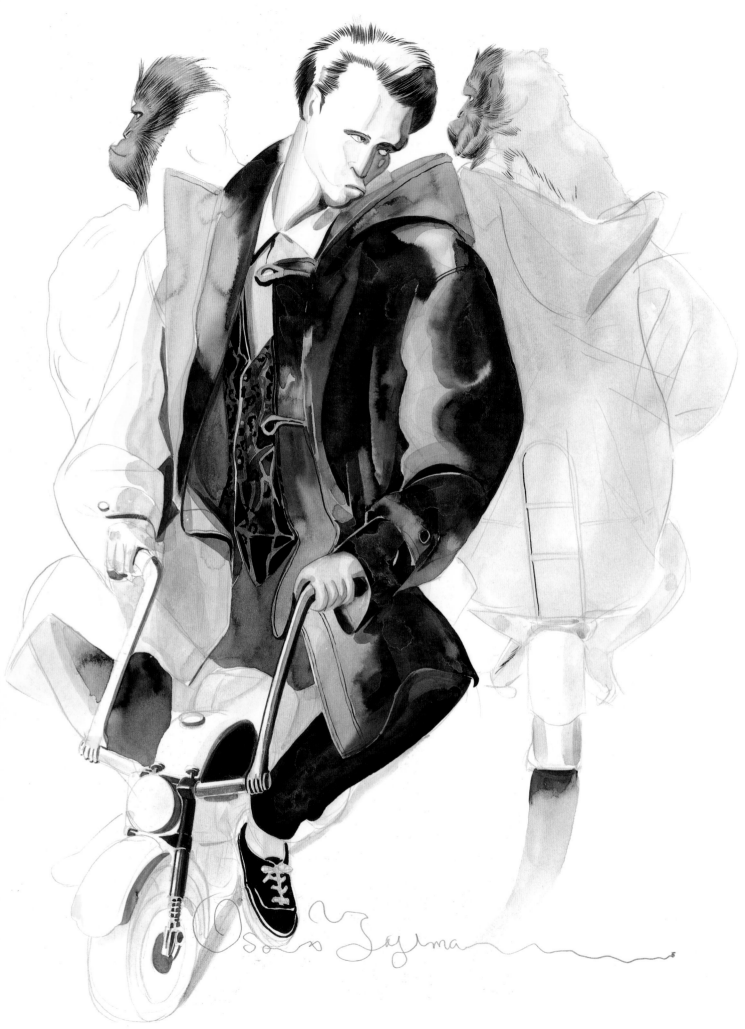

35×24.5　Pencil, Watercolor, Kent paper

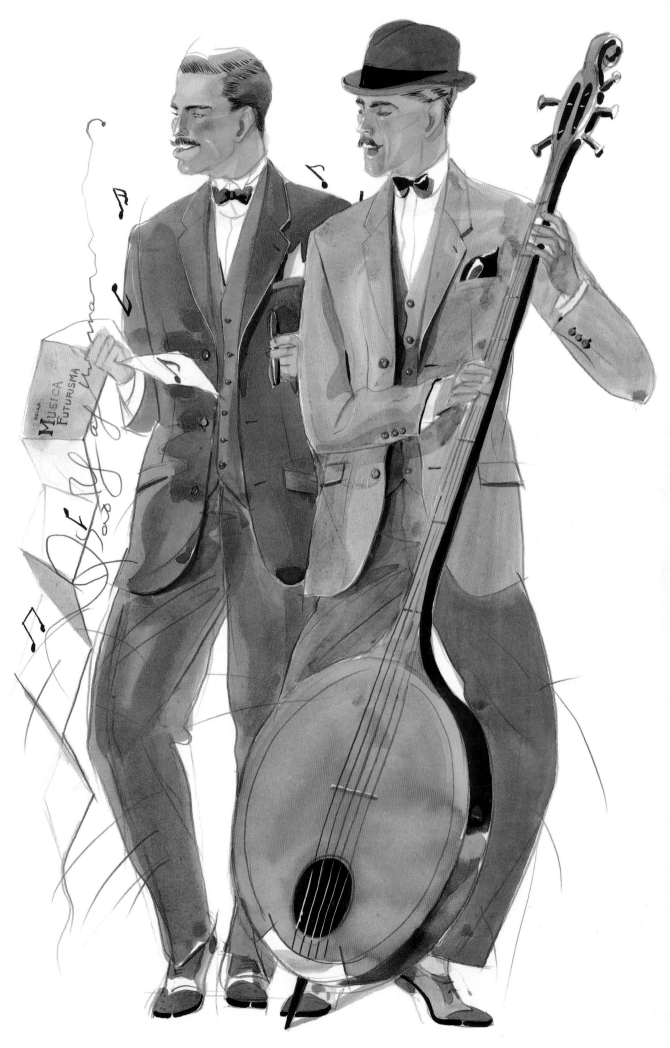

37.5×24.5 Color ink, Musecotton paper

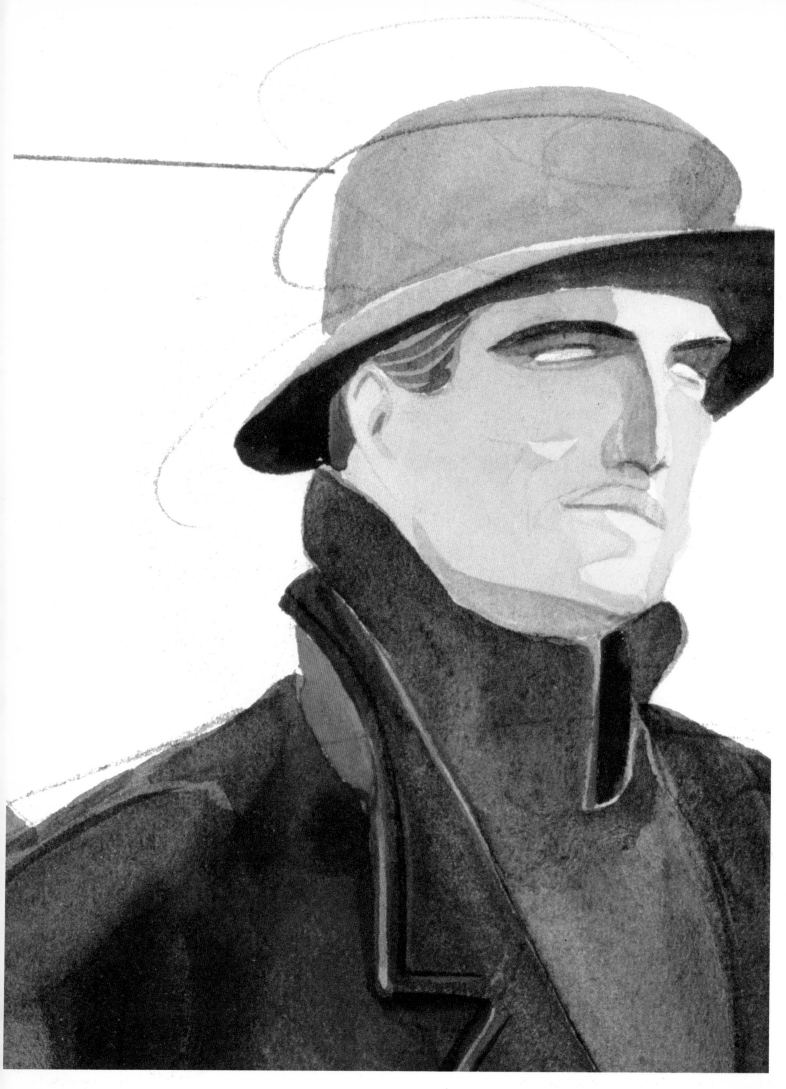

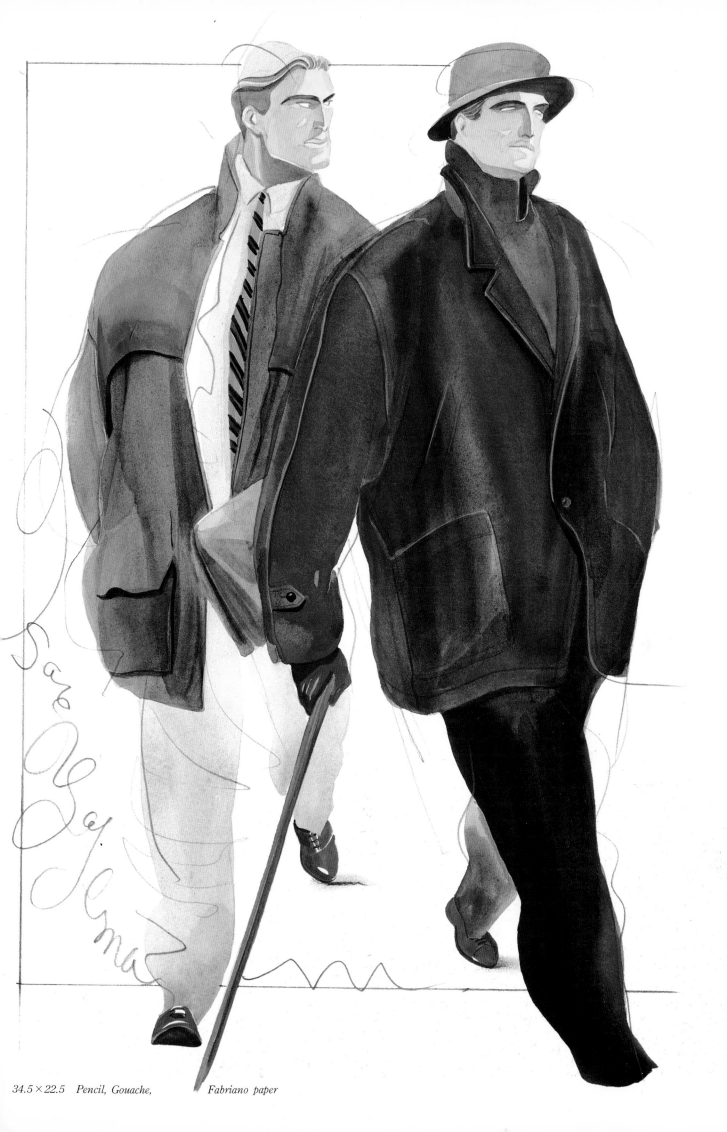

34.5 × 22.5 Pencil, Gouache, Fabriano paper

● Compare the illustrations shown on the left and right. When a face has been drawn in, the viewer eyes will automatically go to the model's face. If the

● 左と右とを比べて見よう。顔が描かれてある場合，絵を見る瞬間，顔に目がまず行くけど，顔が隠れている方は，視線は服に注がれる。

34×14 Pencil, Pastel, Skin paper

face is hidden, however, the viewer's attention will focus on the costume.

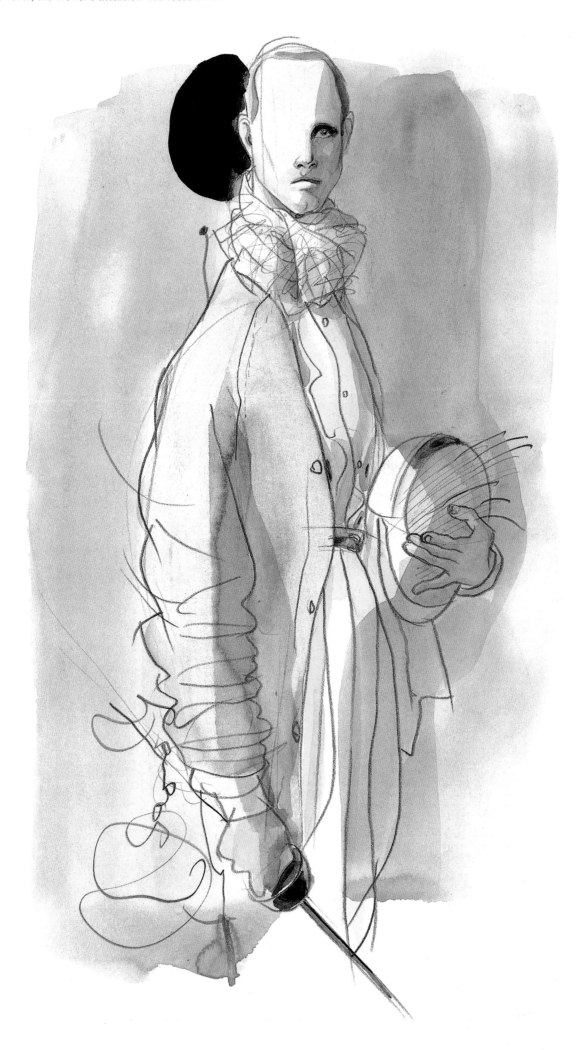

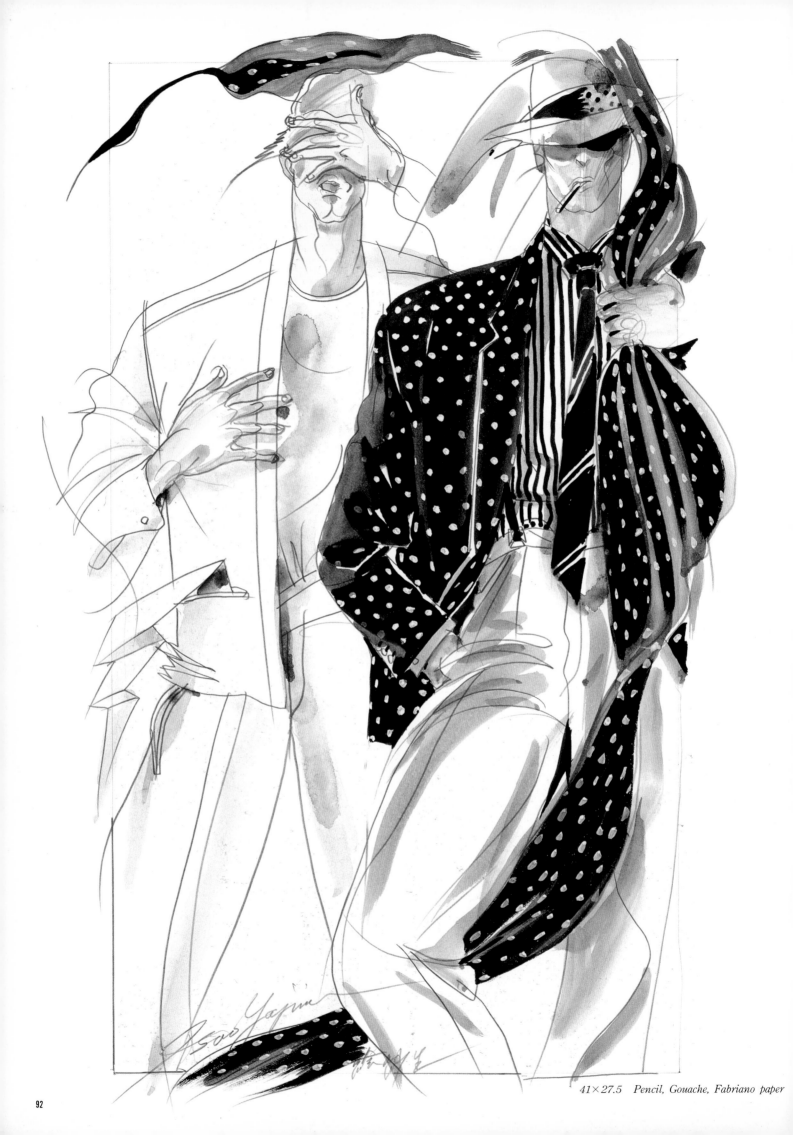

41×27.5 *Pencil, Gouache, Fabriano paper*

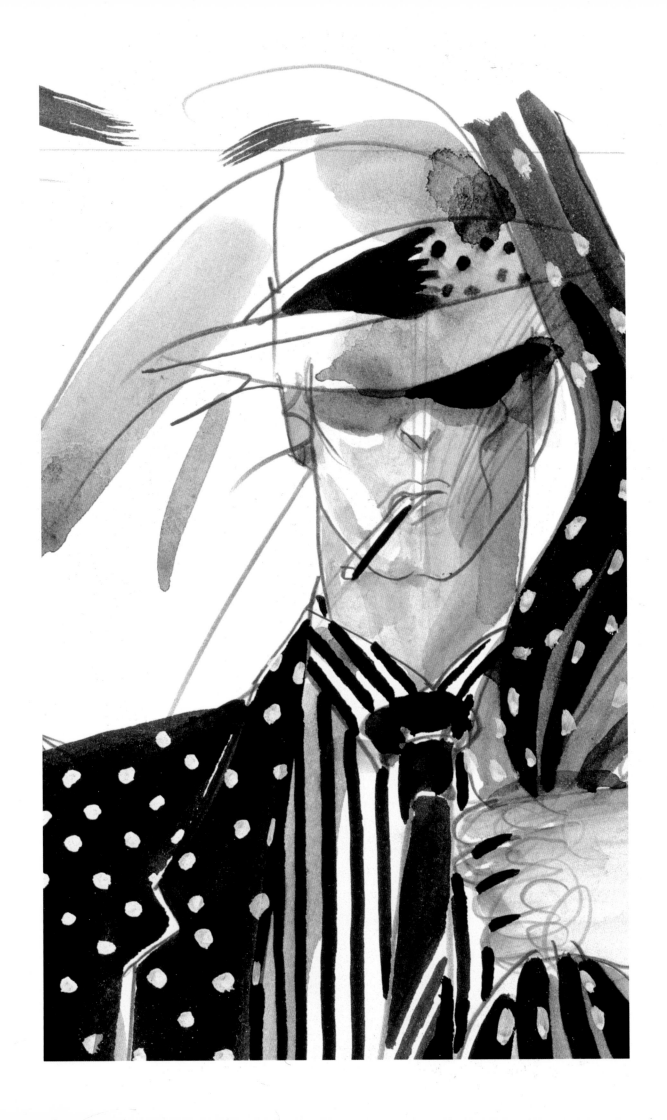

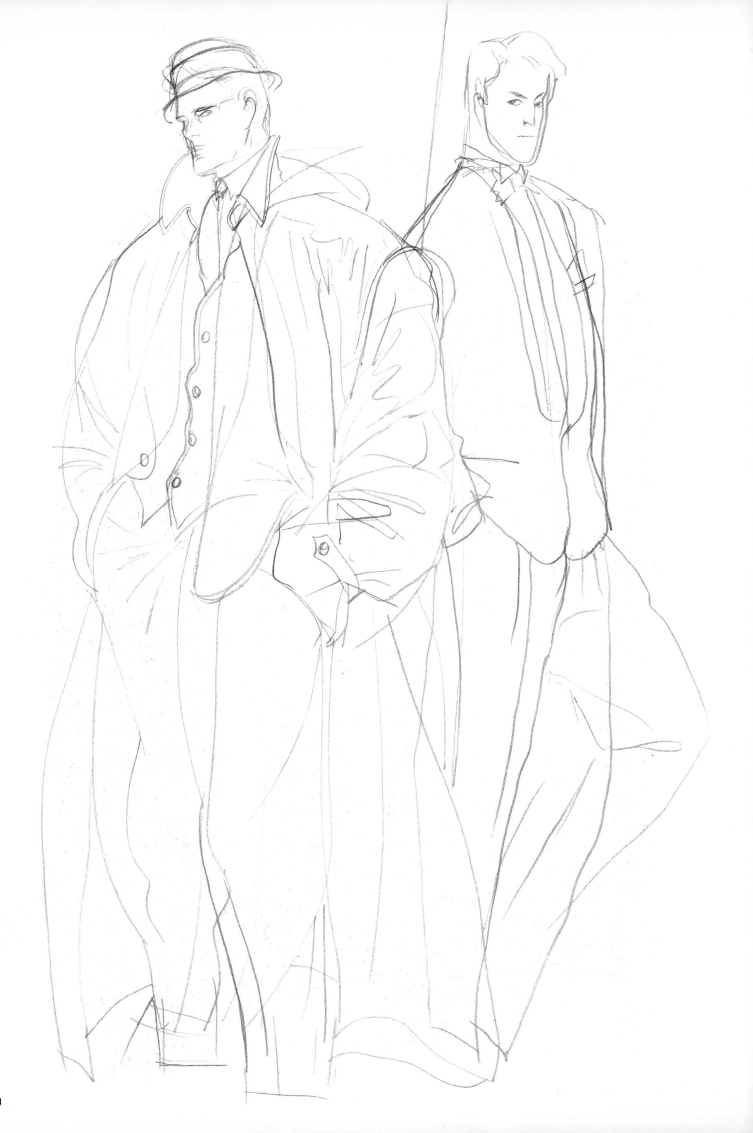

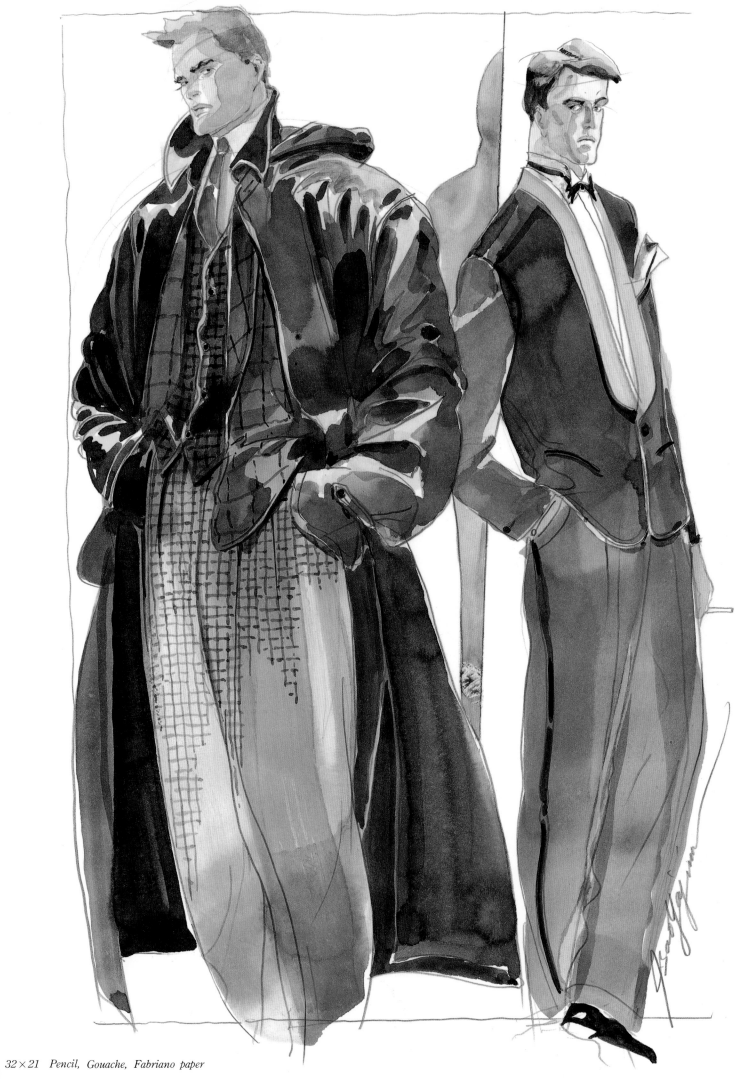

32×21 *Pencil, Gouache, Fabriano paper*

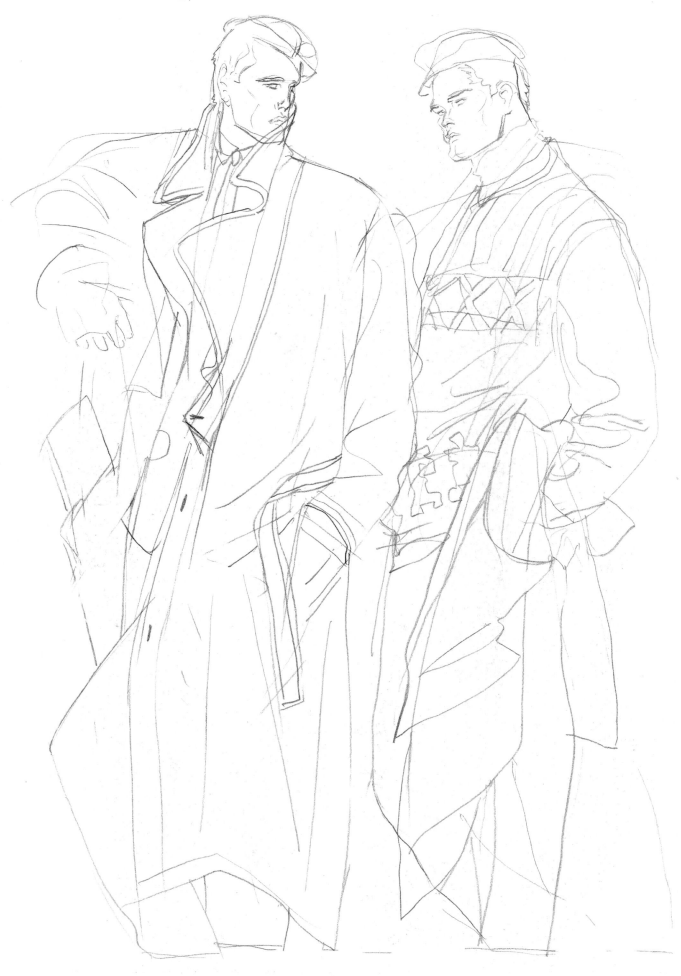

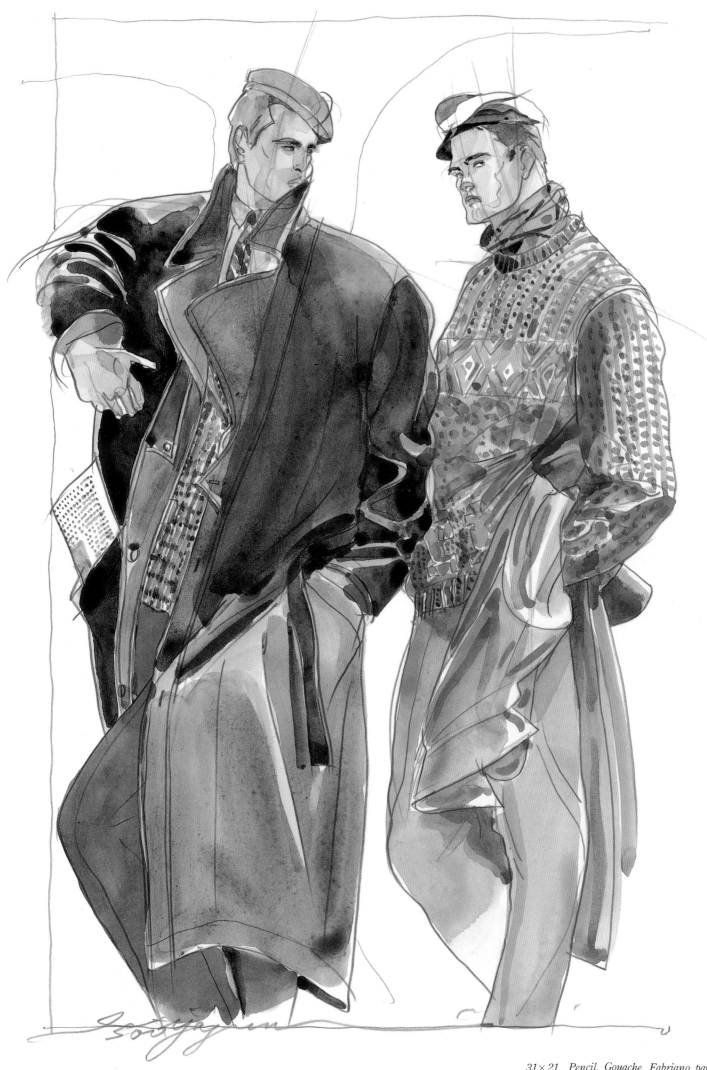

31×21 Pencil, Gouache, Fabriano paper

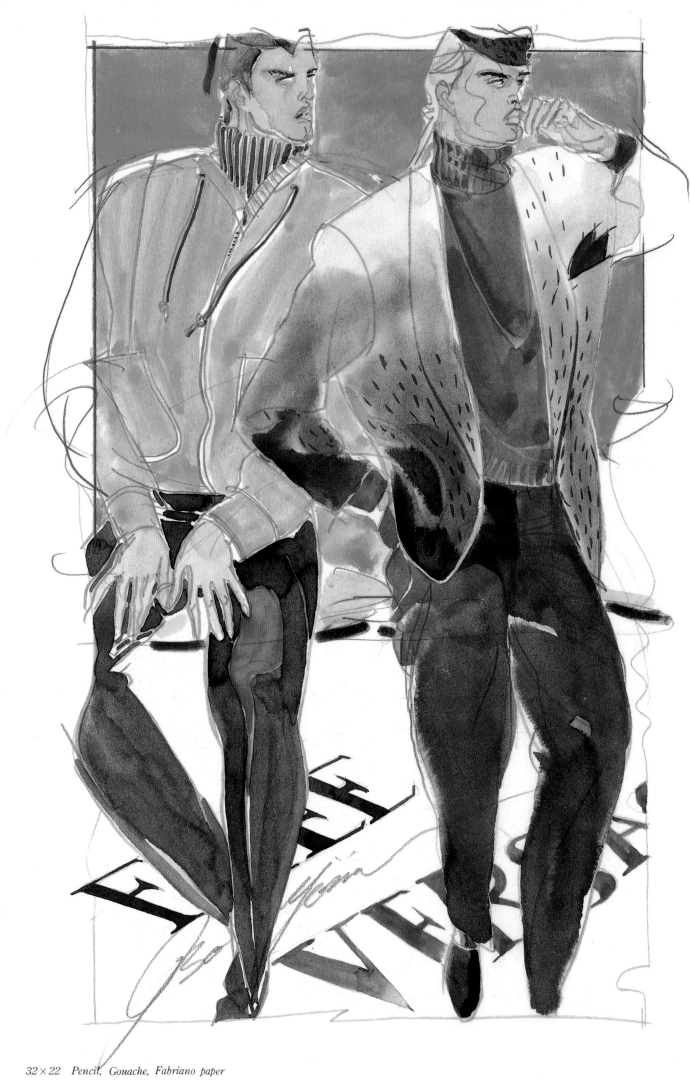

32×22 Pencil, Gouache, Fabriano paper

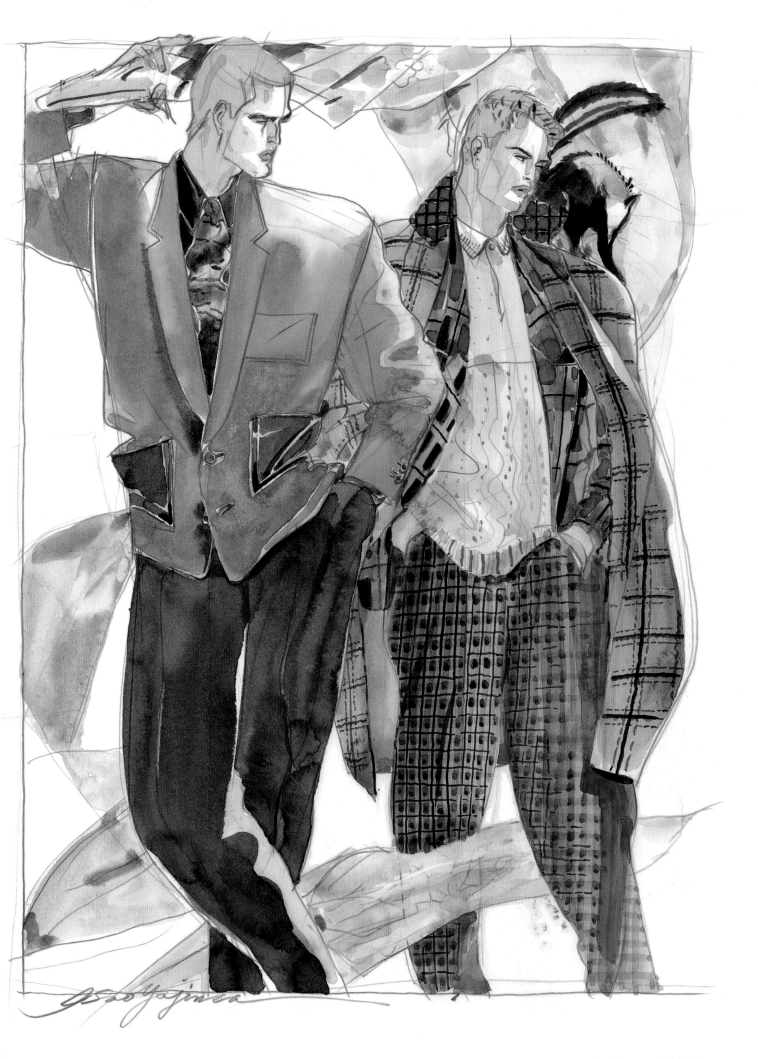

30.5×22 Pencil, Gouache, Fabriano paper

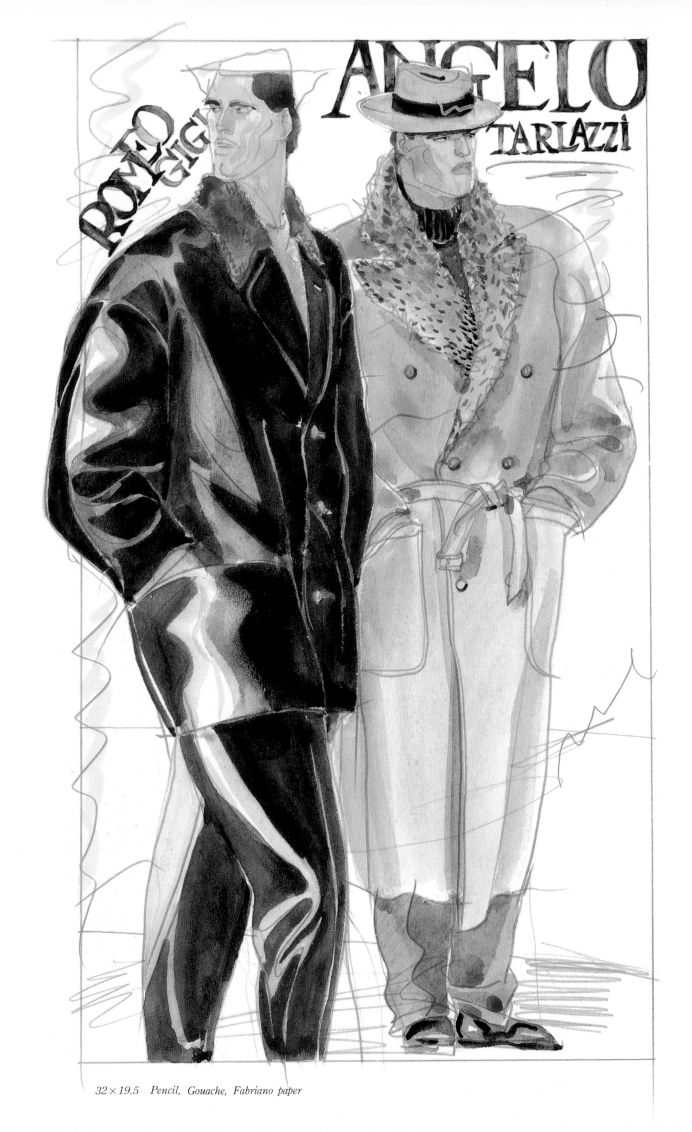

ROMEO GIGLI

ANGELO TARLAZZI

32×19.5 Pencil, Gouache, Fabriano paper

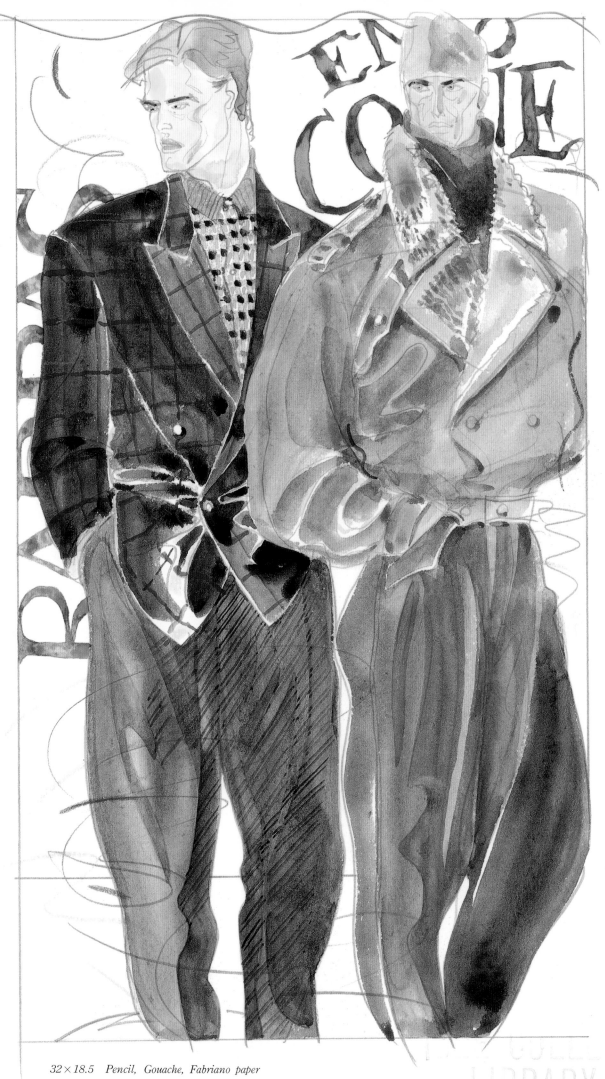

32×18.5 Pencil, Gouache, Fabriano paper

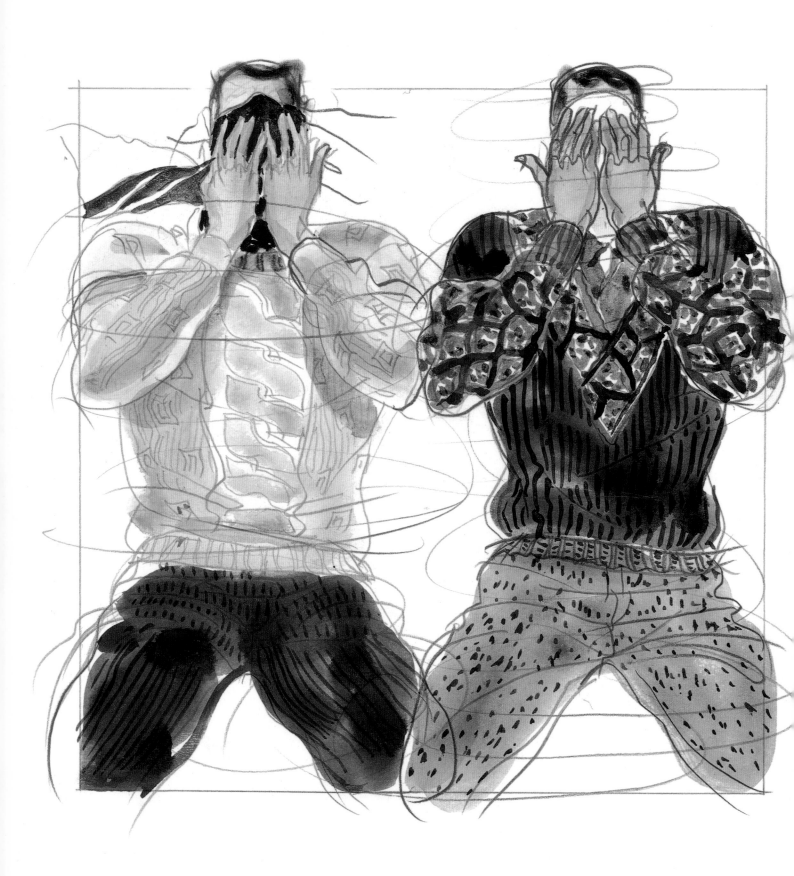

●In the midst of my fashion illustration work, I have had the opportunity
to see the other faces of design in Italy. I have watched the rays of the sun brighten Milan's gray colored streets. I have seen the apparels
introduced in such Italian magazines as *Domus*, *Casa* and *Arredamento* displayed beautifully in its shop windows. Domestically made Italian
lighting fixtures and furniture liven up these window displays. Some people say that exaggeration and indulgence, even in moderation, are
excesses. And yet these excesses appear to be functional in their own ways. In time, the over-indulgences of Memphis and Archimia catch my
attention. On the other hand, I have also seen the use of tables and other perfect display tools that require neither upgrading nor downgrading.

25×26.5 Pencil, Gouache, Fabriano paper

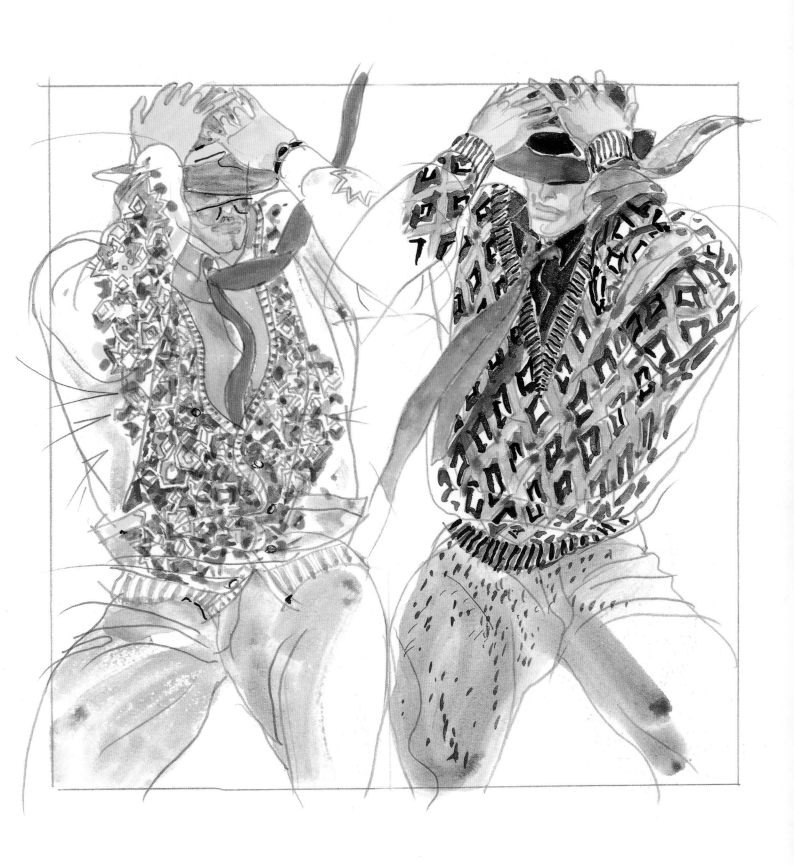

●グレイ色の街の中にあざやかな光がこぼれる。日本で見たドムス
やカーサなんとか，アレダメンドなんとかという雑誌に載っていたものが店のウィンドウに格好よく並べてある。メイドインイタリーの照明具や家具は，う
きうきさせてくれる。適度な誇張，適度な遊び，無駄と言う人もいる。その無駄がちゃんと機能することも考えてある。そしていつの頃からか，遊び狂った
ようなメンフィス，やアルキミヤのそれが目についてきた。反対にもこれ以上つけ足すことも削ることも出来ないような形の椅子やツールも登場してきた。

24.5×25 Pencil, Gouache, Fabriano paper

UNGARO

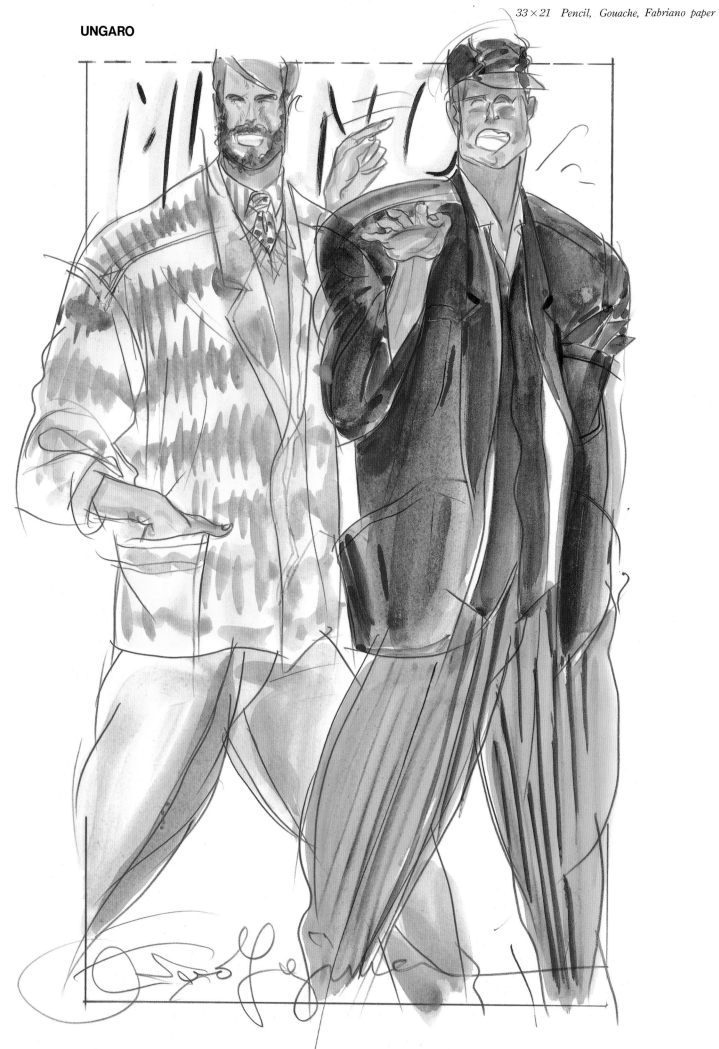

● I have sketched the portraits of Ungaro, Coveri, Venturi, Soprani, Ferre, Armani and others. All of them are great designers, but not perfect models un-

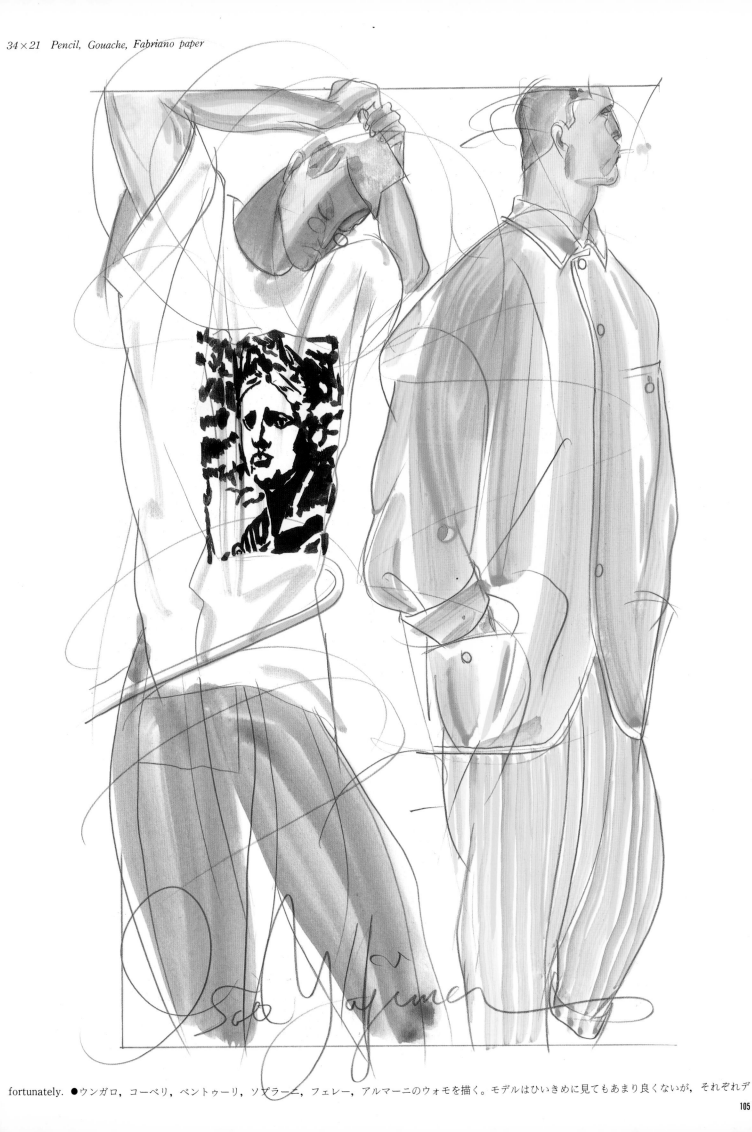

fortunately. ●ウンガロ，コーベリ，ベントゥーリ，ソプラーニ，フェレー，アルマーニのウォモを描く。モデルはひいきめに見てもあまり良くないが，それぞれデ

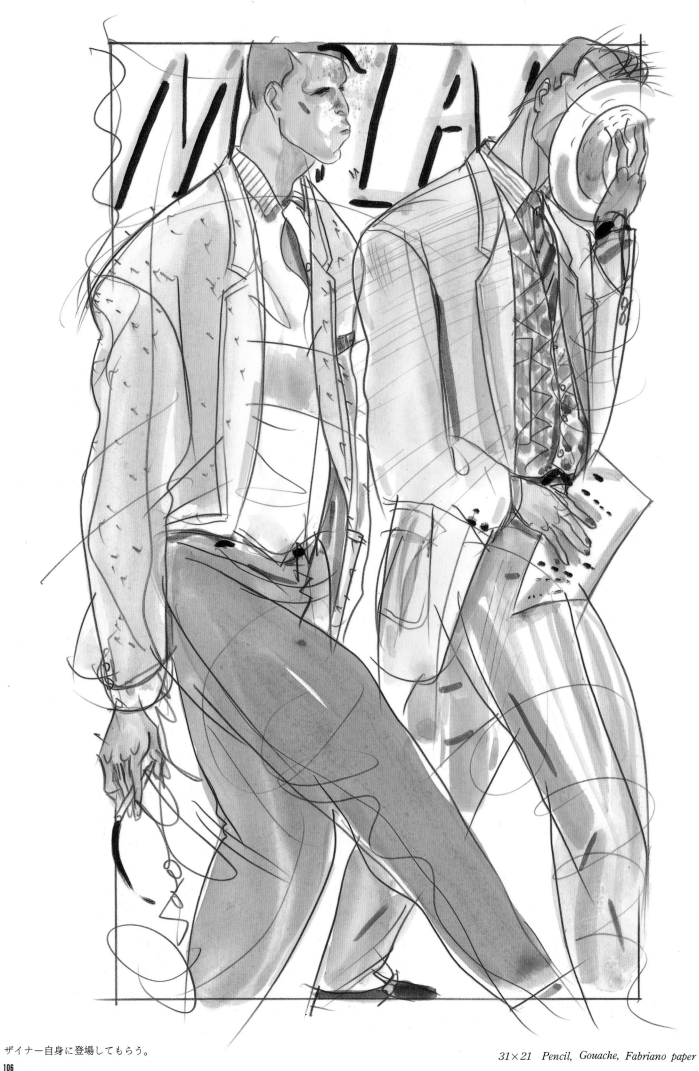

ザイナー自身に登場してもらう。

31×21 Pencil, Gouache, Fabriano paper

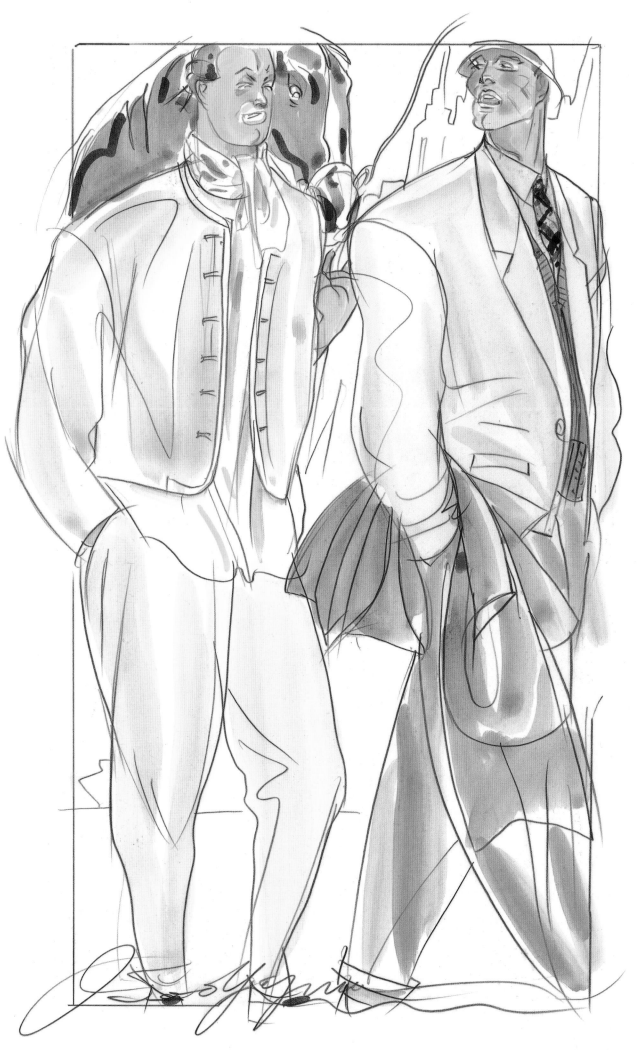

32×21 *Pencil, Gouache, Fabriano paper*

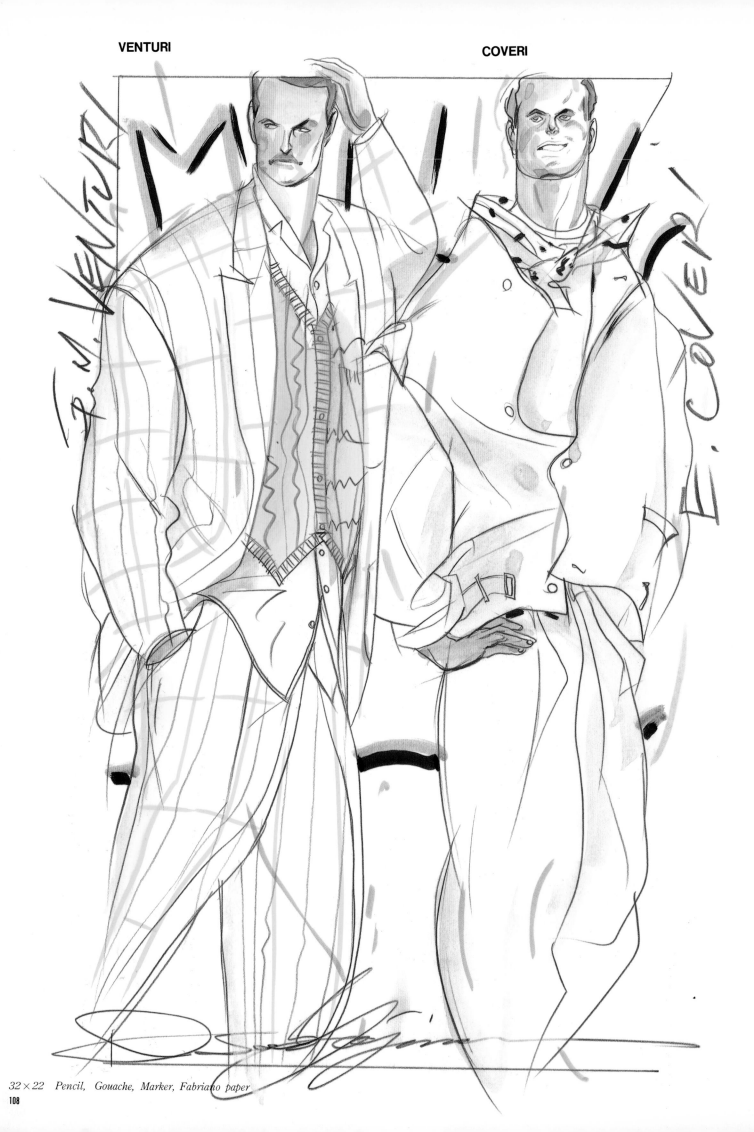

32×22 *Pencil, Gouache, Marker, Fabriano paper*

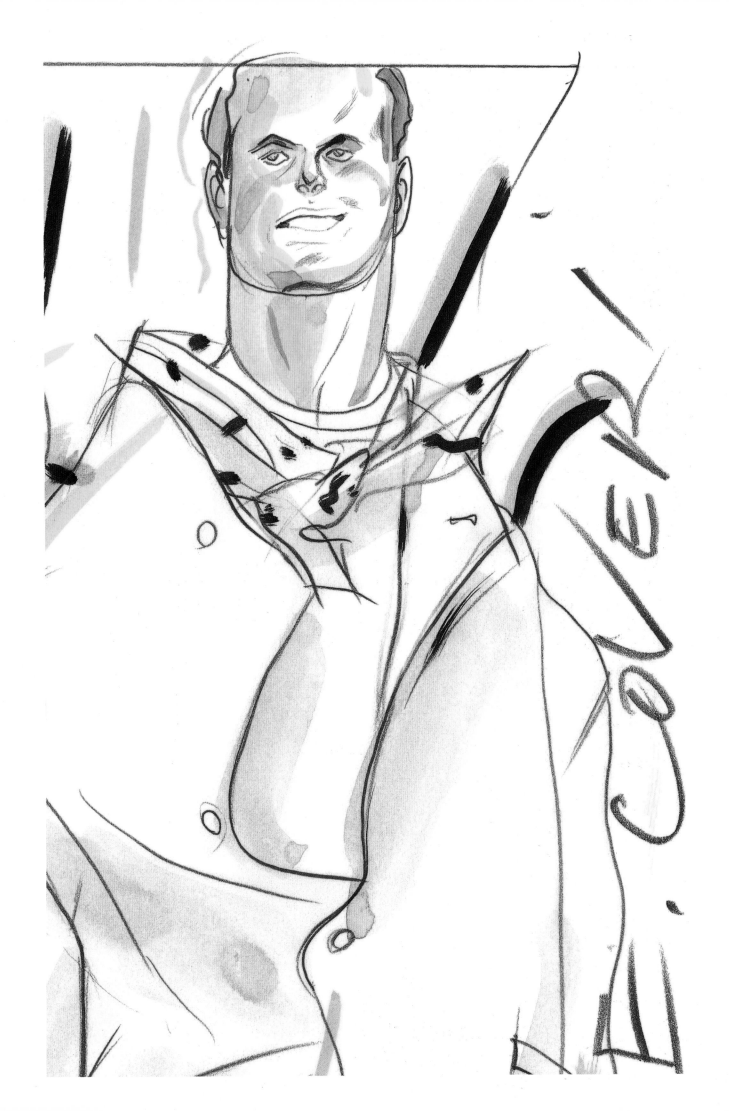

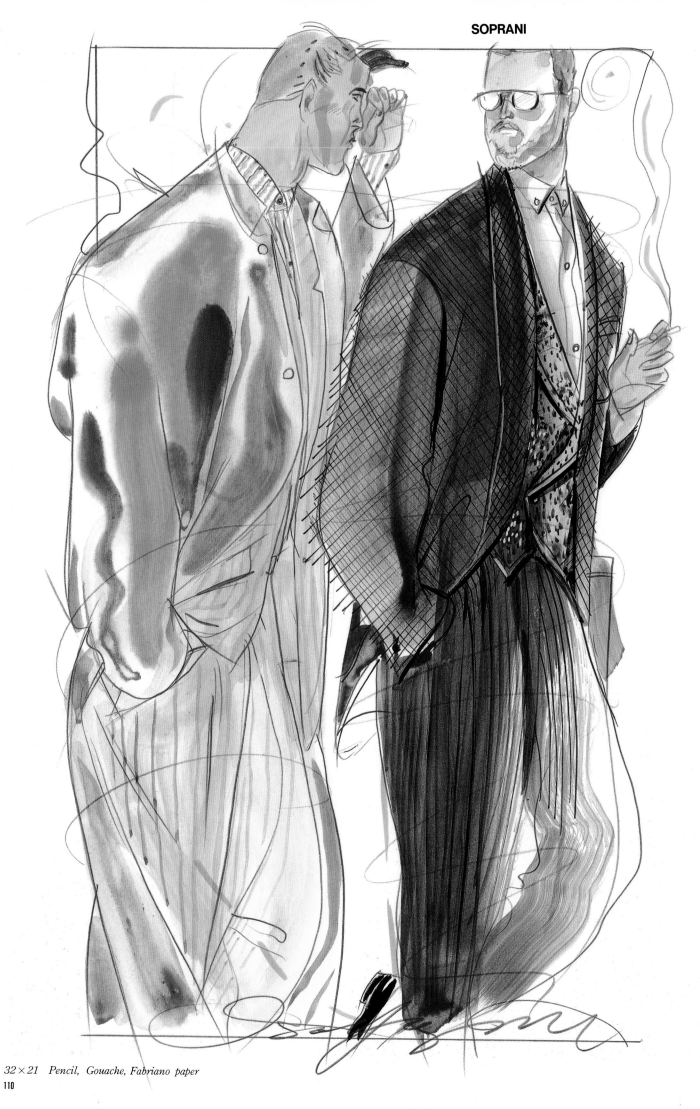

32×21 Pencil, Gouache, Fabriano paper

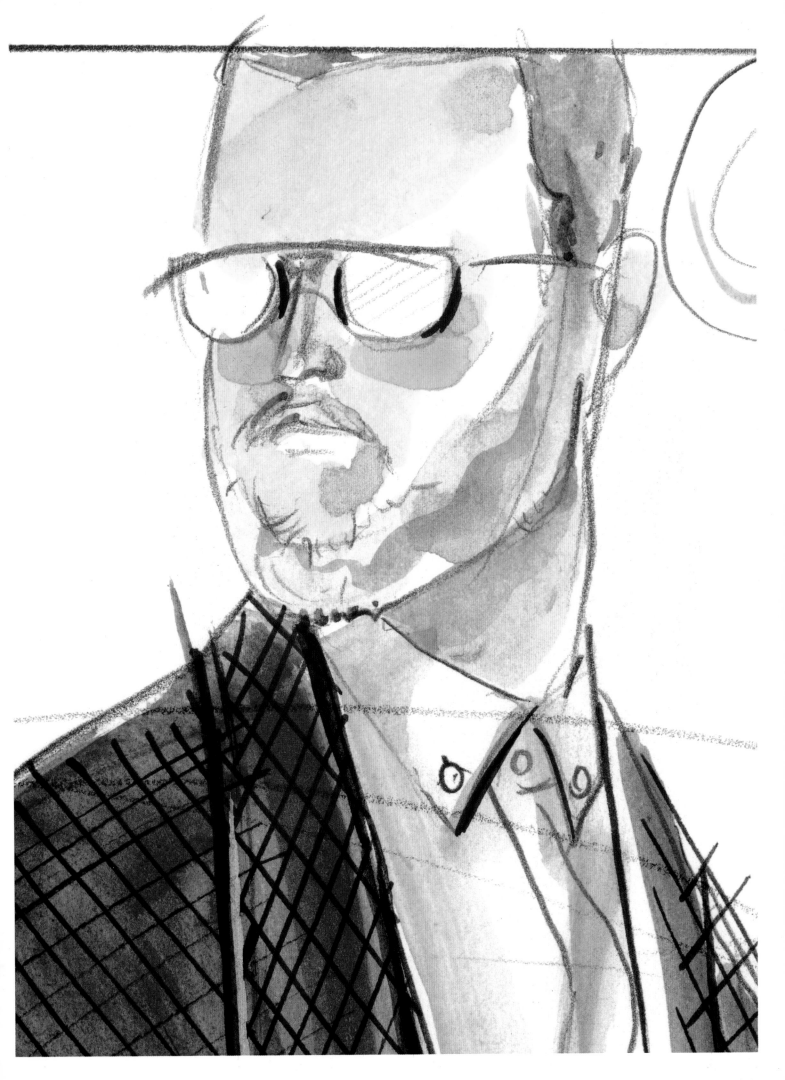

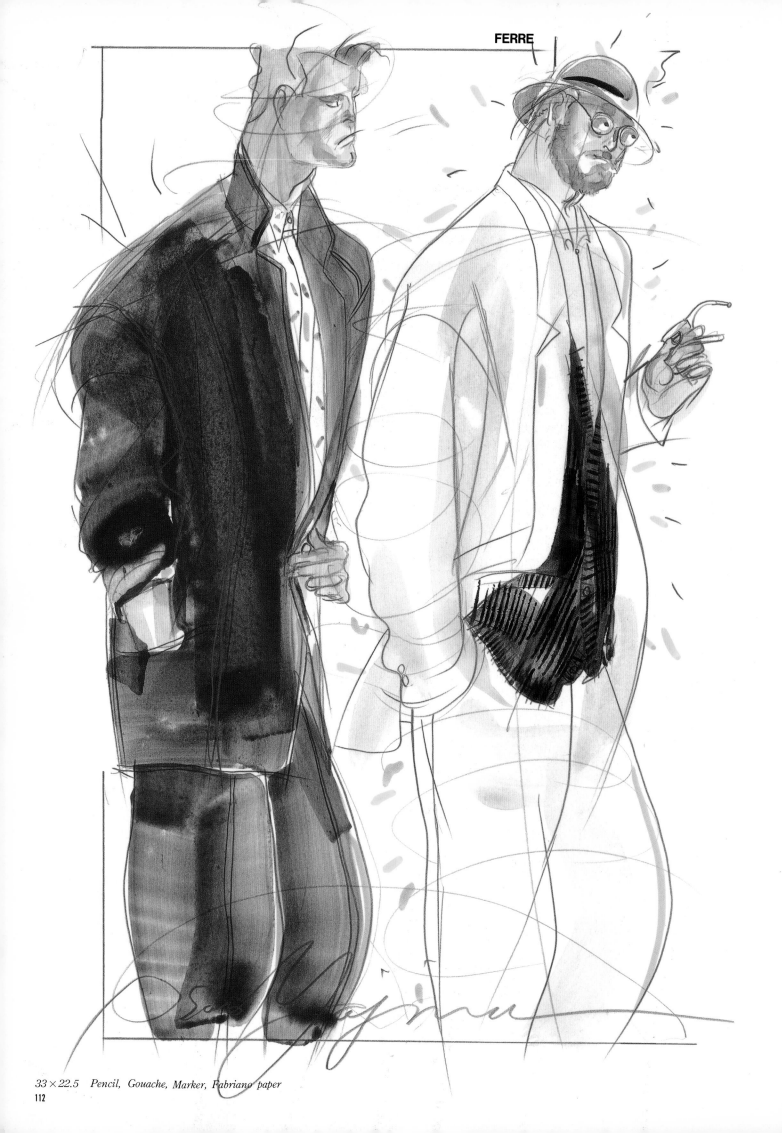

33×22.5 Pencil, Gouache, Marker, Fabriano paper

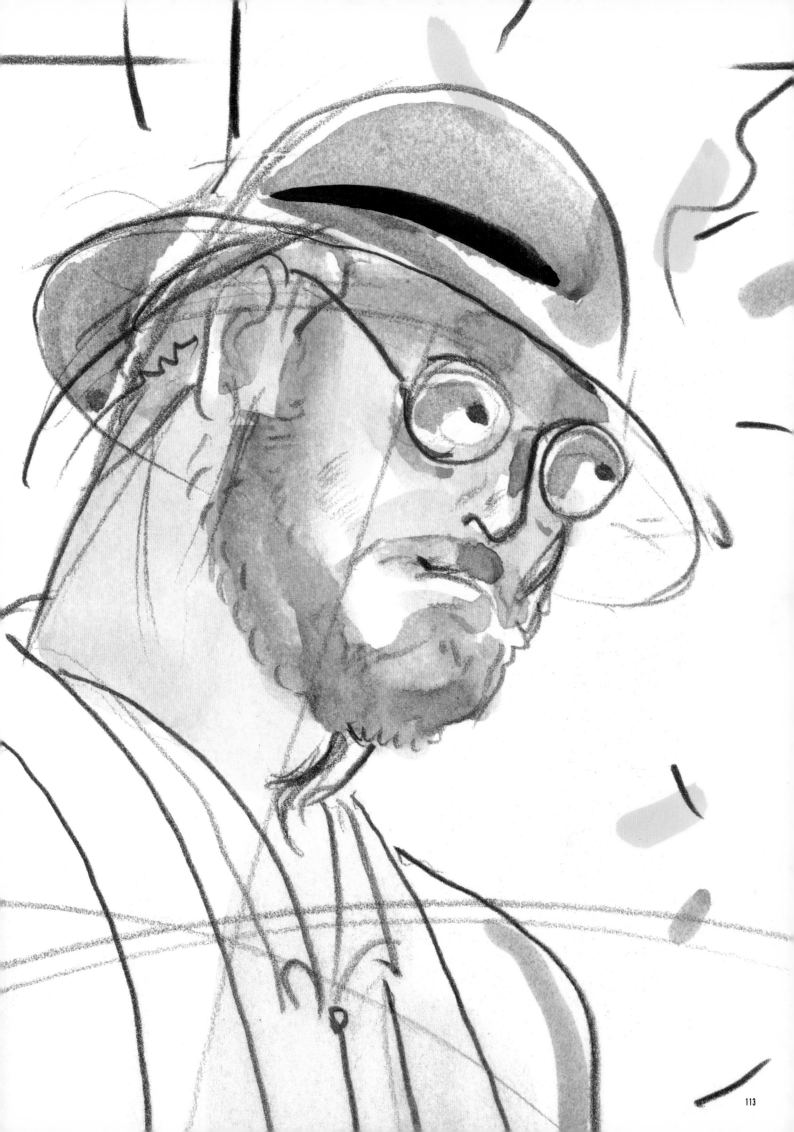

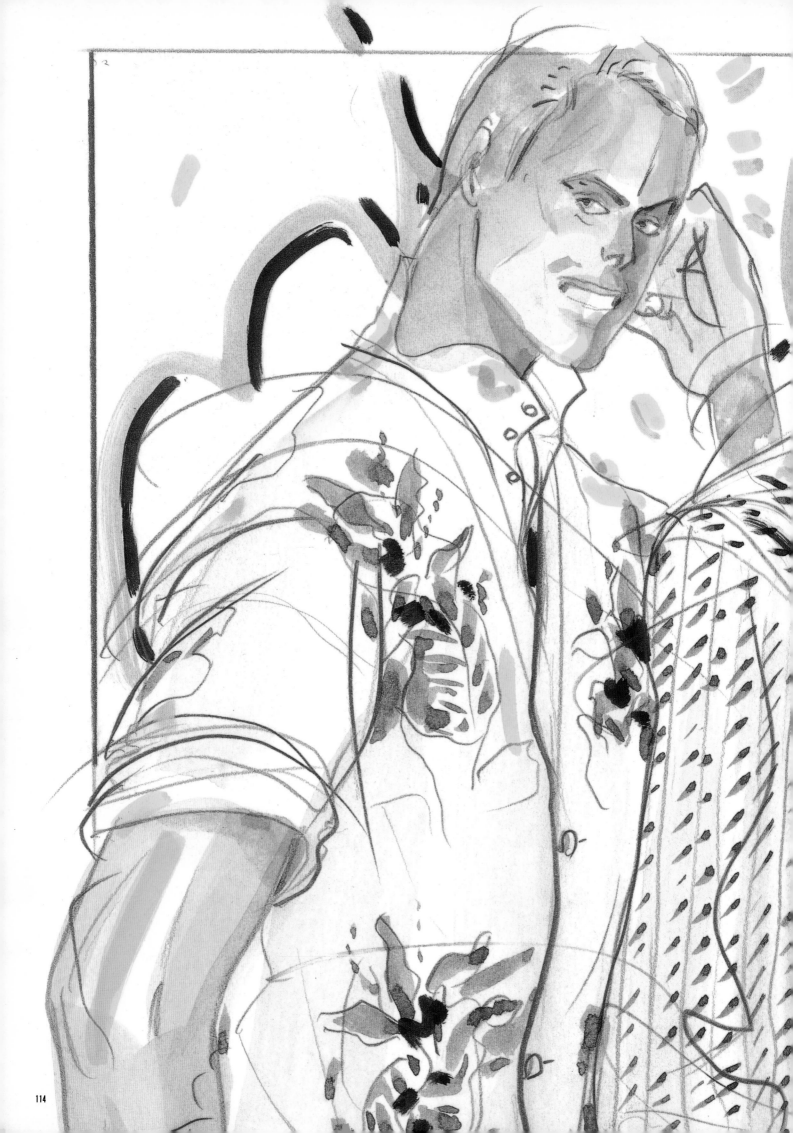

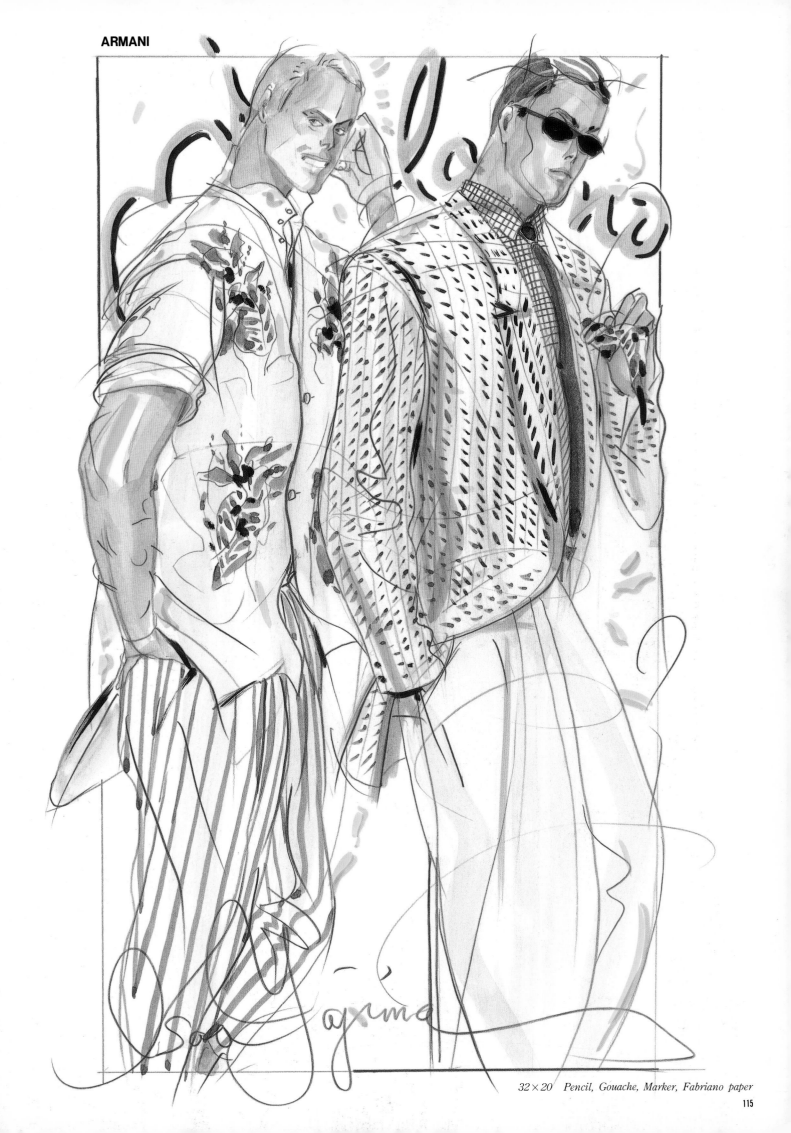

32×20 Pencil, Gouache, Marker, Fabriano paper

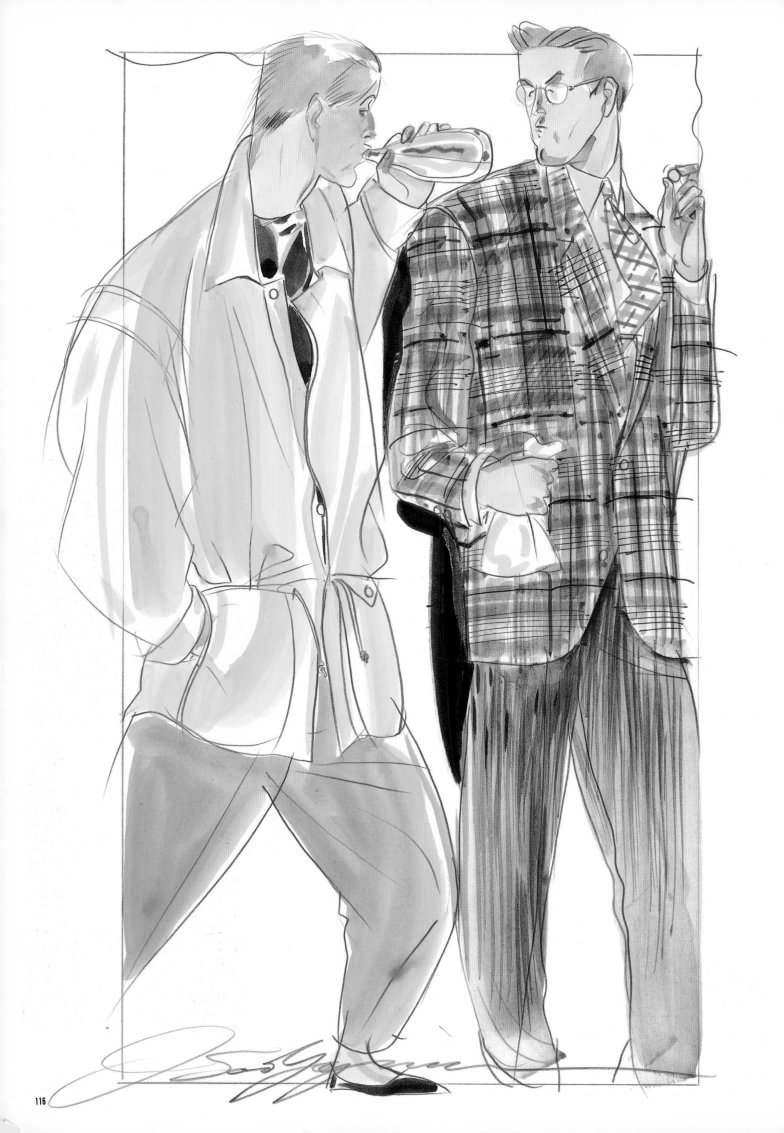

32×21 Pencil, Gouache, Marker, Fabriano paper

Cinelli

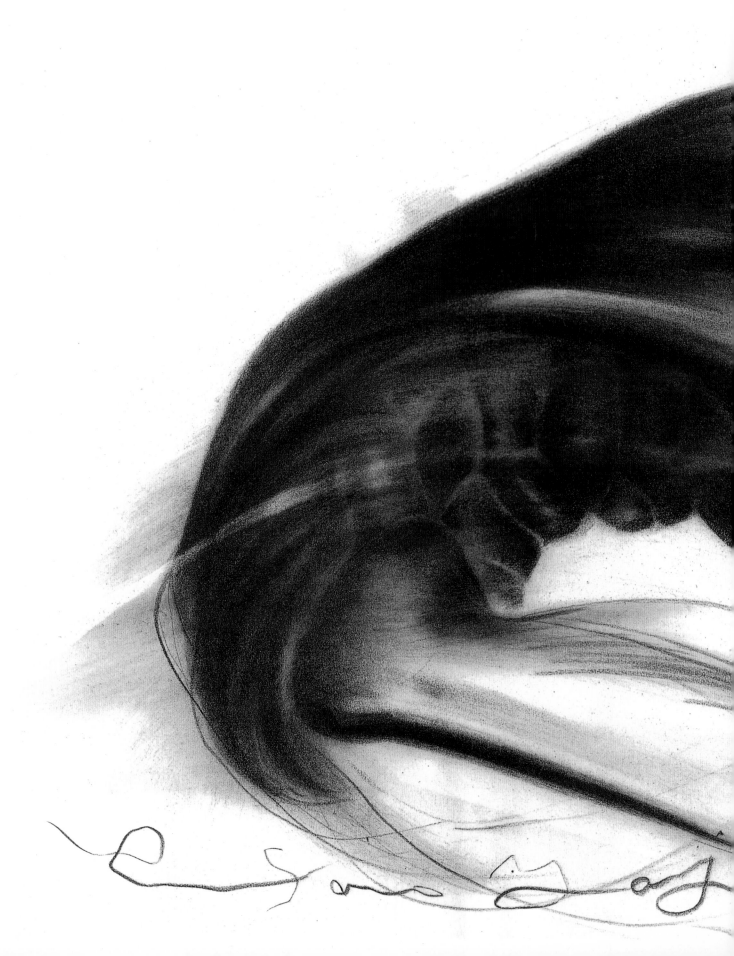

CLISMO

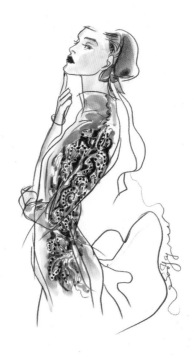

●We often say "chee-zu" (cheese) when we pose for pictures. The "chee" opens our mouths widely so that our faces appear to be smiling. However, the camera shutter usually clicks when we complete the word with "zu" formed by our mouths. When developed, the photos look awkward with the mouths of some persons producing the "chee" sound while others are making the "zoo" sound. Everyone wants his or her face to look beautiful or handsome in a photograph...even if it isn't.

●よく写真を撮られる時チーズなんて言うでしょう。チーズの"チ"がイーで口を横に広げるから笑い顔に見えるのだけど，次の瞬間"ズ"だからシャッター押すのが遅れるとみんなズゥーと言う口形のまま写る。現像して見ると"チー"の口形の人と"ズ"とか"ズゥー"とかいった人が混っていておかしい。
写真を撮られる時は皆ないい顔に撮られたい。うそでもいいから。

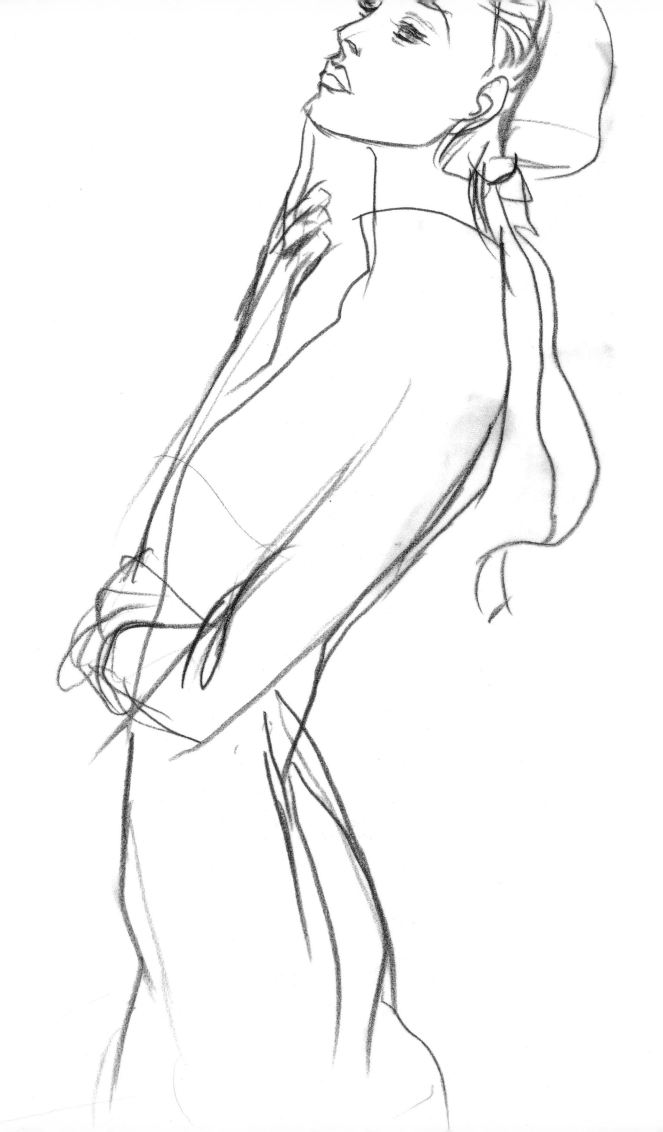

THE AUTHOR ISAO YAJIMA

1966: Graduated from the Kuwazawa Design Institute
of Tokyo
1966: Instructor, Kuwazawa Design Institute of Tokyo
1972: Planning Consultant, Stylist
for Apparel Design Production
1979: Milan Italy

INSTRUCTION
: Instructor of Design, Kuwazawa Design Institute
: Instructor, Chugoku Design School
: Director, Correspondence Course, Tokyo Fashion
Illustration School

PUBLICATIONS (BOOKS)
: Tokyo Fashion Illustration School Text Academy Shuppan
: Yajima Isao Fashion Illustrated (Oribe-Shuppan)
: Figure Drawing for Fashion (Graphic-Sha)
: Fashion Illustration in Europe (Graphic-Sha)
: Mode Drawing Nude Female (Graphic-Sha)
: Mode Drawing Costume Female :
: Mode Drawing Nude Male :
: Mode Drawing Costume Male :
: Mode Drawing Fase and Hand :
: Bici Design (Gengen-Sha)
: Costume Drawing (Graphic-Sha)

MAJOR EDITORIALS (Fashion Illustration)
: Edizione-Hennessen S.R.L.(Fashion) (Italia)
: Il Gruppo Delle Edizioni Conde Nast(Vogue) (Italia)
: Edimoda(Mondo Uomo) (Italia)
: Fujin Gaho (Japan)
: High Fashion (Japan)
: Ryukotsushin (Japan)
: Dansen (Japan)
Etc.

PUBLICITY (Fashion Illustration)
: Gianni Versace Varata la nuova linea in VOGUE italia
: Pal Zileri (Italia)
: Gruppo Zanella (Italia)
: I.W.S. (Italia)
: Cinelli (Italia)
: Le Copan (Italia)
: Odakyu Department Store
: Intermational du pret a porter feminin and Salon
boutique paris porte de versailles (France) '87— '88.

: Teijin Co,.Ltd. (Japan)
: Mitsubishi Rayon (Japan)
: Adam and Eve Co,.Ltd. (Japan)
: Christian Dior (Japan)

: Textile design for GAETENO ROSSINI Italia
: Bici Design in Italia (Milano) PLANA
: : (Bologna) LANZI SELEZIONE
: : (Siena) ARKE' ARREDAMENTI
: : (Emilia) INDICI
: : (Torino) Salone dell'esposizione
 di Torino "IDEA CASA 89"
 in collaborazione con
 AMBIENTE
: : (Bruxelles) Mostra collettiva
 GALERIE THEOREMES
: : (Milano) PLANA
: : (Milano) Euro Luce
 Salone Internazionale
 dell' Illuminazione
: : Architects for PLANA
: Textile Design for clothes for Gaetano Rossini Italia Co,.Ltd.
 Exhibition GRAPHIC STATION in Harajuku
 Painting BICICRETTA
: Exhibition AXIS GALLERY TOKYO
: Interior fabtics textile collection in Italy
 FEDI CHETI CO., LTD., MILANO

: Copan Co., LTD. (Japan)
: Carpet design collection in Italy
 TALAM Co., Ltd,. in Venezia
: CRIE COSMETICS (Japan)

: Bici Design Exhibition (Venora) Gallery Art Nuvo
: (Genevê) Negozio Taglia Bue
: (Tokyo) Seibu Yuraku-cho Creative Gallery

: Object (Italia) Abitare Con Arte

: Ko Isao Yajima Art and Mobile Illustration Exhibition (Hong Kong)

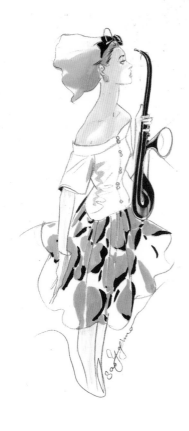

ファッション ドローイング ②
Figure Drawing For Fashion ②

1990年 9 月25日　第1刷発行
September 25th, 1990
著者: 矢島　功(絵紗生)
Author: Isao Yajima
発行者: 久世　利郎
Responsible for Publication:　Toshiro Kuze
発行所: 株式会社グラフィック社
Graphic-sha Publishing Company Limited
〒102東京都千代田区九段北1-9-12
1-9-12 Kudankita Chiyoda-Ku, Tokyo 102 Japan
Tel.03-263-4318　Fax.03-5275-3579 振替・東京3-114345

印刷：錦明印刷株式会社
Printing: Kinmei Printing CO.,LTD.
製本：大口製本株式会社
Binding: Oguchi Seihon Co.,LTD.
写植：三和写真工芸株式会社
Typesetting: Sanwa Shashin Kogei CO.,LTD.

編集協力：アトリエKO
Planning, Layout, and Editing; ATORIE KO CO.,LTD.
東京都渋谷区神南1-5-14三船マンション703
703 Mifune Mansion 1-5-14, Jinnan, Shibuya-Ku, Tokyo, Japan.
Tel. 03-464-8936　Fax. 03-770-3465

ISBN4-7661-0598-2

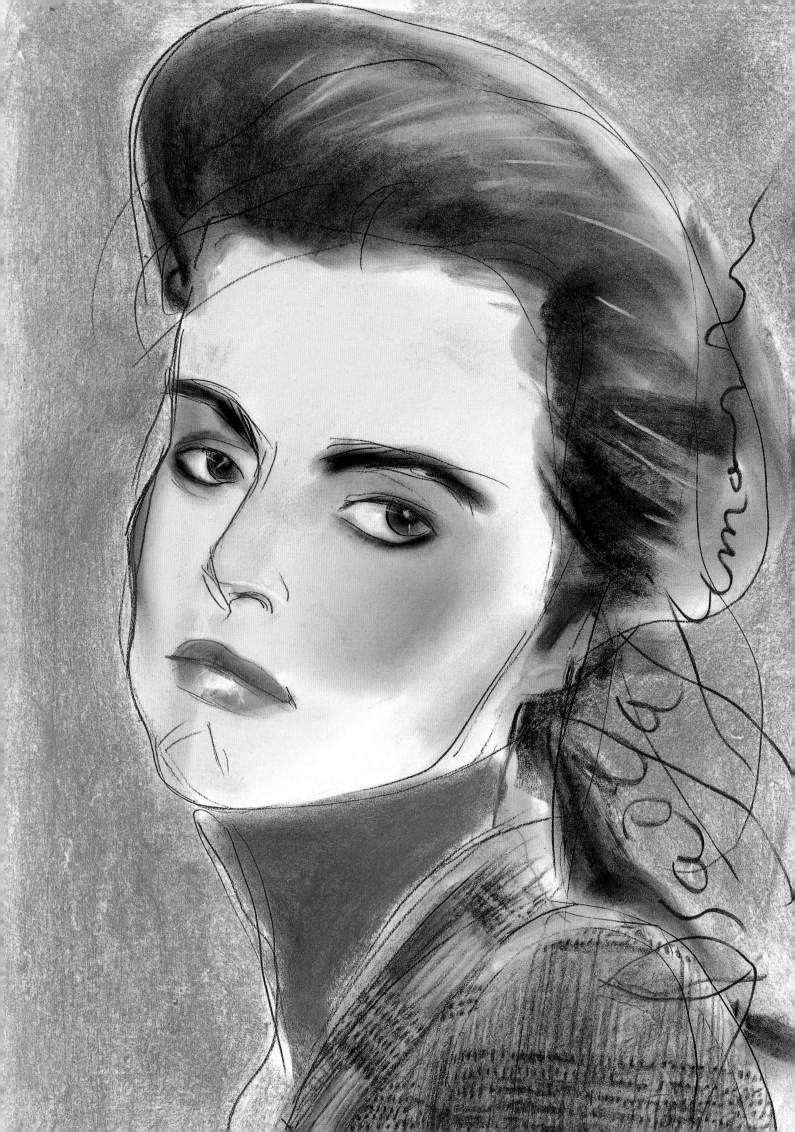

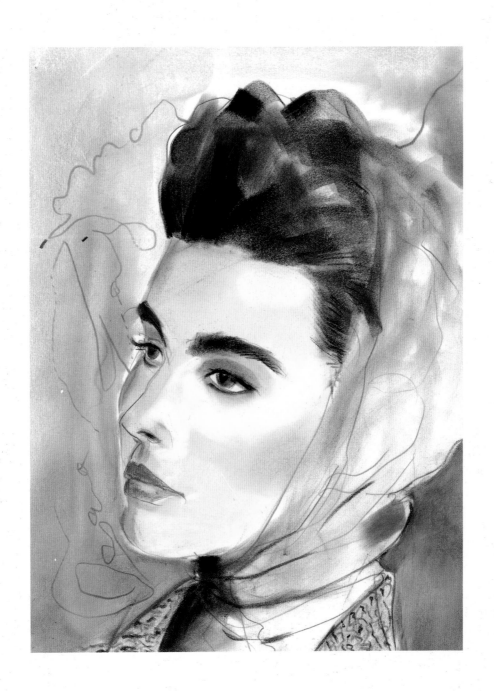

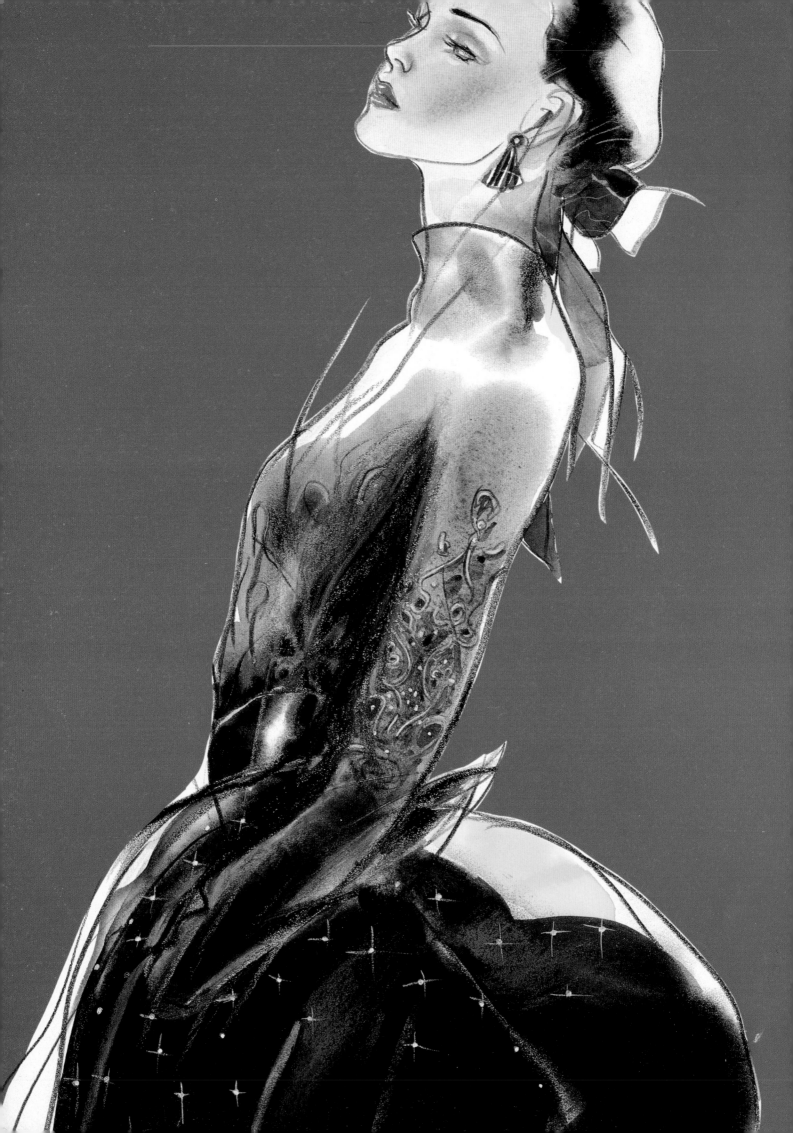